Contents

Chapter 1

Godiva:
Lady, Legend, Legacy

'AD 1057 On the thirty-first of August in the same year Leofric earl of Chester, a man of praise-worthy life; he was buried in the monastery he had founded at Coventry. Having founded this monastery by the advice of his wife the noble countess Godiva, he, at the prayer of a religious woman, placed monks therein and so enriched them with lands, woods, and ornaments, that there was not found in all England a monastery with such an abundance of gold and silver, gems, and costly garments. The countess Godiva, who was a great lover of God's mother, longing to free the town of Coventry from the oppression of a heavy toll, often with urgent prayers besought her husband, that from regard to Jesus Christ and his mother, who would free the town from that service, and from all other heavy burdens; and when the earl sharply rebuked her for foolishly asking what was so much to his damage and always forbade her evermore to speak to him on the subject. She, on the other hand, with the woman's pertinacity, never ceased to exasperate her husband on that matter, he at last made her this answer: "Mount your horse and ride naked before all the people through the market of the town, from one end to the other, and on your return, you shall have your request." On which Godiva replied, "But will you give me permission, if I am willing to do it?" "I will," said he. Where upon the countess, beloved of God, loosed her hair and let down her tresses, which covered the whole of her body like a veil, and then mounting her horse and attended to by two knights, she rode through the market-place, without being seen, except her fair legs; and having completed the journey, she

returned with gladness to her astonished husband, and obtained of him what she had asked; for earl Leofric freed the town of Coventry and its inhabitants from the aforesaid service, and confirmed what he had done by a charter. The said earl also, at the instigation of his countess, munificently enriched with lands, buildings, and various ornaments the churches of Worcestershire, St. Mary of Stone, and St. Wereburg, with the monasteries of Evesham, Wenloe, and Lenton.'

This brief tale is the origin story of Lady Godiva, the earliest known recorded tale and contained within the *Flores Historiarum* written by Roger of Wendover. Little is known of Roger; his birth and the date he became a monk are lost in the fabric of time, but after a stay at St Albans Abbey, he had by 1217 become the Prior of Belvoir in Lincolnshire, a daughter church to the abbey, though his time here was short-lived due to his mismanagement of Belvoir's coffers. Roger returned to St Albans and began his work on *Flores Historiarum* or *Flowers of History*, starting at the creation and ending in 1235, the year before his death. Many wonder where the account originates, who was Godiva, who was her husband, Leofric, and how this tale ended up being written in an obituary at least one hundred and sixty years after the death of Leofric. Delving a little deeper into the depths of time may help to uncover the real woman behind the myth, the real Lady Godiva.

The Kingdom of Mercia was once one of the most powerful of the Anglo-Saxon kingdoms of England and stretched from the English/Welsh border of today, sweeping as far south as to incorporate Bristol, its embrace reaching eastwards to eventually encapsulate London. Its holdings included modern-day Leicestershire, Nottinghamshire, and Lincolnshire to the north and its kings and ealdormen helped sculpt the landscape of England and inform its inhabitants of their temporal and spiritual duties.

However, by the eleventh century, its fortunes had waned, and though it was still governed by a powerful man, he was no king and Mercia was now a province of England. The Earl of Mercia was one of three men who answered to a king, a king whose power extended across the whole of the English realm and at the helm of the country was Edward. Edward,

who would later be known as the Confessor, was the king whose death brought forth a confusing saga regarding who should be his heir and, more importantly, brought Anglo-Saxon England to an end. This confusion, or perhaps manipulation, culminated in multiple claimants and two major battles within the space of just nineteen days. One battle took place in the north with King Harold Godwinson battling against the Viking Harald Hardrada. The second was the infamous battle in the south; the invasion of the Norman, William the Bastard, and his army landing at Hastings.

But what of this story? Does this bear any relation to our story of Godiva? The answer to this is a resounding yes, as it is in the once Kingdom of Mercia her story begins. Although Æthelstan, grandson of Alfred the Great, had, through his tenacity and strategy, united the provinces under one king, this new status did not prove to be permanent. Like all things, the union was transient, and based upon the support offered by those who had money, power, and resources. As mentioned, Mercia was once a large and dominant kingdom and had, in its antiquity, an impressive array of rulers and successes. However, there were times where the kingdom would contract due to less than perfect leadership.

Since 959, the Kingdom of England had been one, but by 1016, it had seen no less than five different kings. Its last king was the Anglo-Saxon Aethelred II, sometimes known as the 'Unready'. This is merely due to the Anglo-Saxon pun of 'Unraed' meaning ill-advised and this pun, unfortunately, continues to malign his rule. Now Cnut was king, a Dane, who would alter the way in which the kingdom was governed. Upon Cnut's arrival, the provinces and ealdormen of England would not see as much land confiscated, as witnessed after the Norman invasion, but it did signal the destruction of the role of ealdorman and the introduction of Danish earldoms. From these changes, Cnut concentrated power in a rather smaller circle of men than had previously been the case in England. This would, in time, allow the rise of three men in particular who would go on to become the most powerful in the kingdom, second only to the king.

Godwin, Earl of Wessex; Leofric, Earl of Mercia; and Siward, Earl of Northumbria had no prestigious lineage to go by; indeed, these were 'new' men, but these three men held not only the confidence of their king, but also the loyalty of their men in their respective earldoms. They held lands,

meted out justice, and possessed many riches. They could found a monastery as well as pull one down if they so chose, such was their power and influence. Leofric, Earl of Mercia, was a significant Anglo-Saxon, but his prominence would be eclipsed by the legend of his wife Godiva.

Godiva, or Godgifu—her Anglo-Saxon name—was married to the third most powerful man in England, though when this took place or, indeed, when she was born, is lost to us now. She was possibly born in what would be Nottinghamshire today, and although little is known of her, to marry into such a prestigious family as that of an earl could mean that she herself came from a preeminent Mercian family.

Unlike her husband, Godgifu's name does not appear in the *Anglo-Saxon Chronicle*, not even in 1057, the year of his death, with the document merely stating that:

> 'Earl Leofric passed away on 30 October. He was very wise before God and before the world, in what availed all this nation. He lies at Coventry.'

So just how was Roger of Wendover able to write such a tale about such a deed over a century after her death? Some twenty years after the Norman invasion, William I ordered detailed surveys of England to be completed by specially appointed Royal Commissioners, whose purpose was to assess what resources and lands William had at his fingertips. This inventory would ensure that he would have an intimate knowledge of the kingdom of England and to whom the lands were distributed. Contained within these surveys is a wealth of information including landowners' names, their tenants, villagers, livestock, and the topography of their land, including woodland, pasture, churches, castles, animals, and any other resources that could have monetary value.

These surveys were compiled into what is now known as the *Domesday Book,* and it is here we can find Godiva's name. The *Domesday Book* has no less than fifty-two references to lands owned by Godiva in 1066, with land holdings in the counties of Leicestershire, Nottinghamshire, Shropshire, Staffordshire, Warwickshire, and Worcestershire. Within these lands is the town (now city) of Coventry, the very same town through which she allegedly rode naked upon a horse

in protest against her husband's heavy taxation policy on the inhabitants. So the question remains, if we are to search for the true Godiva, where can we begin to find her?

In an earlier record, the *Chronicon ex Chronicis*, written by John of Worcester, we can find her name, and an account that holds similarities with that of the *Flores*, minus the legendary ride:

> 'The renowned Leofric, son of the ealdorman Leofwine, of blessed memory, died in a good old age, at his own vill of Bromley, on the second of the calends of September [31 August], and was buried with great pomp at Coventry; which monastery, among the other good deeds of his life, he and his wife, the noble countess Godiva, a worshipper of God, and devoted friend of St. Mary, Ever-a-Virgin, had founded, and amply endowing it with lands on their own patrimony, had so enriched with all kinds of ornament, that no monastery could be found in England possessed of such abundance of gold, silver, jewels, and precious stones as it contained at that time. They also enriched, with valuable ornaments, the monasteries of Leominster and Wenlock, and those at Chester dedicated to St. John the Baptist and St. Werburgh, the virgin, and the church which Eadnoth, bishop of Lincoln, had built on a remarkable spot, called in English St. Mary's Stow, which means in Latin St. Mary's place. They also gave lands to the monastery at Worcester, and added to the buildings, ornaments, and endowments of Evesham abbey. During his whole life, this earl's sagacity was of the utmost advantage to the kings and the whole commonwealth of England.'

Leofric became, as can be seen from his eulogies within these chronicles, a man who wielded much power and influence over the king, second only to his rival Godwin of Wessex. It is certain that Leofric and Godiva had at least one child, a son called Ælfgar, who would inherit his father's lands and title and who had, prior to this event, been granted the Earldom of East Anglia. It is, with some trepidation, that one might assume that in her own right, Godiva may have had some power of her own too, but unfortunately, the annals of time have given us nothing but mere mentions to go by. What is known, or at least can be assumed, is that she seems to

have been a pious lady, founding churches and monasteries and, seemingly, encouraging her husband to do so too.

Piety and power were intrinsically linked at this time. Conversion to Christianity had brought the Anglo-Saxons a section of society that was literate and the church was crucial to the writing of rules and laws. Kings would rely on the scripture of the church as much as the church would rely on the patronage of the king and his advisors. Thus, investing money into the church could be seen as widening one's influence throughout the land.

Godiva's fortunes are also intrinsically linked with that of England and its kingship. Her granddaughter, Ealdgyth, was married to none other than Harold Godwinson and became, all too briefly, queen consort of England. It has also been suggested that it would be highly likely that Ælfgar would have contested Harold's claim to the throne had he not died around 1062/4. Had Ælfgar been alive, that saga of 1066 would have culminated in Harold being embattled on three fronts.

What is known is Godiva's name appearing within the *Domesday Book* is one of only three English names to appear in the 1086 listings. Even though she was likely to have been dead by this point, she is still listed as the tenant in chief to three groups of land, Coventry being one of them. To think that such a figure of legend walked in such circles and at such a tumultuous time and yet she is only known only for a naked ride, which is highly likely to be fictional, is staggering.

Roger of Wendover's account cannot be proven as fact or fiction, as no earlier account survives. Is it possible that this tale was, like many stories, transmitted orally through generation to generation until it reached the ears of a monk in St. Albans? Or did Roger, for reasons we may never discover, utilize his imagination to give Godiva a more saintly appearance? To ride naked through a town without being seen can only be described as miraculous. To return to his tale, one must unpick it to understand the message that Roger was conveying through his story.

Godiva, petitioning her husband to reduce the oppressive toll meted out on the people of Coventry, was met with scorn and anger from her husband, Leofric. He retorted that he would only relinquish the toll if she rode naked upon her horse through the marketplace before all the people there. Godiva, subservient to her husband, asked for his permission and

an accord was struck. Within this short recounting of their exchange, we learn two things; that Leofric is scornful of his wife, believing that she would never acquiesce to such a request, and that Godiva, although contrite enough to ask his permission, felt such a passion for her cause that she would do anything to end the misery of the inhabitants of Coventry.

Godiva, then, to save her modesty, loosens her long hair, which in turn covers her whole body. She mounts her horse, rides through the town accompanied by two knights, and is not seen except for her fair legs. It is the statement 'and is not seen except for her fair legs' that is interesting, as is her hair being described as covering her 'like a veil.' A veil, in modern standards, conjures images of a face covering, though the Anglo-Saxon veil covered the hair, neck, and descended onto the shoulders. The fact that she was 'unseen except for her fair legs' implies that her hair was so long and presumably thick that she was able to hide much of her body with her tresses, and those present on the day that she undertook that ride through Coventry only saw her legs.

Of course, it is possible that this ride did not take place at all, as it has been asserted that Godiva was landowner of Coventry and therefore the only taxes exacted onto the people would come from Godiva herself. However, this argument relies on the information supplied to the Royal Commissioners during the Domesday surveys and there are three possibilities to consider here. The land in Godiva's possession may have been brought with her when she entered into her marriage to Leofric and therefore she retained them. Perhaps they were gifted to her by him, as it was common practice between Anglo-Saxon nobles to bequeath land to their new brides, known as a 'morning gift' to ensure security should their wives become widows. Such agreements could have illustrious witnesses as this example of lands and goods being passed demonstrates:

'Here in this document is made known the agreement which Godwine made with Brihtric when he wooed his daughter; first, namely, that he gave her a pound's weight of gold in return for her acceptance of his suit, and he granted her the land at Street with everything that belongs to it, and 150 acres at Burmarsh and in addition 30 oxen, and 20 cows, and 10 horses and 10 slaves. This was agreed at Kingston in King Canute's presence.'

SEXUALITY AND ITS IMPACT ON HISTORY

Although these lands would be secured in name to the woman, this does not necessarily translate into power or control over them, as women were still expected to defer to their husbands or sons. The third option is that the lands transferred to Godiva after the death of her husband and son, as both had died prior to the invasion of 1066. So whilst it highly unlikely that a woman of her standing would have taken part in such a public display of nudity, Godiva being the Tenant in Chief of Coventry by 1066 is not conclusive enough to rule it out completely.

Putting Godgifu, or Lady Godiva, into a historical context, we can see that it raises more questions of her physical as well as her spiritual being. This in turn creates more interest in her legend, which was enhanced further come the time of the sixteenth century. In 1569, Richard Grafton, printer and soon to be member of Parliament, produced his *Chronicle of England* and introduced a new element to the tale of Godiva and her ride. Godina (as she is named in his version) requested that a:

> '… commaundement should be geuen throughout all the City, that euerie person should shut in their houses and Wyndowes, and none so hardy to lookeout into the streetes, nor remayne in the stretes, vpon a great paine, so that when the tyme came of her out ryding none sawe her, but her husbande and such as were present with him, and she and her Gentlewoman to wayte vpon her galoped thorough the Towne, where the people might here the treading of their Horsse, but they saw her not, and so she returned to her Husbande to the place from whence she came, her honestie saued, her purpose obteyned, her wisedome much commended, and her husband's imagination vtterly disapointed.'

The seventeenth century saw the establishment of Godiva pageants in Coventry and would continue, albeit with infrequency, into the twentieth century. Godiva's image would even be used as a symbol of freedom and became 'a focus for civic pride and independence from state interference'. Over the years, additional characters were introduced to the tale that served to enhance the legend further. Godiva's entourage grew from including several soldiers as bodyguards and then contracted to a single maid accompanying her upon her journey. Yet none of these

embellishments would leave such a lasting impression, save for Godiva herself, than that of 'Peeping Tom.'

The origin of this character is almost as mysterious as the Godiva legend itself. Whether, like Godiva, he began as an addition to the oral tradition or was introduced to bring morality to the physicality of the procession may never be known. There are suggestions that he is first mentioned in 1659 and there is some evidence that he may be seen in a much earlier account, which will be explored later. Regardless of this, his downfall is well established.

The story of Tom the Tailor of Coventry could almost be described as the seedy underbelly of the legend; the contrast between the innocent, godly, and virtuous Godiva and the weakness of the flesh when temptation becomes all too much to bear. Tom's story neatly fixes itself when combined with Grafton's Godiva in which she issues the decree of privacy, to which the townsfolk of Coventry willingly assent, compelled by her graciousness, piety, and the sacrifice of her modesty to benefit them all. Tom, however, unable to resist, perhaps tormented with the knowledge that Godiva was soon to be making her way past his window, upon hearing the horses' hooves, had the audacity to peep through a gap in his shutters. His reward for giving in to temptation was not to be gratified by gazing upon the noblewoman in her nakedness; instead, he was instantly struck blind for his imprudence.

Was the invention of Peeping Tom utilized in the pageants to absolve the masses gathered to watch the parade? It is documented that at each of these processions, a wooden 'Tom' was propped, staring unseeing out of a window or perhaps in the street. It is thought that this effigy was once St. George, re-purposed after the Reformation, and can still be seen to this day. What is interesting is the manner in which Tom is punished for his indiscretion when teamed with the earliest form of Godiva's story.

To return to Roger of Wendover's account and Godiva's legacy to the church, it was not unusual for nobles to found ecclesiastical establishments and to lavish riches on these buildings as it served them in both the temporal and spiritual world. Such moves could yield authority, power, and influence within the physical world whilst ensuring their mortal souls would be cared for in the next. Godiva's suggested sacrifice is almost saintly in its nature. She is willing to relinquish her body and modesty,

her earthly goods, to help those less fortunate than herself. Tom, on the other hand, is portrayed as being almost as villainous as Leofric and his punishment is seemingly well deserved. As such, it is difficult not to make comparisons with an earlier saintly story that resonates so wonderfully with Tom's fate and is the birthplace of the Godiva legend; the Abbey of St Albans.

Alban became England's first Christian martyr and the city and abbey are named after him. He was martyred after he willingly gave his life in place of a Christian he was harbouring in his home. Incensed by Alban's actions, a judge ruled that he should be executed at the nearby arena. In his *Ecclesiastical History of the English People*, Bede explains that the arena was reached via a bridge over a fast-flowing river, but as so many people had turned out to watch Alban's procession to his execution, the bridge used to cross the river was impassable. Wanting to meet his fate quickly, Alban raised his eyes to the heavens and, miraculously, the riverbed dried up, allowing the procession to continue. Overawed by this spectacle, Alban's executioner threw his sword to the ground and refused to continue or to carry out his duty, instead instantly converting to Christianity. However, there was another soldier who took up the mantle of executioner and declared that he would carry out the judgement and so they continued on towards a hill near the arena. Reaching the top of the hill, surrounded by onlookers and framed by wildflowers, Alban declared that he was thirsty and asked God to provide him with water. Suddenly, at his feet, a holy spring began to bubble water and the river that had been dry began its natural course once again. It was on this spot that Alban met his end at the hands of the soldier who, landing a deadly blow upon Alban's neck, cleaved his head from his neck with a stroke of his sword. However, divine retribution was swift. At the same moment that Alban's head struck the floor, so too did the eyes of the soldier, right next to Alban's head, and he was left blinded by his misdeed.

The parallels between the two stories are there to be seen, but whether we can draw any similarities as being anything other than coincidence rather than intent would only be conjecture, though the fate of St Alban's executioner springs to mind when meditating on the fate of Peeping Tom.

The tale of Godiva is multi-layered, and as time progressed, we can

now see how this tale became ever more elaborate. However, it has been suggested that Tom is possibly a misinterpretation of a depiction of Godiva painted in 1581. Nearly four hundred years later, upon the restoration of this image, a shadowy, bearded figure can be seen staring down upon the triumphant Godiva, who boldly rides through a rather larger Coventry than would have been the case. When compared to the literary Godiva contemporary to the time, in this case Grafton, Godiva is unseen save for her husband and therefore it could be possible that the shadowy figure in the window is that of Leofric, who we can observe, watching his wife's procession through the upper window of their dwelling. Regardless of the origin of Tom, to this day, a voyeur caught in the act is known as a 'Peeping Tom,' and for this we have the Godiva legend to thank.

The Godiva pageants, whilst being popular, were localized events and therefore how widespread her story was before the advent of technology such as canals and railways will never be certain. She did feature in at least one broadside ballad of the eighteenth century, that of Erle Leofricus, but one account would catapult the legend into the nation's consciousness further.

Alfred Lord Tennyson's *Godiva* of 1842 transformed the Godiva of folklore and created a legend that would inspire artists for years to come. Paintings and sculptures featuring Godiva increased dramatically after the poem's publication with over eighty known pieces being produced after this time. Godiva was even the subject of a royal commission, with Queen Victoria gifting Prince Albert with a silver Godiva on horseback in 1857.

The folk tale of Tennyson varies from that of the story we have seen so far and, when put into its historical context, echoes of the mass industrialisation and poverty that Britain witnessed during this time. Only a few years earlier, in 1842, Engels would be touring the industrial sites of Britain, which would inspire his *Condition of the Working Class,* published in 1845. Coventry was no stranger to this technological innovation, seeing its population and housing surge as people flocked to its new factories in search of employment. By the time Tennyson was sitting, waiting for his train at its station, Coventry had lost its county status conferred in 1451 and had reverted to a full-fledged city.

SEXUALITY AND ITS IMPACT ON HISTORY

Tennyson, arguably, casts Godiva as a woman who seems to have suddenly awoken to the plight of the poor, as this excerpt demonstrates:

'Godiva, wife to that grim Earl, who ruled
In Coventry: for when he laid a tax
Upon his town, and all the mother's brought
Their Children, clamouring, 'If we pay, we starve!'
She sought her lord, and found him, where he strode
About the hall, among his dogs, alone,
His beard a foot before him, and his hair
A yard behind. She told him of their tears,
And pray'd him, "If they pay this tax, they starve."
Whereat he stared, replying, half-amazed,
"You would not let your little finger ache
For such as these?" – "But I would die," said she.'

Tennyson's version bolstered Godiva's presence and it was during the nineteenth century that the legend truly came into its own. Her story was food for pre-Raphaelite thought and she became a muse for numerous retellings of her journey, though it is within these depictions one gets a real sense of the sexualized Godiva. The earliest portrait, mentioned above, sees Godiva boldly staring out of the painting, seemingly unabashed in her nakedness. Later depictions cast a different spell; one of coyness, shame, and embarrassment. Collier's Godiva of 1898, possibly one of the more well-known images, conjures a feeling of pity from the viewer, that somehow, we should feel ashamed for gazing upon this spectacle. In this composition, she is in profile, sitting upon her horse, her body slumping into the saddle, head bowed, her hair, though not masking her face, is placed in such a way that the eye is not drawn to her features at all, only to the pale skin of her body. Godiva here is the downtrodden woman and, from this perspective, can be perceived to be vulnerability and victim personified; not as the justice-seeking firebrand of literary prose. Her body was to be the battleground for piety and justice, once used as a symbol of independence and a rallying cry, yet here, she is the product of sentiments of an altogether different nature.

Whilst the arena of portraiture and literature that utilised the Godiva legend seemed to be a very male-dominated sphere, a feminine antidote

would soon appear. As the female-dominated private sphere began to push into the public realm with the advent of middle-class women turning to good causes, the mythical Godiva would be invoked and become an emblem of philanthropic work.

Josephine Butler, feminist, president of the Ladies National Association (LNA), and author of the 1883 booklet *The New Godiva,* worked tirelessly in the field of philanthropy. Much like Godiva, she saw the plight of the less fortunate and chose to take up their cause. However, her cause would not be in direct challenge to her husband, but instead against the government of the United Kingdom. In contrast to our legendary Lady, it would be the tragic death in an accidental fall of her young daughter, that would trigger this resolute decision to take up her particular cause. Butler wrote that she had wanted to connect with and help so she might 'find some pain keener than my own – to meet with people more unhappy than myself.' One could see similarities to the particular nature of her philanthropic work and Godiva's own ride inasmuch as both acts could be seen to be requiring the sacrifice of modesty and reputation.

Butler's work began with the campaign for women's education, but it was with her work with women that had been, or were still, working as prostitutes where the comparisons may be made. The Contagious Diseases Acts of 1864, 1866, and 1869 were passed due to alarming rates of venereal disease spreading through, in particular, port and garrison towns. In order to curtail the spread of disease, these Acts allowed policemen to detain any women they suspected might be a 'common prostitute' and required that these women be given thorough examinations by physicians every fortnight. If disease was found, women would be kept in specialist hospitals for up to nine months. Conversely, if the woman was found to be free from disease, she would be sent away knowing that she would be examined again soon. Whilst women were forced to undergo humiliating and painful physical examinations on only the suspicion of prostitution, there were no repercussions for the men who sought the services of these women, as it was assumed that they would object. These Acts were punitive and perpetuated the myth that women were responsible for the spread of venereal disease, not men. Any woman, prostitute or not, could be forced to undergo the examinations, thus many

SEXUALITY AND ITS IMPACT ON HISTORY

poor, working class women lost what respectability they had and soon became fallen women themselves.

Though it was unseemly for women of Josephine's social standing to work with such fallen women, she began campaigning against what she perceived to be amoral law-making. Far from discouraging prostitution, she believed the Acts legalized immoral behaviour and led to the oppression of women whilst condoning the actions of the men seeking illicit sex. Though Butler herself was a committed Christian and did not condone the nature of prostitution, she did rally against the injustice of a government that would make laws that heavily disadvantaged one section of society, whilst allowing another to walk with impunity.

Butler invokes the essence of our legend in her booklet 'The New Godiva' in which two gentlemen discuss good works. The wife of one works, like Butler, with prostitutes and it is the nature of the moral and respectability of such work that is brought to the fore. When working with fallen women at this time, a middle-class woman was not only engaging with those who were socially beneath them, they were also, by association, involved in the practices of illicit sex – and nothing could damage a woman more than an unsavoury reputation.

Godiva's disrobing and display of her body threatened her reputation and her modesty, but ultimately, this was a small consequence for the gains that she would make. To aid those that were less fortunate, were disadvantaged, were ill equipped to cope; to try to save these people was surely a higher and more noble cause. By using Godiva's name, Josephine Butler arouses the sentiment behind the legends tale of morality. Sacrifice for a noble cause is a sacrifice worth making.

To conclude this essay into the Lady, legend, and legacy that is Godiva, I would like to share an anecdote of my own. In a completely unscientific and fun way, I created a poll on Twitter with a simple question; Lady Godiva, fact or fiction? Two hundred and eighty-six people voted with the results showing that sixty-six percent thought she was fact, twenty-five percent thought she was fiction, and the final nine percent admitting that they had not heard of her. As the poll is anonymous, I have no idea from which country any of the voters come, but it did put a smile on my face that at least she was known for the most part.

In conjunction with the poll, I asked what people knew of her, as I

wanted to gauge if it was just her name that was familiar, or if the legend was pervasive too. Most people correlated Godiva with the word 'naked'. Some included the horse, but it was mainly her naked body that people seemed to remember the most. Only a few mentioned Coventry, and only four knew that the naked ride was anything to do with taxes. A couple mentioned Godiva in the context of the luxury chocolate brand. One account was very interesting indeed, placing Godiva and her nakedness in the context of the Black Death of 1348. In this setting, Godiva was a noblewoman who had to disrobe and walk to safety as the plague was thought to have been carried on her clothes. Reflecting on this, I questioned my own children and soon came to the realisation that they had no knowledge of her whatsoever – this has since been rectified!

It seems that the Godiva legend is on the wane; after some eight hundred years, though some may know her name, it is, on the surface, only due to her supposed nakedness and not from the fragments we can gather of what is known of her life. The brief account within the *Chronicon ex Chronicis* and *Flores Historiarum* informs us of her generosity, piety, and evidently persuasive nature; after all, it was she who convinced Leofric to endow riches upon the monasteries.

Whether you believe the account of Roger of Wendover or whether you are in agreement that it is unlikely that her naked ride ever took place, that her story is only folklore – remember this; Godiva/Godgifu, was a real woman. She was a woman that lived and walked amongst the upper echelons of Anglo-Saxon England. She was married to one of the most powerful men in the kingdom. She held many lands, founded and gifted great worth to houses of Christian worship. Her name is one of only three English names listed in the 1086 recordings in the *Domesday Book*. Her son may well have challenged Harold's claim to the throne if circumstances were different, but her granddaughter *was* Queen of England. Regardless of any truth to the legendary ride, her name has become the stuff of legend and has inspired, as we have seen, story makers, poets, artists, and those seeking social justice. This legacy, we could all agree, is worthy of her name and one that should be kept alive.

Chapter 2

Rioting in the Harlot's Embrace – Matrimony and Sanctimony in Anglo-Saxon England

Annie Whitehead

Around the year 966, a noblewoman dictated her will, in which she bequeathed a gold necklace worth 120 mancuses to her successor and rival. A mancus is a weight of gold around 4.2 g or the equivalent of thirty days' pay for a common labourer. Evidently, this was a woman of means. How did this lady, who had scandalized the nation with her behaviour, come to leave such riches? Why did she not end her days in a nunnery, given that history remembers her only for being caught *in flagrante delicto* with her husband and her mother?

Ten years earlier, a young boy had been crowned king of England. He acceded to the throne on 23 November 955, but was in all likelihood not crowned until the following year. King Eadwig was probably fifteen years old, and we can assume that his young bride, Ælfgifu, was of a similar age. His coronation, no doubt, was a lavish affair; a document from the tenth century seems to show some form of tradition of a West Saxon royal consecration rite, including anointing, which had been in use as early as the ninth century. It seems likely that the same rite, the second Anglo-Saxon Ordo (*Claudius Pontificals*), remained in use until the Conquest. The king would have promised that 'the Church of God and the whole Christian people should have true peace at all time by his judgement, that he would forbid extortion of all kind and wrongdoing to all orders of men, and that he would enjoin equity and mercy in all judgements.'

During the feast which followed, it was noted that the king had

disappeared. Dunstan, Abbot of Glastonbury, was sent to find him. And find him he did; in bed, with his young wife and her mother.

From the earliest, almost contemporary *Life of Dunstan*, written by an author identified only as 'B', we have this account:

> 'A certain woman, foolish, though she was of noble birth, with her daughter, a girl of ripe age, attached herself to him, pursuing him and wickedly enticing him to intimacy, obviously in order to join and ally herself or else her daughter in lawful marriage. Shameful to relate, people say that in his turn he acted wantonly with them, with disgraceful caresses, without any decency on the part of either. And when at the time appointed by all the leading men of the English he was anointed and consecrated king by popular election, on that day after the kingly anointing at the holy ceremony the lustful man suddenly jumped up and left the happy banquet and the fitting company of his nobles, for the aforesaid caresses of loose women ... But when he did not wish to rise, Dunstan, after first rebuking the folly of the women, drew him by his hand from his licentious reclining by the women, replaced the crown, and brought him with him to the royal assembly, though dragged from the women by force.'

Dunstan upbraided the young couple, the king argued with Dunstan, not least because of the matter of his grandmother's inheritance, which Dunstan accused him of stealing, and Dunstan was banished. The *Life* goes on to say that as Dunstan boarded the ship which was to carry him to his exile on the Continent, messengers were sent from the king's mother-in-law, threatening that she would put out Dunstan's eyes if he ever returned to England. We know that Dunstan and the king argued about Eadwig's grandmother's inheritance, but how much of the rest of this story is true?

Roger of Wendover, writing in the thirteenth century, uses equally florid language to describe the incident:

> 'A certain light woman, who was nevertheless of lofty birth, inveigled him by her infamous familiarity into marrying either herself or her grown up daughter, both of whom it is reported, though

horrible to repeat, that he in turn shamelessly made the subjects of his base passions. For on the day of his regal consecration, immediately after the anointing, he hurried from the table and left the mirthful company, that he might sottishly indulge his lascivious pleasures.'

He repeats the story about the mother-in-law issuing threats to put out Dunstan's eyes. It is possible that Roger had access to contemporary sources; certainly, his account follows B's story very closely.

William of Malmesbury, writing at a similar time to Roger, has this to say about Eadwig, whom he describes as:

'A wanton youth, who abused the beauty of his person in illicit intercourse. Finally, taking a woman nearly related to him as his wife, he doated [sic] on her beauty and despised the advice of his counsellors. On the very day he had been consecrated king, in full assembly of the nobility, when deliberating on affairs of importance and essential to the state, he burst suddenly from amongst them, darted wantonly into his chamber, and rioted in the embraces of the harlot.'

William does not mention the mother, or the threats to put out Dunstan's eyes. He is known to embellish his stories with folklore, and yet he does not expand on this story. So what are we to make of it, and what was its real significance?

These later sources are versions of the story from the *Life of Dunstan*, so there are no contemporary accounts, and there is no record of it in the *Anglo-Saxon Chronicle*. Anyone writing the life-story (hagiography) of a saint, which is what Dunstan came to be, would emphasize his role as guardian of moral righteousness and so perhaps we must assume that the tale is simply that; a tale. But what is not in doubt is that Dunstan was banished and lived for a while in exile in Frankia. He, and therefore his hagiographer, would certainly have had reason to denigrate those whom they deemed responsible for this ignominy. Dunstan was an ambitious abbot of Glastonbury, who introduced innovations from the Continent, going on to become Archbishop of Canterbury and one of the leaders of

the monastic reformation, restoring adherence to the *Rule of St Benedict* to monasteries in England. Whether the bedroom incident did or did not happen, Eadwig and Dunstan certainly argued – particularly about the dead king's mother being stripped of her property – and the young royal couple was forcibly separated. Yet the marriage was not annulled until after Eadwig lost half his kingdom, when his younger brother became king of Mercia and the north, which suggests that the divorce was driven by political motives.

So, who was this 'mother-in-law' who had helped caused such scandal, and why was the young couple thus targeted? Her name was Æthelgifu – we know this because of a charter which she attested along with her daughter – and there are over a score of entries under that name in the PASE (*Prosopography of Anglo-Saxon England*) database. Many can be dismissed because their occupation is listed as abbess, or because their dates do not coincide with our story. But two in particular are of interest. Æthelgifu 7 is the afore-mentioned 'foolish' woman who subsequently plotted against Dunstan and threatened him. Although Roger of Wendover also denounces her as a violent and vindictive woman, he does not say that she is Eadwig's mother-in-law and, as we have seen, William of Malmesbury does not include her in his story. However, the other Æthelgifu is number 9, who is recorded as being the mother of Ælfgifu, and being the mother-in-law of Eadwig. Her name is recorded once, on that charter (Sawyer Charter number, or 'S'1292) as *Æþelgifu þæs cyninges wifes modur* – the king's wife's mother. It is possible, and generally supposed, that these two women are one and the same.

We must view the *Life* as embroidery, given that it is a hagiography, but what might be the reason for this attack on her reputation?

The twelfth century *Liber Eliensis,* the chronicle of the abbey of Ely, says nothing derogatory about Eadwig, though it records that 'St Dunstan heard voices of heavenly beings singing psalms and saying "Peace of the English in the time of the boy now born and of our Dunstan"', referring to the birth of Eadwig's younger brother, Edgar. Dunstan remains central to this account of double standards and questionable morality, as we shall discover, but as to the reason for the defamation of Æthelgifu the royal mother-in-law, we can only imagine some personal enmity, the basis of which has not been recorded.

SEXUALITY AND ITS IMPACT ON HISTORY

Who was Æthelgifu 7/9, and why was she so relevant to what happened next? If we have identified her correctly, then she was at least of high birth. There are two possible genealogies, both of which have profound importance in unravelling the mystery of the enforced annulment. One has her descending from an ealdorman (earl) of Mercia, and thus through his wife back to the ancient family of the Mercian Gaini. But this does not establish our mother-in-law's royal credentials, because if this ealdorman's wife was descended from the Gaini tribe, the link to royalty would have been one of marriage and not blood; a member of this Gaini tribe married Alfred the Great. We do know, however, that this ealdorman was the father of the powerful Athelstan Half-king, whose family's influence was much felt throughout Eadwig's reign and that of his brother, Edgar. There is a possibility that the link is through the maternal line; in her will, along with the necklace, our young queen left an estate at Risborough, which has been connected to a charter of 903 (S367). In this charter, the king confirms that the owner of the estate is the Half-king's mother, and that the land was given to her by her father, who has the same name as the ealdorman of the Gaini tribe. They are listed separately in PASE, so there is no certainty that these men are one and the same.

The potential link to the Half-king's family is perhaps surprising, given that they formed part of the political opposition to Eadwig's reign, when they might have been expected to support a female relative. It is possible, though, that they had been hoping for favours through kinship that did not materialize, and it might be pertinent that the Half-king stood down, retiring from politics during Eadwig's reign and supporting his brother Edgar's kingship.

The other suggested genealogy could, in fact, sit alongside the first, going up as it does through the paternal line, and suggesting that our 'mother-in-law' was descended from Alfred the Great's brother. It is given credence by the suggestion that she was also the mother of Æthelweard the Chronicler. Æthelweard's chronicle says of Eadwig that 'On account of his great personal beauty, [he] was called All-Fair (*Pankalus*) by the people. He held the sovereignty for four years, and was much beloved.' Given that this is the only chronicle to praise rather than damn Eadwig, it suggests that there was a kinship.

Indeed, Æthelweard himself seems to confirm this by stating that Alfred the Great's brother was his great-great-grandfather. If Æthelweard was indeed our mother-in-law's son, then he was also young Ælfgifu's brother, and this means that she and Eadwig were related other than by marriage and shared a common ancestor, Alfred's father. Certainly, the lady whose will bequeaths the expensive necklace also bestows land upon an Æthelweard. Thus, Eadwig's wife would be related to Eadwig, being his third cousin once removed. This cannot be proved beyond all reasonable doubt, but we do know that the royal couple was forcibly separated on the grounds of consanguinity.

In Bede's *Ecclesiastical History of the English People*, we find the letters of St Augustine and the fifth question, 'Within what degree can the faithful marry their kindred?' The answer comes back from Pope Gregory, 'The faithful should only marry relations three or four times removed.'

If we have identified Ælfgifu's family connections correctly, then she and her husband Eadwig fell within the legal Roman *limits of propinquity* and, under the Germanic system, counting the number of generations from the common ancestor, they would be in the fourth generation. Legislation dating from 1008 – a lawcode of Æthelred the Unready – states that marriage is forbidden 'within six degrees, that is to say, four generations' (*VI Æthelred 12*), but if, as we seem to have established, they were third cousins once removed, then this law, even if it was de facto prior to 1008, would still not apply. Whether or not they were too closely related in law, why was this not contested at the time of the marriage? A document, *Concerning the Betrothal of a Woman*, probably a later source, but interesting nonetheless, cautions that 'It is also well to take care that one knows that they are not too closely related, lest one afterwards put asunder what was previously wrongly joined together'.

There is one other point to consider, which is that this divorce was not initiated until 958, by which time Eadwig had lost most of his kingdom. In all likelihood, it would have been Oda, the then Archbishop of Canterbury, who conducted the marriage ceremony, the same archbishop who instigated the annulment. He must have known at the time that they were related, and to what degree. It appears that this was not a moral, or even a legal problem, but a solution to a political situation that had the potential to divest many privileged people of their power and influence.

SEXUALITY AND ITS IMPACT ON HISTORY

In 955, the young Eadwig had been named king because his uncle had died without issue. Eadwig and his younger brother Edgar had been raised separately, the latter at the palace of the above-mentioned Half-king of East Anglia. By all accounts, Eadwig was ill -suited to the office of king – the huge number of extant land charters suggest that he attempted to buy the support of the nobility – and two years into his reign, he found himself having to share his kingdom with his younger brother. Eadwig was isolated, left with only the erstwhile kingdom of Wessex. His younger brother, Edgar, needed the support of the Church, and one of his first acts was to recall Dunstan. A year after the partition of the kingdom it was decided, some two years or so after the 'incident', that Eadwig and his bride should be divorced. Why; because of a moral and religious objection? More likely it was motivated by a desire to ensure that Eadwig and his bride produced no rival heirs to the throne. Eadwig and his wife had a common ancestor, their children would have high royal status, and that would pose a threat to Edgar's kingship. It was an act of unnecessary vindictiveness, particularly since, conveniently, Eadwig, already divested of most of his kingdom, was dead a year later, aged only nineteen.

What became of his widow? Byrhtferth, a chronicler who wrote the *Life* of Dunstan's ally, St Oswald, says that she was exiled. Osbern of Canterbury, a chronicler writing a *Life* of Dunstan based on author B, suggests that she was ambushed by Mercian supporters of Edgar and died soon afterwards. But if she was the same lady who bequeathed such an expensive necklace, then there must be more of her story yet to tell. Meanwhile, given how the new king, Edgar, came to the throne, and the nature of those around him, we could expect that his reign was marked by piety and the upholding of Church rules. In fact, there were aspects of Edgar's personal life that were equally if not more sordid, and the reign might also have begun with murder.

If the forcible annulment was not driven by religious or even moral considerations, then what was behind the decision to separate the king from his young wife? It is likely that most of the enmity towards Eadwig was politically motivated and driven by those who had lost power and influence when he became king. As mentioned earlier, there were two strands to the argument between Eadwig and Dunstan; the first was the bedroom scene 'scandal' and the second was the withholding of his

grandmother's inheritance. In the preceding three or so decades, a succession of kings had died young and/or childless.

The grandmother so cruelly treated by the king was Eadgifu, third wife of Edward the Elder and mother of the two previous kings. A charter of 959 explains that when the last of her sons died, 'Eadgifu was despoiled of all her property (S1211). As will be discussed later, mothers of kings were awarded higher status than kings' wives, and Eadgifu attested charters as 'queen' during the reigns of both of her sons. A charter of 941, showing the restoring land to Christ Church, Canterbury, is attested by Eadgifu, *'Ego Eadgyua regina signo crucis confirmo'* (S477). In 949, she witnesses a grant by her son to Canterbury cathedral, attesting as *Eadgiua regina matre mea* (S546). She was indeed, officially the Queen Mother, and the family bond seems to have been tight, until Eadwig, the grandson, deprived her of her property. Take them out of the pages of the history books and we have a family like any other, with rifts and tensions. It might have been that Eadwig's main 'crime' was actually his treatment of Eadgifu.

But what of Eadwig's young wife? If we have correctly established Ælfgifu's bloodline, then she was a descendant of Alfred the Great's brother. His son, too young to become king when his father died, later rebelled against his cousin, Alfred's son Edward the Elder, fighting alongside the Danish invaders at the Battle of the Holme in 902. Significantly, it was at this battle that Eadgifu's father, fighting on the side of Edward the Elder, famously met his death. It is possible that the animosity towards Eadwig's marriage stemmed from Ælfgifu's being a member of the 'rival' line, but the bloodline of Alfred the Great was long-established by the time of our story. More plausible is the personal enmity, stemming from the loss of Eadgifu's father, and the fact that Eadgifu had status as the mother and grandmother of kings, status which would be rescinded were Ælfgifu to have children of her own.

The young boys who came to be kings and rivals were brought up separately. We cannot be sure who was charged with Eadwig's upbringing, but Edgar grew up in the house of the man so powerful that his epithet was 'Half-King'. Specifically, Edgar was entrusted to the Half-king's wife.

So, whilst the Half-king might well have been a blood relative of our

'shamed' women, it must be remembered that these were real people, with personal tastes and preferences. His wife was Edgar's foster mother. Maybe that was enough to ensure his championing of the younger brother over the anointed king.

Æthelstan Half-king, Ealdorman of East Anglia, had served the three previous kings, amassing land and wielding influence during the reigns of all of Edward the Elder's sons. We cannot know the full extent of his land ownership because he died as a monk, and thus would not have left a will, but his epithet gives a fair indication of his wealth. In all, he was witness to over 150 charters, *dux* at a time when kings of England achieved military success over the Danelaw and Strathclyde. His influence must have been more than merely political; the families must have been close. When Eadwig and Edgar's mother died in 944, the infant Edgar went not to his stepmother, but to Ælfwynn, the Half-king's wife.

She seems to have been a wealthy woman, whose estates were gifted by her youngest son for the founding of Ramsey Abbey. Is it possible that she was named foster mother to Edgar because of her royal Mercian connections; that she was the daughter of Æthelflaed, Lady of the Mercians? PASE lists six other people, apart from these two, with the same name, but only one can be tenuously linked to the daughter of Æthelflaed, and there is no suggestion that this person, who was a religious woman at that time (S535) was also the Half-king's wife. However, his wife was obviously a woman of means and the connections between the royal family and the house of East Anglia were strong. So, it appears that on one side of the court the East Anglians constituted the 'old guard' who supported Eadgifu, and their family's fortunes changed with the accession of King Eadwig.

The Half-king retired to Glastonbury early in Eadwig's reign. Perhaps this had always been his intention, but what of the timing? It might have been the result of his being ousted from power by Eadwig, who granted an inordinately large amount of land in what can only be seen as an attempt to buy loyalty – around sixty charters survive from this period – and it could be that the Half-king saw that his time of influence was over. Or possibly he waited until his foster son, Edgar, was securely on the throne of Mercia and then, having fulfilled the duty of a foster father, he retired.

In 957, before the annulment of Eadwig's marriage, Edgar, the younger brother, became king of the Mercians. It is likely that Edgar was at this stage only around fourteen years of age, his brother about seventeen. It can be taken as read that he had the backing of the East Anglians, having grown up there, and he now courted the Mercians, whose support, along with that of the Northumbrians, was crucial. For a time, there were two courts, with Eadwig's kingdom now restricted to the central heartland of Wessex.

John of Worcester, an eleventh-century chronicler, wrote that in 957:

'The people of Mercia threw off their allegiance to Edwy [Eadwig], king of England, disgusted at the folly of his government, and elected his cousin [sic] Edgar.'

'And thus in the witness of the whole people the state was divided between the kings as determined by wise men, so that the famous River Thames separated the realms of both.' (B in the *Life of Dunstan*)

It would be difficult and probably inaccurate to describe what happened as a rebellion. The division of the kingdom was very neat and, in 959, there was smooth reunion, but division it certainly was. Eadwig continued to issue charters as full king (*Rex Anglorum,*) but hardly any pertaining to land outside Wessex. No charters of Edgar's from 957 have survived, but those from 958-9 show him granting land and privileges from the West and East Midlands, Essex and Yorkshire, independently, and styled as king: 958 'Edgar, king of Mercia, to ... his *comes*; grant of 5 hides at Ham, Essex' (S676).

A charter of 955, when the boys were both still only princes, has them attesting in identical fashion, as if they had equal status: '*Ego Eadwig cliton consensi et subscripsi . Ego Eadgar cliton consensi et subscripsi*' (S565). It is possible that the division, far from being a 'rising up', was pre-arranged, as had happened before. When Alfred the Great's son, Edward the Elder, died, he bequeathed Mercia to his natural born son Æthelstan, and Wessex to his eldest legitimate son. This division lasted a mere sixteen days, though, and it is telling how short-lived these arrangements tended to be. Perhaps Mercia was seen as a kind of training ground for future kings.

There are several versions of the *Anglo-Saxon Chronicle (ASC)*, and they differ slightly over the dates of accession. The *Worcester* chronicle has Edgar ruling Mercia from 955, as if the division happened immediately upon the previous king's death. The *Parker* chronicle has Eadwig ruling 955-59, as if there were no division at all, while the *Abingdon* version of the chronicle says that in 957 'the atheling [prince] Edgar succeeded to the kingdom of the Mercians'. Edgar attests Eadwig's charters until 957, after which we find him in Mercia, and Eadwig does not then attest any of Edgar's. There is no suggestion of a rebellion and Eadwig continues to sign as full king; however, Eadwig continued to issue coinage, the inference being that in so doing he retained overall control. It is unlikely that Edgar would have risen up in rebellion and allowed his brother to be the one to continue minting coins. Rebellion, coup, arrangement: whatever it was, it must have given renewed hope to Dunstan.

Famously, one of Edgar's first actions when he became king of Mercia in 957 was to recall him, establishing him as bishop of Worcester, a see in the heart of Mercia. When Archbishop Oda, who had presided over Eadwig's enforced annulment, died, Dunstan must have hoped for elevation to the Archbishopric of Canterbury, but if so, he was to be disappointed. Eadwig, still king of the English, nominated the bishop of Winchester instead.

This bishop had not been a monk, but a married clerk. He had a son, and thus was not celibate, which would have earned the disapproval of the reformers who sought to bring strict monastic rules back to the Church. William of Malmesbury, in his *Gesta Pontificum*, accused this bishop of buying the see at Canterbury and of insulting Oda's grave, quoting him as saying:

'At last you miserable old man you have breathed out your life and departed, making room, though late in the day, for a better man.'

Depicted as virtually dancing on the old man's grave, the poor bishop of Winchester certainly had a bad press. Dunstan had studied under his predecessor at Winchester, who was possibly a relative, so perhaps Dunstan took against him for personal as well as professional reasons. Of

more significance was the bishop's closeness to the family of Ælfhere of Mercia, a family with kinship ties to the royal house. Ælfhere was granted his ealdordom in Mercia by Eadwig, in 956, as one of the new 'guard', and thus would have immediately earned the enmity of the East Anglians, whose patriarch, the Half-king, lost land with the granting of that ealdordom. These two great families were to clash horribly later, but the salient point for this stage of the saga is that the bishop of Winchester, the married clerk, appointed Ælfhere's elder brother as godfather to his son.

So, what of Dunstan, frustrated in his ambition to become Archbishop of Canterbury? When Edgar became king of the Mercians, Ælfhere of Mercia became, despite having been appointed by Eadwig, one of Edgar's leading and most trusted advisors. Dunstan, cooling his heels at the see of Worcester, cannot have been happy about this. Yet the papal privilege for Dunstan, confirming his appointment as Archbishop, survives, and is dated 21 September 960, so his hopes for an Archbishopric were realized. From exile to Archbishop of Canterbury in three years; Dunstan's rise, despite the setbacks, was impressive.

Dunstan had served two previous kings, the sons of royal grandmother Eadgifu, and, according to his hagiographer, B:

'When [the king] had been killed by a wicked robber, the next heir … loved the blessed Father Dunstan with such warmth of love that he preferred hardly anyone of his chief men to him.'

This being the case, it is safe to assume that Dunstan would have been in Eadgifu's camp. He owed much to the Queen Mother, little to the louche Eadwig, and everything to the new king, Edgar, and yet he must have been frustrated to find enemies residing at the Mercian court. Not everything was resolved with the reunification of the kingdom in 959.

The tenth century is remembered as a time of reform; specifically, a drive to restore monastic life so that it followed more closely the rule of St Benedict, the aim being to remove secular clerks from monasteries, replacing them with monks. The reform reached its apotheosis during the reign of Edgar and was led by Abbot Æthelwold of Abingdon, Bishop Oswald, later Archbishop of York, and, perhaps to a lesser extent, Dunstan; although B heaps praise on him, his *Life* mentions little in terms of his part in the reformation.

SEXUALITY AND ITS IMPACT ON HISTORY

An Old English Account of King Edgar's Establishment of Monasteries, widely believed to have been written by Æthelwold of Abingdon, says that '[Eadwig] distributed the lands of the holy churches to rapacious strangers'. But an early Yorkshire charter shows King Eadwig giving land so that the archbishops of York could found the minster of Southwell (S659). Granting the land to the Archbishop, the king says, 'He is to possess it profitably for as long as he lives and after his death to leave it to whomever he sees fit.'

Conversely, early on in his reign, reformation of the monasteries was not of pressing concern to Edgar. The St Werbergh's charter of 958 sees him granting land to an unreformed house of secular clerks near Chester, (S667) and can be seen as perhaps more of a move to empower Mercia than as any nod to reform.

Whatever the personal religious beliefs of these two brothers, the events of 959 changed the political and religious landscape. The married bishop of Winchester, archbishop-elect, died on his way to Rome to receive the pallium (the vestment symbolising the office of Archbishop) from the pope, leaving the way clear for Dunstan to become Archbishop of Canterbury. More momentous was that King Eadwig, aged only nineteen, divorced and childless, also died, and his brother Edgar became king of all of England.

What can be said in summation of Eadwig's short and unhappy reign? Was his misfortune a matter of king versus Church? It seems to have been more complex; Abbot Æthelwold of Abingdon had tutored Edgar, and was the leader of the Benedictine reformation, yet he supported Eadwig's marriage and described Ælfgifu as '*thaes cininges wif*' – the king's wife (S1292).

Apart from that, and a brief note in the *Liber Eliensis* – 'Prince Edwy and his brother Edgar of blessed memory, both of whom earned the right to wield the sceptre of the kingdom' (*Liber Eliensis*, Book II 28) – there is little in the chronicles to recommend Eadwig. His wife's brother described him as 'all-fair' but it seems he was a lone voice. There is no suggestion that Eadwig died from anything other than natural causes, but actually the sources are very muted on the matter, with the *ASC* merely commenting that he 'passed away'. One cannot help but wonder whether the young, possibly still teenaged, Ælfgifu was allowed to attend the

funeral, given the evident vindictiveness of those who sought to separate the couple.

That aside, with Edgar apparently of strong character, and the Church reformers eager to begin, it would seem that everything was set fair for a strong, pious reign. If there were shadows cast by the convenient timing of the deaths of Eadwig and the bishop of Winchester, they were not long shadows.

Eadwig may have been nothing more than the proverbial black sheep. Who knows what would have happened in terms of the assessment of his reign, had he lived? Hindsight is a wonderful thing, and his brother Edgar was about to benefit from it. 'In this year, King Eadwig passed away, and was succeeded by his brother, Edgar.' (*ASC*, 959) Conveniently, perhaps suspiciously so, Eadwig died on 1 October, aged just nineteen.

With the exception of his ex-wife and her brother, Æthelweard the Chronicler, Eadwig seems to have been little mourned: '[Eadwig] breathed his last by a miserable death.' (B, *Life of Dunstan*) and whatever the circumstances of the division of the country, it knitted back together seamlessly with Edgar's accession to the whole kingdom when he was, according to the *Liber Eliensis*, 'Chosen by the whole people of England.'

The *Liber Eliensis* expands:

> 'King Edgar, having been properly instructed by the blessed Dunstan, enacted just laws for the kingdom of the English and kept control, all the time, over a kingdom that was in a most tranquil state. He restored the churches which had been destroyed.' (Book I 50)

His enthusiasm, certainly in the earlier years of his reign, could perhaps be described as less than wholehearted. Yet, paradoxically, Edgar's love life seems, at first glance, to be tangled and sordid.

There is no mention in any of the sources of a coronation before 973. Was it kept low-key, and if so, why? Or did it simply go unrecorded, like so many others? It is unlikely that it never happened at all, but Nicholas of Worcester, writing in the eleventh century, says that Edgar delayed his coronation out of piety 'until he may be capable of controlling and overcoming the lustful urges of youth'. Was this a veiled reference

to Eadwig, or an indication that Edgar had as little self-control as his brother before him?

The traditional narrative for Edgar's women is that he married Æthelflæd *Candida* (the White, or more usually, *Eneda* the Duck) by whom he had a son, Edward. He then seduced a nun, Wulfthryth, by whom he had a daughter, Edith. Then he married Ælfthryth, by whom he had two sons, Edmund and Æthelred (the Unready). There are many reasons not to accept this as the whole truth, however.

Edgar's love-life was certainly complicated. Most history books have it that he had two wives and one concubine. He might have been doing the same as many kings before him had done, and putting aside a concubine for a wife; Harold Godwinson did the same thing when he became king in 1066. Edward the Elder, Edgar's grandfather, had a son by his first wife (or possibly concubine), his second wife retired to a nunnery, and Edward was married again, this time to Eadgifu, the grandmother so cruelly treated by Eadwig. Edgar might simply have been following an accepted pattern, which would have gone unremarked upon in different circumstances. Yet whilst it has been widely chronicled, his alleged behaviour did not provoke disapproval from the chroniclers, nor bring down the opprobrium that was heaped upon Eadwig and his young bride.

It is usual to associate Edgar's first marriage with Æthelflæd *Eneda*. According to William of Malmesbury, she was the daughter of an ealdorman, Ordmaer. But there is only one person of that name mentioned in PASE whose dates would make him a contender, and he is only mentioned once, as being the husband of Ælde, and not as an ealdorman (*Liber Eliensis* II 7). On this basis, we can rule out the Æthelflæd the White mentioned in the will of Wynflaed, because she is named as Wynflaed's daughter – 'And she bequeaths to her daughter Æthelflæd her engraved bracelet and her brooch'. PASE associates this Æthelflæd with three others. More ladies of that name can be discounted because their dates do not match, or because their family relationships rule them out. In fact, there seems to be no contemporary record of Æthelflæd *Eneda* at all. It is not unique that there is no contemporary reference to the first wife of a king; the lack of information about her father, however, is an obstacle to establishing her existence.

30

Edgar's second 'woman' and possibly wife was Wulfthryth, later Saint Wulfthryth, who might have been promised to the Church before Edgar impregnated her. In PASE, we find her listed at Wulfthryth 6, who:

'initially was not fully professed as a nun of Wilton, but assumed the veil for fear of Edgar, but had it torn off before being forced into the king's bed. Edgar was reproved by St Dunstan and served seven years of penance. As for her, once Eadgyth (Edith) was born, she returned to the nunnery.' (PASE cites the source as William of Malmesbury's *Gesta Pontificum Anglorum*).

William (c.1095-c.1143) is not the only source of these stories, although none is contemporary. Of those sources, John of Worcester (d.1140) has little to say, beyond that Edgar:

'... also had by his first wife, Ethelfleda the Fair, surnamed *Eneda,* daughter of the ealdorman Ordmaer, a son named Edward... and by St Wulfrith a daughter named Edgitha.'

Osbern of Canterbury (c.1050-1090) said that the baby Edward was the son of a professed nun of Wilton, whose seduction earned Edgar a seven-year penance, causing his coronation to be delayed.

Eadmer (c.1060-1126) believed his contemporary, Nicholas of Worcester, that Edward was the son of Æthelflæd the White, daughter of Ordmaer. Thus, he denied that the boy was born of a consecrated nun, and tells the story of the seduction of the young laywoman and says his offence was worse because he already had a lawful wife:

'For on a certain occasion this same king came to a monastery of virgins, which is located at Wilton, and there, captivated by the beauty of a certain young girl, who took her lineage from the English nobility and was being raised and protected by the nuns though she had not taken the veil, he ordered her to be brought to him secretly to speak with him. While she was being led to him out of fear for her chastity she placed a veil snatched from one of the nuns on her own head, hoping in this way to protect herself should

31

the king by chance wish to demand anything dishonourable from her. When Edgar saw her wearing the veil he said, "How suddenly you have become a nun." He grabbed and dragged the veil from her head while she resisted in vain with whatever strength she had.'

Goscelin of Saint-Bertin (born before the 1040s) wrote in his *Life of St Wulfhild*, that it was she (Wulfhild) who became the object of Edgar's attentions, resisting by escaping naked down a sewer, and that he took Wulfthryth, a laywoman being educated by the nuns instead. He presents her as Edgar's wife.

Here is William of Malmesbury again, conflating these stories and adding a few of his own:

'She was not actually a nun, as popular opinion crazily supposes. She had merely put on a veil as her own idea in her sudden fear of the king, before, as the story continues, the king snatched away the veil and dragged her to his bed. Because he had touched a woman who had been a nun, if only potentially, he was reproved by St Dunstan and made to do a penance for seven years. Also, when Eadgyth had been born, Wulfthryth did not develop a taste for repetitions of sexual pleasure but rather shunned them in disgust, so truly is she named and celebrated as a saint.'

In his *Gesta Regnum*, William rather goes to town, and gives us stories about all sorts of women.

At pains to point out that he is not the originator of such stories, but only reporting them – 'There are some persons, indeed, who endeavour to dim his [Edgar's] exceeding glory by saying that in his earlier years he was cruel to his subjects, and libidinous in respect of virgins' – he nevertheless gleefully describes that along with a charge of cruelty, relating to the circumstances of his final marriage, 'they' add a second of lust, and reports how Edgar carried off a virgin, who was dedicated to God, from a monastery by force, ravishing her and repeatedly making her the partner of his bed, for which he received the seven-year penance.

Then comes a third charge, in which both vices of cruelty and lust 'may be discovered'. He relates how Edgar ordered the daughter of a

noblewoman be brought to him, whose mother managed then to substitute a serving woman in her daughter's bed, whom Edgar subsequently frees 'from her servant's bonds, and loved her entirely, nor left her bed till he took Elfritha, [Ælfthryth] to be his legitimate wife.'

He then sums up:

> 'Besides of Egelfleda, [sic] surnamed the Fair, the daughter of the most powerful duke, Ordmer, he begot Edward, and St Editha of Wulfthritha, who it is certain was not a nun at that time, but being a lay virgin had assumed the veil through fear of the king…'

This seems to bring us full-circle.

What are we to make of these tales? On the face of it, they are not showing any precedents being set. St Boniface castigated an eighth-century Mercian king thus:

> 'From many sources we have learned that thou hast never taken a wife in lawful marriage … And what is worse, those who tell us this, add that this crime of deepest ignominy has been committed in convents with holy nuns and virgins consecrated to God.'

Whatever the truth of the seven-year penance, whether imposed or self-imposed, it was nothing to do with delaying the coronation. We know that Edgar was crowned in Bath in 973, probably not for the first time, and we know that seven years before that he was already married to his last wife.

It is hard to know why these Anglo-Norman chroniclers were at pains to point out Edgar's sexual misdemeanours whilst at the same time revering him as almost saintly. There was a great interest at this time in the events of the tenth century, which might have been driven by a desire to stress continuity of the monarchy and shore up claims of legitimacy. Perhaps they were conforming to a tradition of showing men testing the virtue of saints; Wulfhild's escaping naked, for example.

For, if any of these tales is true, then there is rather a lot of hypocrisy on display. Nothing was said in disapproval of Edgar's antics; the married bishop of Winchester was mauled by the chroniclers, but they seemed relaxed about Edgar's apparent predilection for seducing nuns. If Dunstan

(or more specifically, his hagiographers) were so aghast at the goings on of Eadwig and his bride Ælfgifu, why did they condone this behaviour of Edgar's?

The *Liber Eliensis* might give some clues. In Book II 3, it tells us that, 'Æthelwold [of Abingdon], at the command of King Edgar, ejected the clerics from the church of Ely and introduced monks there'. We have seen that Dunstan perhaps did not have as much to do with the reform, but Book II 53 says that, 'Amongst them, Dunstan and Æthelwold illuminated this their sphere most brilliantly, like a latter-day Peter and a latter-day Paul'.

Either the stories about Edgar's women are not true, and it is clear that they have been embellished, or his activity might have gone completely unnoticed, like his grandfather's plural marriages, were it not for the drive to chronicle the reform. Edgar facilitated that reform, for any number of reasons. He might have agreed with it, he might also have seen the benefits for him in the next life. Giving power to the Churchmen was also a way of curbing the power of those increasingly large and powerful ealdordoms and the dynasties which were beginning to form, but it could also have been a way of ensuring that his sexual proclivities were overlooked by those who should have censured him.

We cannot unravel this by looking at it purely in the context of its own time. So much of what was written was informed not only by what happened during Edgar's reign, but after it. It mattered that Edgar's third wife was, like Ælfgifu before her, associated with a court faction ostensibly hostile to the leading Churchmen. It mattered that his son Edward was not considered legitimate by some. For however tangled Edgar's romantic life, we do know that Edward and Æthelred, who both became kings after Edgar, had different mothers.

In the New Minster charter (S745), the royal children are described differently, with only the son of Ælfthryth, Edgar's last wife, being described as heir, and not Edward. This point is pivotal to the events following Edgar's death.

Edgar married Ælfthryth, widow of his East Anglian foster brother, Aethelwold, in 964, so his son Edward must have been born before that. St Edith apparently died when she was in her twenty-third year, sometime between 984 and 987. Thus it is possible that she was born as the result

of an extra-marital affair whilst Edgar was still married to his first wife.

However, whilst the lack of contemporary mention of Æthelflæd *Eneda* is not necessarily significant, even at Shaftesbury, where Edward's relics were housed, and where his cult grew up, there was no recorded mention of his mother having been Æthelflæd. Tradition at Wilton, where St Edith was the abbess, had it that she was Edward's full sister. It is tempting to conclude that Æthelflæd *Eneda* never actually existed and was invented as a device for later chroniclers to embellish their tales of Edgar's adulterous behaviour.

Those later chroniclers knew that Wulfthryth took her vows at some point, so it may be that they thought she had always been a nun, with hindsight informing their writing. Other royal wives had joined nunneries – Edward the Elder's second wife retired to Wilton after her husband remarried – but it is possible that Wulfthryth's case was only remarked upon in the light of the subsequent succession dispute between Edgar's children, and because Edgar's reign generally was of interest to those chronicling the monastic reform.

Aside from saving or securing Edgar's reputation, the truth and nature of his relationships is not hugely relevant. What did prove to be important was the fact that Edward was not the issue of Edgar's final marriage, so when the time came once again that two young boys were rival heirs to the throne, this half-bloodline mattered.

When Edgar married for the second, possibly third, perhaps even first, but certainly the last time, his choice of bride, the recipient of that beautiful necklace, was to provide yet more grist to the rumour-mongers' mills.

In around 964, Edgar married Ælfthryth, the widow of his foster brother, Aethelwold of East Anglia. Her status was to eclipse even that of Eadgifu, the doughty grandmother who had held sway for so long. She has come to be known as England's first anointed queen, and was the first queen to be given a formal dower; in 964, King Edgar gave to his queen, *Ælfþryð regni*, a grant of ten hides at Aston Upthorpe, Berks (S725).

Not everyone called her a queen, though; Dunstan's hagiographer, B, refers to her only as 'wife'. She was not universally loved, as was to become clear when Edgar died, but there is no doubt that the marriage, be it Edgar's third, second, or even first, was special.

SEXUALITY AND ITS IMPACT ON HISTORY

So, who was Ælfthryth? She was the daughter of a Devonshire nobleman. Her first husband was the son of the Half-king of East Anglia, and William of Malmesbury gives us a typically lurid account of how she first met both of her husbands. He tells us that Edgar sent Aethelwold to scrutinize Ælfthryth and offer her marriage if:

> 'her beauty were really equal to report. Hastening on his embassy, and finding everything consonant to general estimation, [Aethelwold] concealed his mission from her parents and procured the damsel for himself. Returning to the king, he told a tale which made for his own purpose; that she was a girl nothing out of the common track of beauty.'

Having thus duped the king, Aethelwold married the lady himself. When Edgar heard about it, Aethelwold was frightened, and implored his wife to dress as plainly as possible. 'But what did this woman not dare?' She called up 'every charm by art, and by her design,' Edgar fell in love with her. He called Aethelwold to a wood at Harewood, under pretence of hunting, and 'ran him through with a javelin'.

Geoffrey Gaimar spins the story a little differently in his *Estoire Des Engleis* (written c. 1136). In Gaimar's version of events, Aethelwold tells the king, 'She is not the sort of woman you should take as a wife. Her appearance and her looks make her most unattractive.' He marries her himself and impregnates her, though Gaimar says she would not have had children by him through choice – 'She did not love him, and she had been told how he had tricked the king.' So, what we get from Gaimar is the sense of a woman wronged, rather than scheming. When Edgar hears other people talking, he realizes he has been duped, although he finds it hard to believe, because he had 'no reason to be wary of someone he loved, having himself brought him up at court.' Whilst this is not correct, it does gives a nod to the men's shared upbringing in East Anglia. In Gaimar's story, the king goes to see his 'friend' and the mother of his godson, he sees her through a crowd of people, he recognizes her because of her beauty, he kisses her, and 'With this kiss love struck'.

Aethelwold is then sent by Edgar to the north, as lord of all lands north of the Humber, and it is while he is there that he is killed. Gaimar apportions no blame to Edgar, merely stating that Aethelwold was killed

like the common criminal he was – 'Some said that Edgar sent people like that to him, but none would dare to say it was those same people who killed him.'

Ælfthryth then comes to Edgar dressed in:

'... a hooded robe of fine black worsted with a long train stretching down the hall. On top of this she had a short cloak with fine woollen yarn on the outside and lined with grey miniver. Her tunic was of matching silk brocade.'

No more than a month afterwards, he and the queen:

"... were lying in bed, and around them there was a curtain of fine brocaded silk from Persia. Lo and behold, one morning very early archbishop Dunstan came into the king's chamber and stood leaning pontifically against one of the red-painted, panelled bedposts. Speaking to the king in English, he demanded to know who it was lying with him in bed. To which the king replied, "This is the queen, Ælfthryth, to whom this kingdom bends its knee in subjection." To this the archbishop replied: "But wrongfully so. It would have been better for you to be dead than to be wallowing in adultery in this way. The souls of both of you will suffer the torments [of hell]." When the queen heard the archbishop, she was so angry with him that she became his life-long enemy [and never again] showed him any love.'

For the Dunstan presented to us through these chronicles, this really must have been a case of déjà vu.

Gaimar's story portrays the queen almost as a heroine of a courtly romance, depicting love for its own sake. His description of the love affair paints Aethelwold as a villain, and Ælfthryth as an innocent beauty, whose marriage to Edgar earned the condemnation of Dunstan because Edgar was godfather to her son by Aethelwold.

It is a wonderful 'tale for telling', but it seems implausible that Edgar would have killed Aethelwold; he grew up with him, and of the Half-king's sons, two also became ealdormen of East Anglia, prospering under Edgar's reign, establishing the practice of inherited title that would

become the norm. Edgar was always keen to support the family, particularly the youngest brother, whom he promoted to ealdorman ahead of his two elder brothers after Aethelwold's death. We can but wonder, however, whether this family of East Anglians, who were later to turn against Ælfthryth, openly, did so because she began the affair with Edgar while her first husband, Aethelwold of East Anglia, was still alive. It is another example of how, many centuries later, the nuances of family disharmony are lost to us.

The 'New Minster' Charter of 966 has much to tell us about the queen's status, and about that of her children. The frontispiece for this re-foundation and grant of privileges of the minster at Winchester shows Edgar alone, but Ælfthryth attests as the king's 'lawful wife'. At this time, she had borne Edgar only one child, a boy named Edmund. Edward (Edgar's son by a previous liaison, or possible marriage) and Edmund both attest as athelings (*clitones*), but Edmund, whose attestation precedes that of his half-brother, is described as 'the king's legitimate son (*clito legitimus*), whereas Edward is merely 'begotten by the same king'. Each member of the royal family, Edgar, Ælfthryth, Edmund, and the king's grandmother Eadgifu, all have gold crosses against their names. Edward's has only an outline of a cross.

There were periods when Ælfthryth spent time away from court and a charter (S904) shows her as having an estate at Æthelingadene, which can be translated as 'the valley of the princes'. It is clear that her sons (she later bore Edgar another son, Æthelred) were considered legitimate athelings, but what of her status? We know that she was described in the New Minster charter as 'lawful wife', but she attested as *regina* as early as 964 (S731) and she retained the rank after Edgar's death. Ælfgifu bride of Eadwig, Æthelflæd *Eneda* (if she indeed existed) and Wulfthryth did not attest any charters at all.

Ælfthryth is mentioned by name in the *Regularis Concordia* (*The Monastic Agreement of the Monks and Nuns of the English Nation*). This document, attributed to Bishop Æthelwold (formerly Æthelwold of Abingdon), lays out the rules of monastic life for monks and nuns. Although he does not call her a queen, her status is clear in the foreword:

'[Edgar] most wisely ordered that his wife, Ælfthryth, should defend communities of nuns like a fearless sentinel, so that naturally a man might aid men and a woman might aid women without a breath of scandal.'

Even though she is not referred to as queen here, but as his wife (*conjiugique suae Ælfthrithae*), nevertheless, it is very similar to the wording in the *Old English Account of King Edgar's Establishment of Monasteries*, also thought to have been written by Æthelwold:

'In some places also [Edgar] established nuns and entrusted them to his consort, Ælfthryth, that she might help them in every necessity.'

We have seen her named '*regina*', but was she an anointed queen? There has always been speculation about the nature (and number) of Edgar's coronation/s. The seven-year penance, and the idea that he himself delayed his coronation simply do not add up. William of Malmesbury tells us:

'This is certain, that from the sixteenth year of his age, when he was appointed king, till the thirtieth, he reigned without the insignia of royalty.'

It is unlikely that he waited from 959 to 973 before being crowned. The absence in the records of an earlier coronation means little; for example, there are no records of Cnut's coronation either, but no claims that it never happened. We have very few records, in fact, of coronations of kings from this period.

In 959, when Edgar acceded to the whole kingdom, Dunstan was not yet archbishop of Canterbury. Given the situation, with the kingdom having been divided, and Eadwig initially appointing the new archbishop of Canterbury, there might have been confusion and thus delay. But the Second Ordo, in connection with Eadwig's coronation, had been in use from the first half of the ninth century and, having been 'trained' by Æthelwold and Dunstan, it is unlikely that Edgar would have breached such tradition, particularly when anointing bestowed such divine gifts.

The question must also be asked; why would Dunstan and Æthelwold wait? Royal family history suggested that Edgar might be unlikely to reach the age of thirty, whether or not he might die of natural causes. Given the political climate of 957-959, it seems unlikely that anyone associated with Edgar's rule would allow any suggestion that his kingship was not legitimate. Thus, the chronicled coronation of 973, during which Edgar was crowned in Bath, and then paid homage by a number of British kings, was not a delayed coronation, but a show of strength. The location is important; Bath not only had associations with the Roman Empire, but was also on the border of the two old kingdoms of Wessex and Mercia. Was Ælfthryth anointed alongside him? She certainly attested as *regina* as early as 964. In the ordo, the queen's anointing follows the king's and the 'oil of sacred unction is to be poured by the bishop on the crown of her head'. Gaimar says of Edgar that 'he had her crowned and served with appropriate dignity'.

Byrhtferth of Ramsey, author of the *Vita S. Oswaldi*, describes the coronation feast:

> 'When all these royal nuptials were completed, all went home, blessing the king and queen, desiring for them that peace and tranquillity of which kings of old had been worthy.'

Whether or not she was consecrated in 964, and/or 973, Ælfthryth was doing something that no king's wife had hitherto done – signing as queen, anointed as queen – and it was enough to bring enemies, especially from within the religious houses.

From the *Liber Eliensis* II 56 comes a curious story. Ely's abbot goes on a journey and has to stop to answer the call of nature. By chance, beneath a tree, he comes across Queen Ælfthryth, 'engaged upon her concocting of noxious potions'. She has taken the form of a horse; apparently, she was wont to run hither and thither and, 'cavorting with the horses, she indecently exposed herself to them, in contempt of the fear of God and the honour of her royal dignity'. She is evidently peeved that he has caught her out, and she summons him, claiming to have some matters 'concerning the salvation of her soul'. But when he arrives, she speaks to him in an 'exceedingly cajoling and immodest way, uttering a number of lustful enormities'. She hopes to entice him to join her in her

evil-doings, but when the man refuses, she is 'roused to fury'. She orders him murdered, but not in any normal manner. Devising a way to do away with him and not leave any marks, she instructs the serving-women from her 'evil household' to thrust heated daggers into his armpits. The abbot is consigned to burial but no one dares to say anything against the queen.

Yet, the *Liber Eliensis* happily mentions in Book II 37 that 'King Edgar and Queen Ælfthryth gave St Æthelwold an estate called Sudbourne, together with the charter for the land…' (with the request that he translate his *Regularis Concordia* into English) and she went on to be a much-loved grandmother. Her grandson, who predeceased his father, wrote in his will:

> 'I now declare that all those things which I have granted to God … are done for the soul of … Ælfthryth my grandmother, who brought me up …'

She is remembered in a will (S1511) and two charters (S1242 & S1457) as a *forespreaca*, speaking on behalf of women in legal disputes. A queen, a beloved grandmother, an advocate of women; what happened to sully her posthumous reputation?

In 975, Edgar died at the age of around thirty-two. Once again, England had the choice of two young boys, both sons of a king, both too young really to rule. The difference, though, was that these were not even full brothers, having different mothers. Ælfthryth's son, Edmund, died as an infant in 971, so the choice of athelings was now between Edward, her stepson, and Æthelred, her youngest child.

Whatever had been the arrangement in 957, there was to be no joint kingship this time. Neither, it seems, was there any consensus or suggestion that the succession had been decreed and approved. Goscelin's *Life of St Edith* even has the crown being offered to her. Goscelin was always at pains to point out that Edith was a legitimate child of Edgar's and that her parents were lawfully married.

When Edgar died, Edward became king. As the *ASC* tells us:

> 'In this year Edgar's son succeeded to the kingdom. And soon in the same year in harvest time there appeared the star 'comet' and

in the next year there came a very great famine and very manifold disturbances throughout England.'

Elsewhere, the *Chronicle* hints at political unrest too – 'And at this time also the famous Earl Oslac was exiled from England.'

There is no other information regarding the banishment of Oslac, who, during Edgar's reign, had been named, along with Ælfhere of Mercia and Aethelwine of East Anglia, as one of the three 'leading earls', but it hints at a time of faction and dispute. We can safely suppose that those supporting Edward's claims were Dunstan, Oswald, and the East Anglians, and that the champions of Æthelred were his mother, and Ælfhere of Mercia. Bishop Æthelwold also supported the younger boy, so the Church reformers did not stand as one on this issue.

The family of Mercian brothers were to feature prominently in this period, with connections that allow us confidently to place them in the queen's camp. The eldest brother was the seneschal who fostered the son of the married would-be archbishop, after the bishop, having so nearly thwarted Dunstan's ambitions, died on his way to Rome. This seneschal was also close to both queens, Ælfgifu and her successor, Ælfthryth. He died around the year 971 and his will (S1485) reveals the extent of his relationship with the royal family. He bequeathed an estate at Wycombe in Buckinghamshire to his 'kinsman', who has been identified as being the brother of Ælfgifu. PASE identifies Æthelweard 36 as the recipient of the land in Buckinghamshire and as the beneficiary of Ælfgifu's will S1484, thus confirming his identity as Æthelweard the Chronicler.

The seneschal also left an estate to Queen Ælfthryth, a gift of thirty mancuses plus a sword to the elder atheling, Edmund, and an estate to Æthelred, the youngest son. More pertinent is the fact that he refers to the queen as his '*gefæðera*', a word indicating some kind of godparent/godchild relationship. If he was godfather to one of the princes, it suggests a close friendship indeed. There is no mention in the will of the other royal prince, Edward. Resentment was probably brewing long before 975.

Alongside any personal preferences, the Mercian family, as represented by the second of the brothers, Ælfhere, had suffered land loss at the hands

of the reformers, or more specifically Bishop Oswald, and there was disputed territory in the Fenland to which both the East Anglians and Mercians laid claim.

The turmoil in Edward's reign is most often remarked upon in terms of being an anti-monastic reaction, in which the supporters of Æthelred, mainly Ælfhere, attacked monasteries and evicted the monks. Bryhtferth, in his *Vita S. Oswaldi*, says that 'God-fearing men stood firm against the blast of the mad wind which came from the western territories'. But Ælfhere was not anti-monastic per se, being a noted benefactor of Glastonbury Abbey, and he attacked, in the main, the institutions established or reformed by Oswald, on Mercian territory, deeds which would have been duly noted, and thoroughly disapproved of, by the chronicler of Oswald's life. Aethelwine of East Anglia got a glowing report from the same chronicler:

'The righteous man Aethelwine was by no means ready to tolerate this, but assembling a noble army he, whom the prince of angels protected and strengthened, himself became the leader of the forces [along with his brother who] warlike … opposed the iniquity which the will of Ælfhere … was supporting.'

However, as has been the case throughout this story, the situation was not so clear cut. Asked to preside over a land settlement case at Horningsea, Aethelwine 'began for ever making fine promises to do this, but his words had no weight to them, and his promises never came to fruition' (*Liber Eliensis* II 49). There was also a case at Hatfield, where it was claimed that:

'After the death of King Edgar, the aforesaid Aethelwine, and his brothers, laid claim to the estate of Hatfield. When, however, [his] claim had been narrated and made clear, they entered this estate and took possession of it for themselves.'

Rather than being a simple tussle between pro- and anti-monastic sympathizers, it is more likely that this was a settling of old scores. Perhaps, as suggested earlier, Aethelwine was hostile to Ælfthryth because her affair with Edgar had started while her first husband, Aethelwine's

brother, was still alive? In which case, there might have been a kernel of truth to the stories so scurrilously spread by William of Malmesbury and the other chroniclers.

Ælfhere of Mercia and Bishop Æthelwold were essentially on the same side, in terms of support for the queen and her son, but one would not know it from the *Life of Oswald*. They supported the same claimant, but were at odds, less so than Ælfhere and Oswald, so there were factions within factions. Even Brythtferth seemingly changed his mind about Ælfhere of Mercia, saying later on in his *Life of Oswald* that Ælfhere was the renowned ealdorman who oversaw the re-interment of Edward, ensuring that he was buried 'honourably, where Masses and sacred oblations were celebrated for the redemption of his soul, by the ealdorman's orders'.

Therein lies a clue to the conclusion of this difficult period. In 978, after a turbulent reign, during which, along with famine and a portentous comet, the *ASC* also recorded that many leading noblemen were killed when a building collapsed, Edward himself was killed at Corfe, while visiting his stepmother and half-brother.

This succession dispute, having rumbled on for three years, was similar to others of this period, in that it ended with the premature death of a young king. Where it differed, was that Queen Ælfthryth was accused of murdering Edward. Truly she was painted as the archetypal wicked stepmother.

According to the *Liber Eliensis*, the only reason we know about her witchcraft, and the murder of the unfortunate abbot via stab wounds to his armpits, is that she became grief-stricken, confessed her 'sorceries and abominable activities', and to the murder of King Edward, and in recompense founded the nunnery at Wherwell, remaining there all the days of her life 'in sorrow and in penitence'.

That King Edward was murdered is not in doubt. The accounts all place him at Corfe, the home of his stepmother Queen Ælfthryth, in 978, but they differ over exactly what happened and who was to blame. Different versions of the *ASC* state merely that he was 'martyred' and that 'men murdered him'.

Of the incident, John of Worcester wrote:

'Edward, king of England, was foully murdered at Corvesgeate [Corfe], at the instigations of his stepmother, Queen Elfritha, and was buried at Wareham without royal pomp.'

But he describes Æthelred as 'the illustrious etheling [sic], a youth of graceful manners, handsome countenance, and fine person'.

Gaimar embellishes the story with the addition of Edward's dwarf, Wulfstanet, who goes missing, and thus Edward travels to Corfe to look for him. Gaimar says that Edgar 'wrongly' invited foreigners to England during his reign, a tantalising remark, which might shed further light on Edgar's reign, hinting at unresolved political tensions preceding the succession dispute, but he does not accuse Ælfthryth of murdering Edward.

Byrhtferth's *Vita S. Oswaldi*, written in praise of Oswald, a reformer who supported Edward, nevertheless does not assign any blame to Ælfthryth, although perhaps it is pertinent that it was written during the reign of her son. It criticizes Edward, saying of the succession dispute that:

'some of the nobles wanted the younger [Æthelred] because he appeared to all gentler in speech and deeds. The elder, in fact [Edward] inspired in all not only fear but even terror, for he scourged them not only with words but truly with dire blows, and especially his own men dwelling with him.'

On the other hand, William of Malmesbury tells us that:

'Meanwhile, King Edward conducted himself with becoming affection to his infant brother and stepmother, he retained only the name of king and gave them the power ... With the hatred which only a stepmother can entertain [Ælfthryth] began to lay a treacherous snare. On his arrival [at Corfe], alluring him to her with female blandishment, she made him lean forward.'

This, he claims, is the moment her attendant stabbed him. He ascertains that 'She was a beautiful woman; singularly faithful to her husband; but deserving punishment from the commission of so great a crime.'

SEXUALITY AND ITS IMPACT ON HISTORY

An anonymous *Passio et miracula sancti Eadwardi Regis et Martyris*, dating from the late eleventh or early twelfth century and possibly written by Goscelin, also adds an accusation that she arranged the murder.

It seems almost obligatory in hagiographical tradition that wicked women are associated with royal martyrdom. From an unreliable thirteenth-century *passio*, we learn that, in the ninth century, St Cynehelm was murdered by his tutor at the instigation of his jealous sister, and that her eyes fell out as she was reciting a psalm backwards, as some form of spell to prevent information arriving about the whereabouts of the royal corpse.

Queen Ælfthryth was a generous patron to Ely, as we have seen, which even so, accused her of witchcraft. Her own foundation at Wherwell remembered her as atoning for Edward's murder, and in the aforementioned charter referring to her estate in the Valley of the Princes, Wherwell accused her of appropriating those sixty hides at Æthelingadene. This was on her death in 1002, and no doubt affected her posthumous reputation. Why? Perhaps the religious foundations were jealously guarding their rights and lands at a time when the queen was becoming far more than merely the king's wife. The envy and hatred could have been very personal; she was a beautiful woman with a great deal of power.

Ælfthryth, royal consort, queen mother, beloved grandmother, fared no better at the hands of the later chroniclers than did her predecessor, Ælfgifu.

The chroniclers would have us believe that after their disgraces, these two royal women disappeared; one kidnapped and murdered, one driven to the walls of a nunnery to repent her sins.

In fact, we know that Ælfgifu bequeathed a necklace to Ælfthryth, so presumably there was no animosity between the two of them, and that the former was not sent off to a nunnery either. The bequest suggests that she was still alive after the marriage of Edgar to Ælfthryth, so she was not sent away in disgrace at the time of the annulment. Thus, the objection to her was never a moral one, but a political one. Of course, this 'bedtime' story comes to us from the *Vita S. Dunstani*, so what are we to deduce? That he was saintly, and she was not.

RIOTING IN THE HARLOT'S EMBRACE

Can anything be made of the fact that Edgar named his youngest child, Æthelred, after Alfred the Great's brother, from whose line his disgraced sister-in-law was descended? Edgar described her as 'Ælfgifu, his kinswoman' when he granted her land in two separate charters of 966 (S737 & S738). It is clear, then, that Ælfgifu made peace with Edgar, which seems remarkable given the unrest prior to his becoming king of Mercia. Perhaps it was more the case that, after the annulment, she was no longer a threat, or maybe Edgar himself was not especially perturbed about the alleged incident. We have seen that, at least early on in his reign, Church reform particularly, and matters of piety generally, were not uppermost in his mind.

The *Liber Eliensis* tells us (II 47) that 'King Edgar and Ælfthryth gave … land at Marsworth which Ælfgifu bequeathed to him on her death'. This parcel of land, and the necklace, were far from the only bequests in her will, however:

'She grants to the Old Minster, where she intends her body to be buried, the estate at Risborough just as it stands, except that, with [Edgar's] consent, she wishes that at each village every penally enslaved man who was subject to her shall be freed.'

There was a grant of 200 mancuses of gold to the same minster. To the New Minster she left an estate at Bledlow and 100 mancuses of gold. Personal bequests, aside from the necklace, included a gift to Edgar of two armlets, each worth 120 mancuses, a drinking cup, six horses, and the same number of shields and spears. To the atheling (presumably Edmund, since she likely died before Æthelred was born and before Edmund died) she left an estate at Newnham and an armlet of 30 mancuses.

She also left an estate to Bishop Æthelwold, praying that he 'will always intercede for my mother and me', demonstrating the closeness between this mother and daughter, the 'loose women' of our original tale, and the bishop. This former queen was not universally condemned by the Church, and certainly not by this bishop, who described her as '*thaes cininges wif*' – the king's wife.

In the will, there are further grants, to two men whom we assume to be her brothers, and a woman whom she names as her sister. In a short sentence, we are given another reminder that these people were

recognisable family members, when she says that she grants to her sister 'all that I have lent her'. She was obviously a thoughtful and loving or at least patiently indulgent sister. Far from being murdered as a whore, she evidently prospered, and without taking a long lifetime to amass her wealth. We must remember that if this will can indeed be dated to 966, then this woman had probably not even reached the age of thirty when it was dictated.

Of Ælfthryth, whether or not we assuredly know that she was the first consort to be formally crowned, her status cannot be underestimated. The New Minster charter describes her as 'legitimate wife of the aforesaid king (*legitima Regis prefati coniunx*)' and her son as legitimate, as opposed to Edward as a prince born to that king *('eodum rege clito procreatus')*. She retained the title *Regina* after Edgar's death. In 980, Æthelred made a grant to the Old Minster, Winchester, and she attested as *Ælfðryð regina* (S837). She was also remembered as a *forespraeca*, acting on behalf of women in legal disputes. As for the Churchmen, she outlasted them all, dying in 1002, while Æthelwold, her friend and champion, died in 984, followed by Dunstan in 988 and Oswald in 992.

The later chroniclers did a lot of damage to the reputation of both women. There might have been some truth to the lurid tales, but the excoriation seems ill-placed in the light of their treatment of Edgar's reported antics early in his reign.

Were the two royal women friends? It is possible, especially if Ælfthryth was indeed reviled during her lifetime, which she probably was, given what we know about the factions at court. The women might have overlapped at that court by as little as two years, in those early days of Ælfthryth's marriage when it looks like she could have used a friend. Ælfgifu had no daughter to leave the necklace to, but she did leave personal effects to her sister, so was the gift of the necklace more than mere protocol; was it a sign of personal friendship?

Her brother, Æthelweard the Chronicler, the only man openly to praise Eadwig, went on to become a prominent ealdorman during the reign of Æthelred the Unready, Queen Ælfthryth's son. He negotiated a treaty when Olaf Tryggvason attacked London with ninety-four ships, and took Olaf to Andover for his baptism ceremony (*ASC* 994). Whether he was appointed by Edgar or Edward would give a different perspective on the factions, but

we cannot be sure. However, knowing that he was a prominent minister in 994, we must assume that he was a very young boy at the time of the scandalous 'incident'. Perhaps his glowing report of Eadwig was the result of a young boy idolising his older brother-in-law?

Whatever his motivation, he was a lone voice and, conversely, praise for Edgar was unbridled and unanimous:

> 'What man is there dwelling in England who does not know how he advanced and protected God's kingdom, that is, God's Church, with benefits both spiritual and worldly, with all his strength?' (in all probability written by Bishop Æthelwold)

From the *Vita S. Oswaldi,* we read of Edgar as 'The glory of rulers, and emperor of the whole of Albion'.

John Evelyn said of Charles II that he was 'a prince of many virtues and many great imperfections, debonair, easy of access, not bloody or cruel.' It is easy to envisage Edgar in a similar way, a leader who tolerated the histrionics and machinations of his ministers, indulging them in the expectation that they would return the favour. Again, had the reform not been so much on the minds of the chroniclers, perhaps we would have heard more about Edgar the man. Whether or not he was as committed to the Benedictine reform as the chroniclers suppose, it seems he took very little else personally, bearing no grudges and keeping the factions at court well-balanced during his lifetime. He benefited from hindsight, a king whose reign witnessed no wars, no invasions, just a glorious reformation of the monastic institutions.

While Edgar was lionized, Ælfthryth was denounced as a witch and murderess. Ælfgifu was reviled as a harlot, when in fact she was a member of the royal family and was perhaps no more than collateral damage in political power struggle. Everything about this tale was more personal than principled, and ultimately the winners of the propaganda war were those who had the best spin doctors. In this era, that was the Church.

Chapter 3

The Art of Courtly Love:
The Ideal and Practice of Love
in the Middle Ages

Jessica Cale

The term 'courtly love' conjures idealized images of medieval romance, such as Edmund Blair Leighton's sun-drenched paintings of luminous ladies awarding favours to knights in gleaming armour. The idea of courtly love is usually associated with that of chivalry, but although they were both developed during the High Middle Ages to govern behaviour, they were concerned with two separate, if adjacent, sides of life. Chivalry was a code of social and moral conduct related to virtues such as prowess, piety, and largesse, while the 'rules' of courtly love that came from Troyes outlined how, when, and whom one could love.

We have Marie de Champagne (1145-1198) to thank for our modern ideal of courtly love. Marie was the daughter of Eleanor of Aquitaine, and the great-granddaughter of William IX of Aquitaine, the earliest troubadour whose work is still in existence. From her court at Troyes, she had a hand in commissioning Chrétien de Troyes' work, notably the Lancelot-Guinevere romance, *The Knight of the Cart*, and her conversations with Andreas Capellanus resulted in his writing *De Amore*, more commonly known as *The Art of Courtly Love*.

Marie's stamp on history cannot be overstated. Her vision of love would influence literature and shape the very idea of romance for the next thousand years.

In its simplest form, courtly love was a fairly innocent way to honour those in power. Knights might pay tribute to the wives of their masters,

showering them with poetry and tokens of affection with questionable sincerity, as a means of honouring their masters. It is worth noting that where Troyes is located, in the south of France, women were permitted to hold land in their own right and could be considered powerful 'lords' with or without a husband. In these cases, knights paying court to them might do so in order to honour them directly.

While there were some who subscribed to the idea of 'pure love,' a spiritual, non-physical devotion thought to improve the moral character of the lovers, it is dangerous to assume courtly love was a bloodless ritual observed only for the purposes of advancement. Capellanus himself confirms the sexual expression of love in his instructions on retaining love after it is consummated, and the bawdy verse of contemporary troubadours leave little to the imagination. While Capellanus' *The Art of Courtly Love* cannot be read as an objective sociological study, it does offer valuable insight into the desire, belief, and practice of love among the higher classes in France and, by extension, England, in the twelfth century.

It was written in the late twelfth century as a guide to the ideal and practice of love. Capellanus was a friend and contemporary of Chrétien de Troyes, and though he was not really a literary figure himself, his manual offers an invaluable insight into life in the French court. Inspired by his letters and conversations with Marie de Champagne, it presents a picture of medieval women at odds with our somewhat reductive modern view. More than merely prizes or pawns, Capellanus' women are sophisticated and possess thoughts and desires of their own. Moreover, it is likely the women and conversation featured were based on those he observed in Troyes.

Capellanus and de Troyes did not invent what we would call romantic love. Capellanus' work embellished on ideas put forth by Ovid, Plato, and Ibn Hazm. Ovid's *The Art of Love* and *The Cure for Love* predate Capellanus' text by some twelve hundred years and contain many of the same ideas; that women's power over men is absolute, men must do anything necessary to please them – including neglecting basic necessities such as sleep and food – and that a little jealousy goes a long way.

Similar ideas also existed in eleventh century Spain. In 1022, Ibn Hazm compared contemporary ideas about love to those of Bedouins and

ancients, including Ovid and Plato. He agrees that people in love may experience jealousy and palpitations, but also subscribes to Plato's idea of soulmates, that true love is a reunion of souls that have been separated since creation. He differentiates between love and passion; passion may be felt for any number of people, but true love can only be felt for one.

Many of the ideas, or 'rules,' still hold true today, but one of the starkest differences is the irrelevance of marriage. Ovid and Capellanus agree that marriage has nothing to do with love – it is not the objective of falling in love, and it is not an excuse to not fall in love with someone other than your spouse. The obstacle of a husband can even make love sweeter because it is forbidden.

In response to the question of whether true love could exist within marriage, Marie de Champagne wrote to Capellanus:

'We declare and we hold as firmly established that love cannot exert its powers between two people who are married to each other. For lovers give each other everything freely, under no compulsion or necessity, but married people are in duty bound to give in to each other's desires and deny themselves to each other in nothing.

'Besides, how does it increase a husband's honour if after the manner of lovers he enjoys the embraces of his wife, since the worth of character of neither can be increased thereby, and they seem to have nothing more than they already had a right to?

'And we say the same thing for still another reason, which is that a precept of love tells us that no woman, even if she is married, can be crowned with the reward of the King of Love unless she is seen to be enlisted in the service of Love himself outside the bonds of wedlock. But another rule of Love teaches that no one can be in love with two men. Rightly, therefore, Love cannot acknowledge any rights of his between husband and wife.'

For Marie, love was aspirational. She argues that love cannot exist within marriage because the safety of the relationship leads to spouses taking each other for granted and there is no need to better oneself for the sake of the other. The marriage itself enables the formation of love outside of

it by serving as an obstacle to overcome. Love is a joy made possible through suffering for it, an idea Leopold von Sacher-Masoch would follow to its conclusion some eight hundred years later.

Along with etiquette and the chivalric ideal, the rules of love were taught and probably practiced to a point. A look at Capellanus' Rules of Love offers a few surprises:

I	Marriage is no real excuse for not loving.
II	He who is not jealous cannot love.
III	No one can be bound by a double love.
IV	It is well known that love is always increasing or decreasing.
V	That which a lover takes against the will of his beloved has no relish.
VI	Boys do not love until they reach the age of maturity.
VI	When one lover dies, a widowhood of two years is required of the survivor.
VII	No one should be deprived of love without the very best of reasons.
VIII	No one can love unless he is impelled by the persuasion of love.
IX	Love is always a stranger in the home of avarice.
X	It is not proper to love any woman whom one would be ashamed to seek to marry.
XI	A true lover does not desire to embrace in love anyone except his beloved.
XII	When made public love rarely endures.
XIII	The easy attainment of love makes it of little value; difficulty of attainment makes it prized.
XIV	Every lover regularly turns pale in the presence of his beloved.
XV	When a lover suddenly catches sight of his beloved his heart palpitates.
XVI	A new love puts to flight an old one.
XVII	Good character alone makes any man worthy of love.
XVIII	If love diminishes, it quickly fails and rarely revives.

XIX	A man in love is always apprehensive.
XX	Real jealousy always increases the feeling of love.
XXI	Jealousy, and therefore love, are increased when one suspects his beloved.
XXII	He whom the thought of love vexes eats and sleeps very little.
XXIII	Every act of a lover ends in the thought of his beloved.
XXIV	A true lover considers nothing good except what he thinks will please his beloved.
XXV	Love can deny nothing to love.
XXVI	A lover can never have enough of the solaces of his beloved.
XXVII	A slight presumption causes a lover to suspect his beloved.
XXVIII	A man who is vexed by too much passion usually does not love.
XXIX	A true lover is constantly and without intermission possessed by the thought of his beloved.
XXX	Nothing forbids one woman being loved by two men or one man by two women.

It is interesting to note that jealousy here is a virtue. Total devotion is the rule, avarice is forbidden, and marriage, as we have seen, is a not an issue.

> 'Real love comes only from the affection of the heart and is granted out of pure grace and genuine liberality, and this most precious gift of love cannot be paid for at any set price of be cheapened by a matter of money.'

Marriage and family structure changed significantly when primogeniture became the rule sometime around the thirteenth century. Before this, property was partible and freely managed and sold by both husband and, in the case of inheritance or dowry, wife. Estates were divided up between children, a policy that, while fair, could result in people inheriting tracts of land too small to be farmed adequately. As impartible inheritance became the norm, one son, usually the oldest, was designated to inherit and manage the estate upon his father's passing.

As a result of this, marriage and family structure changed. While noble medieval families might have multiple sons, only one could inherit and, as such, was likely to be the only one who married. The rest of the

children could be expected to remain within the household unmarried until circumstances changed. A second son was likely to enter the church, not because he was called but by accident of birth, while younger sons might become knights, provided the family could afford to equip them appropriately.

The knight errant of romantic literature was based on a real social problem; the issue of the youngest son. Unlikely to inherit or marry, his life was destined to be one of rootless adventure as he was obliged to build a life for himself through military prowess and tourney wins. One such youngest son was William Marshal (1146-1219), the youngest of four boys. Marshal was able to earn his knighthood with the sponsorship of a wealthy relation, William de Tancarville, after which he made a name and fortune for himself through considerable tournament wins, eventually becoming tutor to Henry II's eldest son, Henry. Stephen Langton (1150-1228), the Archbishop of Canterbury, described him as 'the best knight that ever lived'. Though he was a favourite of Henry II and was gifted an estate in Cumbria, Marshal remained unmarried into his forties. When he married seventeen-year-old heiress Isabelle de Clare in 1189, he became the Earl of Pembroke. This was a remarkable achievement for a youngest son, most of whom could expect to remain landless and unmarried. Marshal himself was such a notable figure, he is believed to be the real-life inspiration for Chrétien de Troyes' Lancelot.

The situation was equally dire for noble daughters. Most men of marriageable age would have been landless and without a reliable source of income, so a daughter could expect to remain in her family's household until a suitable husband could be purchased or a place in a convent found.

Social mobility was possible and even common. Marriages often joined the petty nobility with successful burgher families. Younger sons were fortunate if they were able to win heiresses, and a wealthy widow could make the fortune of a struggling artisan.

'When poverty comes in, the things that nourished love begin to leave, because 'poverty has nothing with which to feed its love.'

Although Capellanus flatly states that love could not exist among the poor, the lower classes had a clear advantage when it came to marriage. With no estates to consider, they were free to marry for their own reasons,

including companionship and love. It was common practice for peasants to marry in secret and without witnesses, and these marriages were no less legal than those performed outside a church.

Gratian tried to answer the question 'What makes a marriage?' in 1140. In his *Concordia Discordantium Canonum*, known as Gratian's *Decretum*, he attempted to solidify four thousand texts from Church councils and papal pronouncements into a set of Christian legal principles. The peasants' practice of marrying in secret had caused legal issues for the church courts, primarily in the handling of disputes and abandonment. As such, it had become necessary to define what made a marriage.

> 'We declare and we hold as firmly established that love cannot exert its powers between two people who are married to each other. For lovers give each other everything freely, under no compulsion of necessity, but married people are in duty bound to give in to each other's desires and deny themselves to each other in nothing.'

This quote from Marie de Champagne in *The Art of Courtly Love* is not indicative of the overall state of medieval marriage, only her experience of it as a noblewoman. To Marie de Champagne, love could not exist within marriage because there was no danger to the giving of it; by consenting to the marriage, both parties agreed to love indefinitely whether they felt it or not. In reality, love or 'marital affection' was one of the only three essential components that made a legal marriage; love, sex, and consent.

For Gratian, the key component to a legal marriage was consent. Most marriages involving property were arranged, but as far as the church was concerned, a parent could not force their child into one. In practice, obedience was emphasized and children relied on their parents' approval to set them up financially, but according to Gratian, 'a father's oath cannot compel a girl to marry one to whom she has never assented'. The church largely agreed on this point and preachers were critical of marriages made solely for money.

After consent, there were two other elements necessary to make a valid marriage; sexual consummation and 'marital affection'. On the subject

of marital affection, Gratian explained, 'Where there is to be union of bodies, there ought to be union of spirits.'

By focusing on marital affection, Gratian himself disproved the idea that medieval marriages were never made for love or companionship. With consent, sex, and genuine affection, any couple could be married without the permission of family, lord, or Church. According to Gratian, a sexually active couple with genuine affection for each other should not be condemned as fornicators, but accepted as spouses. Marriages made in secret were nevertheless valid as the couple had conferred the sacrament on themselves, and as long as they consented to it, loved and were sexually attracted to each other, that was all they needed.

Gratian took this logic one step further by validating concubinage. As long as the man limited himself to one concubine and 'marital affection' was present from both sides, the concubine relationship was considered an informal marriage and he would not be refused communion.

While theologians emphasized reproduction as the primary purpose of marriage, it was not the only one. Gratian was not alone in seeing the merits of marriages made for love or companionship. Church authorities encouraged celibate marriages, and unions in which one or both partners were impotent or otherwise infertile were no less valid. Celibacy inside or outside of marriage was the ideal, but very few people met this unrealistic standard, let alone the priests themselves.

Although clerical marriage had been condemned by Pope Leo IX in 1049 and again at the Lateran councils in 1123 and 1139, many priests were married, had children, or openly kept concubines. The move toward celibacy was met with no little resistance. The bishop of Paris was forced into hiding after he ordered his priests to give up their wives and children (they refused), but he got off lightly; in 1077, a reformer in favour of clerical celibacy was burned alive in Cambrai.

As reproduction was not essential to marriage as far as the church was concerned, it did not view infertility as a valid reason for annulment or divorce. This is one key issue on which the beliefs of the church and the public diverged. Monarchs and landed noblemen depended on male heirs to keep their property intact, and the church's refusal to grant annulments

based on infertility led to some noblemen going to great lengths to remarry. The most common reason for annulment was provided by the church itself; consanguinity and affinity.

Until 1215, Christians were prohibited from marrying anyone related to them by blood up to seven degrees, which ruled out even distant cousins. Affinity was broader still, encompassing those related by marriage or through baptismal sponsorship. These relationships were not always enough to prevent a couple from marrying, as in many royal and noble families, but it was not unusual for a childless marriage to be dissolved upon the 'discovery' of a blood relation. If a distant relation could not be found, it was not unheard of for the wealthy to hire people to invent them.

After Pope Alexander III determined that a marriage could not be considered valid without the consent of both parties in the mid-twelfth century, this was also employed as a means of ending a marriage, particularly in the case of marriage that took place while both parties were too young to reasonably consent or were most vulnerable to parental influence. According to Canon Law, the minimum age of marriage was twelve for girls and fourteen for boys, although high-profile marriages were often arranged much younger. If it could be proven the marriage took place as a result of parental pressure rather than free consent, marriages could be dissolved even years after taking place.

Adultery was viewed as equally sinful for both sexes, but in practice, women were punished more harshly as adulterous relationships could compromise succession. If convicted, a woman could have lost her home, her dowry, and her children. In some places, adulterous women faced the public humiliation of having their heads shaved before being paraded through the streets to verbal and physical abuse. Should both parties involved become free to marry following their affair, they were prohibited from marrying each other before the Fourth Lateran Council in 1215. Abortions that took place as a result of adultery incurred more severe penance as well.

Most of our modern assumptions about medieval sexuality are based on Canon Law, which is only one piece of a much more complicated puzzle. There was no consensus on sexual morality within the Church, let alone among the population. To get a better picture, we must draw on

a range of sources such as legal documents, medical texts, and confessional literature.

'From ancient times, four distinct stages have been established in love: the first consists in the giving of hope, the second in the granting of a kiss, the third in the enjoyment of an embrace, and the fourth culminates in the yielding of the whole person.'

The *Decretum* of Burchard of Worms (ca. 1008) served as the primary source for penitential provisions on sexual matters through to the end of the twelfth century, until it was replaced by new forms of penitential literature, *summae confessorum*, following the Fourth Lateran Council of 1215. This confessional literature was written by educated authors drawing from Canon Law, theology, and practical experience, with an aim to educate the clergy in the theory and administration of confession in the real world. The books on sexuality are particularly illuminating of the morality and behaviour of the period outside the theoretical dictates of Canon Law.

Although it is commonly believed that all sex outside of marriage was considered a mortal sin, as theologian Thomas Chobham argued in the early thirteenth century, many penitentials appearing from the twelfth century onward state otherwise. Bartholomew of Exeter referred to the common practice among clergy to overlook any fornication taking place outside of marriage between single men and women. In 1217, members of the Synod of Angers stated that they knew first hand that many confessors gave no penance for it. In practice, if there was no adultery being committed, unmarried couples received a degree of tolerance from the church, recalling Gratian's theory that unattached couples could be considered informally married to each other provided they loved each other and were having sex. Gratian's reasoning was considered radical to many at the time, but taking into consideration how many secret or informal marriages there were, determining the existence or severity of fornication must have presented a challenge to the confessors.

Whether they took place within marriage or without, sex offences were dealt with through private confession and penance. Penitential literature and handbooks for confessors dealt with sexual sins in such thorough and

imaginative detail, it is not unreasonable to assume these behaviours were fairly common. In spite of the church's best efforts to convince the public that sex was inherently sinful, evidence suggests that much of the laity disagreed and carried on as they wished.

The church did not have the last word on sex and sexuality. Many medieval authors viewed sex in a far more positive light; not only was sexual pleasure necessary for conception, but sexual release was essential for maintaining overall health. If sex, and by extension, ejaculation, was a way to expel toxic humours from the body, abstaining could prove potentially fatal in the long term.

To the medical world, sex was as important as eating, sleeping, and exercising to health. Constantine the African's medical encyclopaedia included it with bathing and excretion as a process that affected the 'fullness or emptiness' of the body; it affected emotional health and was necessary in moderation.

While Jean Gerson (1363-1429) believed masturbation was so grave a sin it could only be pardoned by a bishop, Albertus Magnus (1200-1280) argued that it was both natural and healthy for males and females; like sex, it expelled potentially dangerous humours. Further, it was necessary for development during puberty.

Medical texts offered discreet contraceptive advice with aphrodisiacs and recipes for infertility and other sexual issues. Writing in the fourteenth century, John of Gaddesden suggested foreplay as a cure for premature ejaculation:

'He should touch the woman with his hand on her genitals and breasts, and kiss her; and then know her. And this works as a cure.'

Contrary to popular belief, female sexual pleasure was a priority and, according to some authors, an inevitability. It was commonly accepted that women were not only more sexually insatiable and vulnerable to sexual corruption, but experienced greater pleasure during the act.

There were different theories as to why. Gies explains one thus:

'Was pleasure in intercourse greater in men than in women? The answer was no. In the first place, according to the sages, since matter desires to take on form, a woman, an imperfect human

being, desires to come together with a man, because the imperfect naturally desires to be perfected. Therefore, greater desire and pleasure belong to the woman.'

Another common theory held that sexual pleasure was rooted in ejaculation; while men could only experience it once, women felt twice the pleasure from her both her own climax and receiving her partner's.

The late medieval text *Secrets of Women* had another explanation based on their understanding of *physiology:*

'The more women have sexual intercourse, the stronger they become, because they are made hot by the motion that the man makes during coitus. Further, male sperm is hot because it is of the same nature as air and when it is received by the woman it warms her entire body, so women are strengthened by this heat. On the other hand, men who have sex frequently are weakened by this act because they become exceedingly dried out.'

Following this logic, female masturbation was not discouraged as it was viewed as a way to expel negative humours, while doctors recommended a degree of sexual restraint for men.

Capellanus used men's natural 'heat' to impose age limits on who was capable of falling in love. In this passage, Capellanus argued that love was only for those of childbearing age:

'Age is a bar, because after the sixtieth year in a man and the fiftieth in a woman, although one may have intercourse his passion cannot develop into love; because at that age the natural heat begins to lose its force, and the natural moisture is greatly increased, which leads a man into various difficulties and troubles him with various ailments, and there are no consolations in the world for him except food and drink. Similarly, a girl under the age of twelve and a boy before the fourteenth year do not serve in love's army.'

In this statement, at least, Capellanus is in agreement with Canon Law regarding the ages of consent. As he limits the ability to fall in love to

those who were more likely to be influenced by hormonal impulses, it is not unfair to deduce that for Capellanus, love and lust certainly went hand in hand; although they were not the same, love could not exist without sexual desire.

Birth control and abortifacients existed and they were arguably more widely tolerated than they are today. As conception was not understood on a cellular level as it is now, contraception and abortifacients were lumped together under medicines made to regulate the menstrual cycle. They were aware that these medicines acted as contraceptives and abortifacients and they did use them for this purpose. The euphemism was widely understood among women and recipes were passed down through the generations and distributed in medical texts and through household handbooks alongside folk remedies for common ailments and recipes for cleaning products.

One early medieval recipe for a menstrual regulator appeared in the Lorsch Manuscript, a medical treatise composed by Benedictine monks around the year 800. It was described as being 'for women who cannot purge themselves, it moves the menses': 8 oz. white pepper; 8 oz. ginger; 6 oz. parsley; 2 oz. celery seeds; 6 oz. caraway; 6 oz. spignel seeds; 2 oz. fennel; 2 oz. geranium or giant fennel; 8 oz. cumin; 6 oz. anise; 6 oz. opium poppy.

Modern medicine indicates that this recipe would have been effective in terminating early pregnancy. Pepper had been used since ancient Rome as a contraceptive, and fennel and giant fennel are related to sylphium, a plant with contraceptive properties so powerful it was farmed to extinction in the ancient world. Parsley, ginger, celery, cumin, and anise have all been proven to have antifertility effects, and the opium poppy was probably added as a mild sedative. Other menstrual regulators used similar ingredients throughout the Middle Ages and beyond; pills and 'restorers' using the same ingredients found in the Lorsch manuscript were advertised as late as the nineteenth century.

As texts relied on euphemisms rather than explaining what the medicines were for, contraceptive knowledge was largely limited to women, and they did employ it effectively. This knowledge was not limited to wise women or witches; historian John Riddle argues that all

women knew what plants inhibited fertility and how to use them. Indeed, abortion was not considered immoral in the ancient world. It was widely believed that life did not begin until the infant drew its first breath; St. Thomas Aquinas argued that souls are created by God, not man, and it was generally accepted that the soul did not enter the body until birth. Abortion inhabited a moral grey area; it certainly took place, and whether it was immoral depended upon who was asked. There was no one rule regarding contraception and abortion, and penitentials treated them differently depending on the circumstances.

Burchard of Worms' *Decretum* discussed the issue of abortion at great length in a section intriguingly titled *Concerning Women's Vices*. To Burchard, all abortion was not created equal; abortion as a result of fornication carried the recommended punishment of ten years of penance on appointed fast days unless the woman was poor or a prostitute, in which case, even Burchard was sympathetic:

'It makes a big difference whether she is a poor woman and acted on account of the difficulty of feeding, or whether she acted to conceal a crime of fornication.'

In the same section as abortion and contraception, Burchard assigned penance to a number of sins related to love magic. While some of this may have been handed down from Pagan times, some of his scenarios are so imaginative it is difficult to believe anyone would have done such a thing:

'Have you done what some women are wont to do? They take their menstrual blood, mix it into food or drink, and give it to their men to eat or drink to make them love them more. If you have done this, you should do five years of penance on the appointed fast days.

'Have you done what some women are wont to do? They take a live fish and put it in their vagina, keeping it there for a while until it is dead. Then they cook or roast it and give it to their husbands to eat, doing this in order to make men be more ardent in their love for them. If you have, you should do two years of penance on the appointed fast days.

'Have you done what some women are accustomed to do? They lie face down on the ground, uncover their buttocks, and tell someone to make bread on their naked buttocks. When they have cooked it, they give it to their husbands to eat. They do this to make them more ardent in their love for them. If you have, you should do two years of penance on the appointed fast days.'

While Burchard clearly categorizes these as sorcery, it is interesting to note that these were only punished with nominal penance, a far lighter punishment than the death sentences handed down to women accused of witchcraft in the *Malleus Maleficarum*, published only four centuries later.

While the church officially condemned prostitution and sexual promiscuity, they had no reservations about profiting from it. St. Thomas Aquinas himself compared it to 'a cesspool in the palace; take away the cesspool and the palace becomes an unclean evil-smelling place.' Prostitution was accepted as a necessary evil, and from the end of the twelfth century onward, regulated to maximize revenue for the church.

Prostitution flourished in medieval London, and in the twelfth century, Southwark became the city's official red light district by order of Henry II. His *Ordinances touching the gouerment of the stewhoulders in Southwarke under the direction of the Bishop of Winchester* (1161) gave control of the Southwark brothels to the ecclesiastical authorities, which allowed the church to draw untold sums of money from them through the sale of licences. At the time of the ordinance, there were eighteen licensed brothels in Bankside employing about a thousand prostitutes at any one time. As a result of the church taking control, most of London's churches built during this period were largely financed by prostitution.

As for the prostitutes, they were refused Christian burial, but they could still receive Holy Communion. They were not shunned but viewed as public servants of sorts, and could be redeemed through marriage or entering convents. Men were actively encouraged to marry prostitutes to enable this rehabilitation.

'We have no desire to explain to you the way to gain their love, because whatever the feeling that makes them give themselves to a suitor, they always do so without much urging, so you don't need to ask for instructions on this point.'

In practice, prostitution was tolerated if not precisely encouraged by the Church. St. Augustine argued it was necessary for maintaining the peace, and that access to licenced sex workers would prevent men from harassing other women. Although the church officially viewed sex as a sin, its tolerance of prostitution is indicative of a more realistic understanding of sex; no matter the penance, the natural sexual urges of the public could not be indefinitely suppressed.

The word 'sodomy' was a catch-all term that covered any kind of sexual activity other than standard heterosexual sex, including oral sex between men and women as well as same-sex activity. In his *Canon of Medicine*, Avicenna (980-1037) described male homosexuality as a 'meditative illness' that could not be cured by medicine, acknowledging its existence while discouraging further discussion.

'In love you should note first of all that love cannot exist except between persons of opposite sexes. Between two men or two women love can find no place, for we see that two persons of the same sex are not at all fitted for giving each other the exchanges of love or for practicing the acts natural to it. Whatever nature forbids, love is ashamed to accept.'

Homosexuality certainly existed, but there was no concept of it as an identity. People were not viewed as 'homosexual' or 'heterosexual'; although sodomy was considered a serious sin, it was one anyone was capable of and one that might appeal to anyone regardless of gender or what we now view as sexual orientation. Sodomy was uniformly condemned by both society and church, but not all contact between men was necessarily seen as equally sinful. Legally, sodomy was not something shared by two partners, but something one did to another. In Florence, the sin belonged to the partner who did the work, while in Rome, it was a greater sin to take the traditionally passive feminine role.

Homosexuality was not often punished, but when it was, it was punished harshly and often publicly as a deterrent to others who might be tempted.

As now, love between men was not limited to the physical. English Cistercian abbot Aelred of Rievaulx recorded his own romantic feelings for his fellow monks. Although he was criticized in life for the carnal nature of his writings, he insisted his feelings were holy, and they could have been interpreted as such. With sodomy removed from the equation, who was to say his love did not come from God? There was no real separation between erotic and spiritual love; love of Jesus could be erotic and love of a dear friend could be spiritual. Of one such love, Aelred wrote of his:

> 'dear friendship, whose loving breast you can approach, safe from all the temptations of the world, and if you unite yourself to him without delay in all the meditations of your heart, by whose spiritual kisses, like healing balm, you will discharge the weariness of your stressful concerns.'

There is some debate over whether Richard the Lionheart may have had a homosexual relationship with Philip Augustus of France. Contemporary chroniclers recorded that 'at night their beds did not separate them. And the King of France loved him as his own soul'. While it was not so unusual for adults to share beds outside of a sexual context, two monarchs certainly would not have had to. Further, Richard I married late, ignored his wife, and did not leave an heir. It is not clear whether the chroniclers suspected Richard and Philip of sodomy, but if they did, the lack of explicit condemnation does suggest a degree of tolerance.

Another case for tacit tolerance can be found on the tomb of two fourteenth century English knights, Sir John Clanvowe and Sir William Neville. Both had died in Constantinople in 1391. The inscription on their shared tomb slab states that they had been inseparable companions for thirteen years, and when one died, the other refused food and died only days later. Their likenesses carved on the tomb shows them holding matching shields that combined the coats of arms of both of their houses, something only married couples did at the time. We cannot prove conclusively they were in a romantic homosexual relationship, but all signs certainly point in that direction.

Sexual relationships between women were acknowledged even less frequently than those between men. Penitentials offer some insight into how these were judged; sexual relationships between widowed or unattached women such as nuns were treated as less serious than those between married women. Sex between women using phallic implements was significantly worse than sex that did not, the rationale being that sex between women was only acceptable if there was no man available to satisfy them. If a lesbian relationship resulted in the rejection of a man, presumably one partner's husband, it was a much greater sin.

There are surviving songs from medieval troubadours that make clear references to sex between women, particularly nuns. Surviving letters between the nuns themselves confirm occasional involvement, but it was cast in an altogether more romantic light. This anonymous twelfth century letter from one nun to another transcends the bounds of typical female friendship:

> 'Why do you want your only one to die, who as you know, loves you with soul and body, who sighs for you every hour, at every moment, like a hungry little bird ... as the turtle-dove, having lost its mate, perches forever on its little dried up branch, so I lament endlessly ... you are the only woman I have chosen according to my heart.'

Cross-dressing women were tolerated or even praised, as it was viewed as a virtue to attempt to live as a man because men were still viewed as the superior sex. Conversely, men in women's clothing were mistrusted and suspected of criminality and sexual assault, as the typical medieval mind could not comprehend why a man would ever want to dress as a woman unless it was for a nefarious purpose. As in later years, cross-dressing male prostitutes served London throughout the Middle Ages, such as John Rykener, a noted sex worker from the late fourteenth century. Rykener was taken in by a madam at an early age and dressed in women's clothing to serve local demand, much of it from clerics. His case was not typical of medieval homosexuality; according to historian Ruth Mazo Karras, most medieval sodomites did not wear women's clothing. Rykener himself personally preferred women.

Who could fall in love? According to Capellanus, anyone in their childbearing years. As he believed love and marriage were mutually exclusive, class distinctions were largely unimportant for would-be lovers.

'Love is a thing that copies Nature herself, and so lovers ought to make no more distinction between classes of men than Love himself does. Just as love inflames men of all classes, so lovers should draw no distinctions of rank, but consider only whether the man who asks for love has been wounded by Love.'

Love was not invented by Capellanus and Chrétien de Troyes. *The Art of Courtly Love* was only one treatise on the subject in a literary tradition stretching back to ancient times. The feelings he attempted to record and make sense of were real, and people acted on them in spite of the restraints of class and Canon Law. His understanding of it was limited by his own bias, but by piecing together medieval literature, church documents, and medical texts, we can recognize a world not so very different from our own. Regardless of the terminology used to describe it, 'romantic love,' that impractical, all-encompassing feeling capable of driving people to madness, has always existed in spite of efforts to legislate or otherwise suppress it. Capellanus' treatise is not perfect, but it offers a tantalizing snapshot of how love was viewed by the noble classes in the high Middle Ages.

Chapter 4

The Tudor Marriage Game

Maryanne Coleman

Twelve years after the death of the last Tudor monarch, John Stephens wrote his *Essayes and Characters*. In it, he describes an element – perhaps *the* element – in the life of a typical farmer:

> 'The bringing up and marriage of his eldest son is an ambition which afflicts him so soon as the boy is born and the hope to see his son superior or placed above him, drives him to dote upon the boy in his cradle.'

Today we hope our children will be happy, whatever walk of life they choose or wherever destiny takes them. The sixteenth century was harsher than ours. Life for the majority was nasty, brutish and short and teenaged dreams of true love had to be balanced by a tough economic reality. Was the man of those dreams rich, a girl of the time asked herself. Could he hold his own in the dog-eat-dog commercialism of the Livery Companies or the Bourse? Was his estate large enough to answer the many demands made upon it? Would he be a good father to his children? A man asked himself similar questions. Could the girl of his dreams give him children? Could she read and write, order a household of sullen servants, attend to the thousand and one daily problems for which Tudor men had no time or inclination?

Much of this, of course, had to do with social status. The Tudor age was one of new men, ingenues elevated to higher status out of the aristocratic chaos of the Wars of the Roses. Jack was as now good as his master, but not quite. To that end, the Sumptuary Laws, several of which

were passed by parliament in the period. Men and women must know their status, however that was attained and however much they may long to improve it; and this was reflected in the clothes they wore, laid down by statute; gentlemen and ladies wore silk and velvet; the 'many-headed monster' of the mob wore fustian and leather. Lords and gentry were keen to extend their wealth and in the sixteenth century, that still meant land. What better way to do this than by negotiating an arranged marriage? Henry VII famously did this early in his reign by seeing his eldest boy, Arthur, betrothed to Catherine of Aragon. Kings had the option of war to extend their kingdoms, but war was expensive and the outcome uncertain. Henry was no general and the marriage game was by far the better option. Had all gone to plan, the marriage would have been a political and economic alliance almost without parallel. Arthur would become king in due course, not merely of England, Wales and Ireland but of Spain and her dependencies too. Even the New World, newly opened up by Christopher Columbus working for Catherine's parents, Ferdinand and Isabella, would have become British a century and a half before it did. Had things gone differently, Arthur and Catherine's heirs would have been Holy Roman Emperors and there would very possibly have been no English Reformation to rock the religious world to its foundations.

At a lower social level, merchants and craftsmen made similar marriage arrangements. The Tudor world was one of expansion; and trade was a mighty motivator. Dynasties were created at this level too, the leading lights of the Merchant Venturers, the East India Company and many more marrying into commercial families so that rivalries became partnerships in every sense.

Lower still in social terms, the poor, yet to develop into a recognizable working class, aped their 'betters'. Farm labourers courted girls who could milk the cows, herd the sheep and handle a plough. Fishermen looked for lovers who could make and mend nets. In the infant coal and iron works, brides must be prepared to scrape for the black stuff, breaking their backs alongside their men in the surface mines; or swing the pots of molten metal that hissed and bubbled dangerously near their tattered dresses.

Today, boy meets girl. They are at school together or at college. They

go to the same bars and discos, read the same books, watch the same television. They communicate by phone, pad and app. There is virtually nothing legally that can stand in the way of a relationship and, perhaps crucially, the endgame of that relationship is not always marriage.

Now consider the Tudor experience. If boy met girl, it was never via school. Boys' schools were rare; both William Shakespeare and Christopher Marlowe attended them, but they themselves were rare talents. Girls' schools barely existed. Colleges were universities; there were only two of them in England – Oxford and Cambridge – and females were not allowed. The only women officially involved in academe were the downtrodden souls who made the beds, for all there was a woman on the throne for fifty years of the Tudor dynasty. 'Dates' as we know them never happened. Most people lived and died in the parish where they were born. A weekly event would be a trip – miles on foot – to the nearest market town. Going to an annual fair, with its fire-eaters, conjurors and hedge priests, would be looked forward to for weeks and talked about for as long afterwards. Distant families, especially beyond county boundaries, never met. In the more remote country areas – and Tudor England had not yet seen the rise of the city – virtually all marriages took place within one village or at best a cluster of parishes.

Even then, it was not that simple. Every society has its rules, its traditions, its values. And that, in Tudor times, despite the upheaval it was going through, meant dealing with the Church. A child was baptised quickly before the Devil took its breath away. A boy and girl took communion, to pledge their souls to God in an uncertain age. They married in the same building in which they had been baptised, the banns read to announce to the world that such a union was to take place. They took their children to the font in due course and when they died, they were buried in the same building that had been there for them all their lives. The rich were laid inside, with their names and their likeness in brass and in stone. The poor ended up outside, their wooden markers long rotted and gone. If a visitor stands today in an English country churchyard, he is standing on up to seven layers of the parish dead.

And beyond the Church was the law, a tangled mass of contradictions decided by monarchs and parliaments of the past. Most people in Tudor England had no idea precisely what these laws said, partly because they

could not read and partly because most legislation was still in Church Latin.

Among the aristocracy, gentry and the more well-to-do of the 'middling sort', marriages were often arranged by the parents of a prospective bride and groom which was all to do with the amalgamation of wealth and power and nothing to do with love matches. The bride was expected to provide a dowry, a cash sum which exists today in the tradition that it is the bride's parents who fork out most for the wedding reception. Not until that had been thrashed out – and such negotiations could take months or even years – were the prospective couple told about the arrangements.

The Church had laid down that the age of consent for a boy was fourteen and a girl, twelve. By that time, boys were men in the economic world; it was also the usual age for entry to the universities. Girls were arguably able to conceive, but everyone knew the risks of early pregnancies. Henry VII's mother, Margaret Beaufort, endured agonies when she gave birth to the boy at Pembroke Castle in 1457. She was thirteen and mother and son nearly died. In practice, Tudor marriages usually took place when the partners were in their later teens or even twenties. This was especially important lower down the social scale where men, in particular, were expected to have 'made something of themselves' before taking on a wife and family.

The image we have, usually through historical fiction, is of a beautiful young girl betrothed against her wishes to a repulsive – if rich – old man. It is the stuff of folksongs and Hollywood epics, but it was rarely true. Certainly, the daughter of Margaret Paston, who lived in East Anglia in the fifteenth century, was being particularly difficult when she refused to go along with her parents' wishes and certainly both parents took it in turn to 'break her head' until she came to her senses. We must accept that few were as headstrong as Miss Paston! The most common situation in which an age imbalance occurred was in the case of second marriages, where a widower might take a younger wife, both to relive his own youth and to help bring up any family he may already have.

Courtship was never as romantic as it had been portrayed in the Medieval words of, say, Chrétien de Troyes. It was a chance for a young couple to get to know each other and at a certain social level, it was

chaperoned. Shakespeare in his *Seven Ages of Man* has his lover 'sighing like a furnace', pitching a self-composed ballad to his mistress's 'eyebrow', but it wasn't often like that! Female beauty was all about pale skin and high foreheads, showing at once refinement and intelligence. Queen Elizabeth spent a fortune on potentially deadly make-up full of lead to ensure the pallor of her skin. Since most of her own hair had fallen out by the time she was fifty, her flashy auburn wigs could be worn well back on her head, accentuating the queen's brilliance in all senses.

The marriage contract was called *de futuro* and was intended to last for life. Divorce, which assumed centre stage for Henry VIII as the 'king's great matter', was difficult, expensive and extremely rare. At that stage, there was nothing binding, so if the courtship did not work out, everybody shrugged ruefully and started all over again. Assuming that it went well, the annoying and watchful chaperone sitting in the corner apart, the next phase was *de praesenti*, the betrothal itself. Vows were exchanged:

'I do willingly promise to marry thee. If God will and I live, whensoever our parents shall think good and meet; till which time, I take thee for my only betrothed wife and thereto plight thee my troth.'

The couple kissed, clasped hands (the old handfasting of the Saxons seven hundred years earlier) and exchanged rings.

At this stage, everything had to be made public, hence the banns read out on three successive Sundays in church. A secret or clandestine marriage caused problems – the origin of the officiating priests asking whether anyone has a 'just cause or impediment' to stop the proceedings. The whole thorny problem of the 'princes in the Tower' hinged on this. Had their father, Edward IV, already agreed to marry Eleanor Butler before he took up with Elizabeth Woodville? If he had, the boys were illegitimate and could not rule a kingdom. Enter Richard of Gloucester and five centuries of intrigue!

Weddings took place on Sundays, traditionally in the church porch. The upheaval of the Reformation kicked in here. In the reigns of the two

Henrys, couples promised to be 'bonny and buxom in bed and at the board [table]'. Under the boy king Edward VI and his Protestant guardians, the words changed to the rather more boring and still extant, 'love, cherish and obey' – even if most brides today drop the last word! 'For better, for worse,' intoned the priest who was turning into the parson, 'for richer, for poorer, in sickness and in health, 'til death us do part'. Mary Tudor, marrying Philip of Spain at Winchester in July 1554 promised to be obedient 'as much in mind as in body'. As one good Catholic marrying another, this sounded fine; most of Mary's increasingly Protestant subjects disagreed.

Rings were exchanged again – wedding rings, this time, not the engagement type. Under Catholic dispensation, the groom placed the ring on his bride's thumb, then her index finger, then her middle finger, with the words 'In the name of the Father, the Son and the Holy Spirit'. Only under the low church of the Reformation would it become 'With this ring, I thee wed,' straight onto the appropriate, but still middle, finger.

Under Catholic tradition, the couple lay before the altar inside the church and were covered in a veil; later, the whole ceremony happened inside and the veil vanished. Presents were then exchanged, not merely the dowry, already passed over by the bride's family, but gifts of all kinds. Mary promised Philip – as if the world's richest man needed it! – 'gold and silver' and 'with all my worldly goods I thee endow'. Knives and jewels were popular, because Tudor ladies often took their own favourite knives with them when they dined out.

Where possible, the bridal party enjoyed a day or more of festivities. Elizabethan brides wore their hair long as a symbol of their virginity, garlanded with flowers and ears of corn, suggesting fertility. There was a procession of guests headed by the couple, with as much music, food and drink as could be afforded. 'Honeymoons' did not happen and the couple were not waved off in a carriage with 'Just Married' tied to the back. Instead, the bridesmaids prepared the bridal bed, sometimes pre-blessed by the priest and the happy pair climbed in. In what must have been an appallingly embarrassing moment for a shy bride (or inexperienced groom for that matter) all the guests trooped through the room, offering their good wishes, sly winks or open advice in the sexual performance department.

But it was not all a Tudor bed of roses. The poor went through a very pared-down version of the above. Every element of the sixteenth century marriage game cost, just as it does today. The twenty-first century's bridal magazines suggest a mind-boggling list of 'must-haves', from exotic Hen and Stag party locations to honeymoons on the far side of the world. In terms of cash, the Tudor experience was very similar. Among the poor, a simple hand-fasting would have to suffice. There was work to be done the next day.

In fact, it was money that made all the difference. If a man – or a woman, in some cases – were rich enough, it was possible to overcome any barrier to marriage. Sometimes, this involved the swallowing of pride, accepting a more humble social status to retain a certain lifestyle. The French princess, Catherine de Valois, married the relatively cash-strapped Owen Tudor (a gentleman of her own household) after her husband, Henry V, died of dysentery in 1422. Catherine Parr, the last of Henry VIII's wives, went on to marry the scheming Thomas Seymour after the king died. Death was a great leveller.

Inevitably, we know most about the Tudor marriage game via the royal family itself. They were constantly in the public eye and although there was no intrusive media with paparazzi clicking their cameras in all directions, keeping secrets was difficult in a court alive with gossips.

Because Henry VII came to the throne by force, defeating Richard III at Bosworth in August 1485, he spent virtually his whole reign looking over his shoulder. Pretenders to the throne seemed to be everywhere; Yorkists and their sympathisers lurked in every corner. So Henry had Katherine Woodville, Edward IV's widow and mother of the 'princes in the Tower; married off to his uncle, the trusted Jasper Tudor. Another relative, Sir Richard Pole, became the husband of Margaret Plantagenet, widow of George, Duke of Clarence who had ended his days, according to legend, in a vat of Malmsey wine in the Tower. The universally accepted idea was that husbands could and would control their wives, so the Plantagenet women would now have to do as they were told.

Henry's claim to the throne was notoriously weak and he knew it. He spent a great deal of time closeted with his political advisers finding a

way to twist the facts of genealogy and marriage to suit his own ends. The problem went back to his grandfather Owen and Catherine of Valois. His full name was Owain ap Maredudd ap Tewdwr in the Welsh language, then still spoken fluently beyond the Welsh marches. We know very little about him and it may be that the marriage to Catherine was the result of a genuine love match. Details are hazy but they were solemnized somewhere between 1425 and 1428. Their first child, also Owen, was born in 1429 and became a monk at Westminster Abbey, dying there in 1502. Edmund followed in 1430, born in Hadham, Bedfordshire. Jasper was born in Hatfield, Hertfordshire, the following year.

Henry V's Council was at first tolerant about Catherine's indiscretion. She had asked no-one's permission to marry and that was a scandal bordering on the illegal at the time. Her son by Henry was only a baby when his father died and the Council had plans to marry Catherine to Edward Beaufort, a suitable nobleman. Knowledge of her marriage to Owen Tudor put paid to that. The mother of the future king of England argued that the Tudors had once been prosperous landowners in Wales but their part in the rebellion by the freedom-fighter Owain Glyndwr had destroyed everything.

The Council was furious. Rumours flew of Catherine's unbridled lust. She had caught Owen naked in the bath. He had fallen into her lap while dancing. After all, she was French and he was Welsh – what did the average Englishman expect? Nothing was resolved before Catherine's death in January 1437 except that Owen spent considerable time in a prison cell at Newgate, London.

When Owen's grandson became Henry VII, one of his first acts was to marry Elizabeth of York, the eldest daughter of Edward IV. Shakespeare would have us believe that her uncle, Richard III, tried to seduce her in order to provide an heir after the death of his wife and son. There is no evidence at all for that. If Richard *did* plan to remarry, he had Joanna of Castile in his sights. So the red and white roses of Lancaster and York became the multi-coloured version that still adorns Tudor palaces and churches today.

Elizabeth's sisters had to be married politically too. The youngest was Bridget, probably born in 1480. In common with several youngest girls in a large family, she became a nun and posed no threat of rivalry for the

throne. Anne, born in 1475, was married off to Thomas Howard, Duke of Norfolk. The Howards were a tricky family, swapping allegiances as it suited them, but by Henry VII's reign, they were nominally in the Tudor camp. Henry hoped that the marriage would keep them there. Katherine, born in 1479, was married to William Courtney, whose family had welcomed Henry Tudor at Milford Haven when his invading army of French mercenaries landed there at the beginning of the Bosworth campaign.

The problem came with the remaining daughter, Cecily. Henry must have considered his job done when he married her to John, Viscount Welles. He was Margaret Beaufort's half-brother, a dependable and 'safe' choice. But Cecily turned out to be a loose cannon. The death of Welles in 1498 unleashed her to marry a man she actually loved. He was Thomas Kymbe (there are various spellings) from the Isle of Wight and he was a humble squire. How the pair met is unknown and the actual date of the wedding is in dispute. The loss of status involved rankled with Henry – despite the clear parallel of his own grandparents – and he confiscated Cecily's lands just to make a point. For the rest of her life, Cecily relied on handouts from friends, especially Margaret Beaufort, who paid for her funeral and interment at Quarr Abbey in the Isle of Wight, a tomb destroyed by the commissioners working for Henry VII's son in the dissolution of the monasteries.

Even among royalty and the very rich, however, there was the problem of consanguinity. This was where the Church held sway and it was bound up with the most pressing problem of Henry VIII's reign, his divorce from Catherine of Aragon. This had nothing to do with genetics – the Egyptian pharaohs had happily married their sisters and daughters to keep the bloodline pure. It was all about the Bible. Every word of the Vulgate, even the English versions appearing clandestinely as the Reformation gathered ground, was Gospel, literally the word of God. And various references in the Old Testament forbade marriage links with family members. There were 'six degrees of separation' that had to be accounted for and only the richest members of society could afford to bribe the Pope to grant a special dispensation. As head of the Catholic Church, the holder of St Peter's chair wielded enormous power. Long before the Papacy saw the

need to defend itself by claiming infallibility in the 1870s, the man's word was law. But, like any other man, the Pope had his price.

Most famously, Henry VIII became concerned that, with Catherine of Aragon as his wife, he had no male heir. His father had taken the throne by force; he was actually a usurper and everybody knew it. He had come to the throne after thirty years of tribal warfare between aristocratic families because of the weakness of the then king, Henry VI. No one wanted a return to the bad old days, so a strong king was essential to continue the Tudor dynasty. A queen would not do – the last independent queen of England had been Matilda in the twelfth century and she had never actually been crowned. Her 'reign' was wrecked by civil war, as Henry VI's had been. So Catherine's daughter, Mary, was pushed aside. Henry VIII needed a son.

He sent Thomas Wolsey, his hatchet man, to Rome to plead before the Pope, Clement VII, claiming that the Book of Leviticus made it clear that he who marries his 'dead brother's wife shall be childless'. Catherine had been married to Henry's elder brother, Arthur and technically, Henry was not childless. Even so, we should not see Henry as being completely cynical in all this. He was a scholar and a devout Catholic. It is likely that the Leviticus warning genuinely bothered him. It bothered Clement too, but in a different way. Popes were politicians first, spiritual leaders second. Rome was besieged at the time by the armies of Charles V, the Holy Roman Emperor, who happened to be Catherine of Aragon's nephew. The secret negotiations of Wolsey were in fact common knowledge and, faced with this dilemma, Clement felt he had to decline the king's request.

The rest, of course, is history. Without annulment from the Pope, Henry simply declared himself head of the church and gave himself the necessary permission. With divorce virtually unheard of, Henry was in a straitjacket. Couples could and did separate over abuse or infidelity but the Church held that such a marriage was still legal; remarriage was out of the question. And that was precisely the point. Henry must remarry in order to produce a legitimate (male) heir. It was traditional and expected that a king should take a mistress or two and the result, in the days before effective contraception, was likely to be children. Henry's mistress, Elizabeth Blount, gave birth to Henry Fitzroy (literally, the bastard of the

king) who was made Duke of Richmond by his father. By Joan Dobson, he had Audrey, who went on to marry John Harrington. By Mary Buckley he had John Perrot and by an unknown lady, Thomas Stukeley. There is serious doubt over the patrimony of the last two, both of whom ended up enmeshed in Irish politics in Elizabeth's reign. The point was that none of these children could legally inherit the throne. By taking the unprecedented step that he did, Henry paved the way for his own excommunication from the Catholic Church and the rise of the Protestant Church of England, something he almost certainly never intended.

His choice of mother for the new Prince of Wales he had planned was Anne Boleyn, the daughter of a Kentish nobleman, but there were problems there too. She had been betrothed to Henry Percy, of the house of Northumberland and she famously played hard to get, remaining cool and aloof even when Henry was bedding her sister, Mary (who, by the way, was already married to William Carey).

The king's decision split the country. While Catherine was quietly hived off to a rumoured affair with a Franciscan monk who gave her syphilis, and eventual death, probably from cancer, in January 1536, Thomas More and others stood on their dignity and refused to accept the marriage to Anne and the king's new status as head of the Church. More, who would be elevated to the sainthood in the twentieth century for his martyrdom, faced the headsman's axe in 1535 and Henry enriched himself enormously by dissolving the monasteries and selling off the vast wealth of the Church. In the process, of course, in the face of rising Protestantism, unforgivable vandalism broke out across the country. Shrines were smashed as examples of Papist idolatry and irreplaceable vestiges of Medieval England were lost forever.

But Henry's marital problems were not over. The coquettish Anne, clever, resourceful but not the scheming *femme fatale* that history has made her, produced not the longed-for son but another girl, Elizabeth. There was no Leviticus now to provide Biblical ammunition for Henry so he passed the problem to his new hatchet men, Thomas Cromwell and Thomas Cranmer and they were happy to resort to lies. Infidelity was acceptable as a reason for a marriage to be annulled, but infidelity *by a queen* was equivalent to treason against the king. And treason was a capital offence. Such was the legal disparity between the sexes that

infidelity by a wife was deemed petty treason. When the king was involved, the 'petty' was dropped.

A string of men were paraded who were claimed to have cuckolded the king, including Anne's music teacher, Mark Smeaton and her own brother, George. This is not *quite* as shocking as it might be today; astonishingly, there was no temporal law against incest until 1908!

Anne died, as many opponents of Henry died, on Tower Green in the shadow of the White Tower. It took three sweeps of the French executioner's sword to remove her head.

The king – and the country – rejoiced in October 1537 when Henry's next wife, Jane Seymour, gave birth to a boy; the future Edward VI. Traditionally, the royal family have always had the 'heir and the spare'. Edward was as sickly as his father had been, as a young man, hale and hearty and it would be wise to produce another prince to wait in the wings. Jane Seymour's death genuinely rocked Henry but the needs of state pressed and he noticed Hans Holbein's flattering portrait of Anne of Cleves, heiress of a minor duchy on the Rhine. She was German, she was Lutheran, she was plain. Henry is said to have referred to her as his Flanders mare, as looking similar to the horses he regularly imported from her part of Europe. Legend has it that they played cards on their wedding night because Henry could not bring himself to make any closer physical contact. There was a rich irony in that Henry's divorce this time was on the grounds of lack of consummation of the union; he was almost making up the rules as he went along! Catherine of Aragon had long ago put forward that argument. She had not been living in sin with Henry, she claimed, because she and Arthur had never consummated their marriage. After two proxy marriages, Arthur and Catherine finally reached the marriage bed on 14 November 1501. She was sixteen; he was fifteen. For what *actually* happened on the wedding night, we only have Catherine's word.

Catherine Howard was Anne's replacement in the quest for a 'spare'. Unlike the biddable Jane Seymour and Anne of Cleves, Catherine was feisty and not averse to intrigues of her own. The Howard family, with landed estates all over the country, were famously ambitious and a marriage to a king of England suited their book very well. Once again, Henry tired of the girl. Once again, there was no son. By this time,

Henry was ageing fast, the princely thirty-one inch waist, attested to by the size of the armour he wore as a nineteen-year-old had now ballooned to fifty-four inches. He had painful leg ulcers and bouts of black depression perhaps caused by too many knocks to the head during tournaments. He had become a grouchy, irritable old man annoyed by the flirting of his younger wife and levelled Boleyn-style accusations of adultery at her.

Catherine's motto was 'No will but His', which referred to God, but wags whispered it meant the king's will and the crawlers at Court were all too ready to do the girl's reputation down. That said, it is likely that Catherine really did have lovers, especially Thomas Culpepper, a gentleman of Henry's Privy Chamber. Thomas Cranmer grilled the queen at Hampton Court in November 1541 and she confessed. Culpepper was beheaded at Tyburn tree in west London, spared the appalling torture of hanging, drawing and quartering because of his status. Guilty of treason, Catherine went down before the headsman's axe in February 1542.

Henry's final marriage, to Catherine Parr, was not complex because he was a widower. She was a widow. The only thing that raised eyebrows was her relatively lowly status. But times had changed. Edward IV had invited shock and scandal by marrying the pushy Elizabeth Woodville, one of his own subjects. Henry VIII made a virtue of it. Catherine of Aragon and Anne of Cleves were European royalty and aristocracy in their own right; the others were commoners. The gossips' tongues wagged but such is the way of gossipers and Henry's back was broad.

Henry's son-begetting days were over and the king had other 'great matters' to bother him now. When he died, perhaps of syphilis, in 1547, Prince Edward became king and Catherine Parr was free to marry her true love, Thomas Seymour.

Among the Tudors themselves, Henry VIII is merely the highest profile family member to flout the marriage rules of the time. His sister Mary was expected, like all royal females, to make a political match. Her chosen husband was Louis XII of France and the 'intensity' of their relationship is perhaps proved by the fact that the first marriage was by proxy, at Greyfriars Church, Greenwich in August 1514. The second took place at the Church of the Celestines in Paris two weeks later and it was not until

October that the pair actually held hands at Abbeville cathedral. She was crowned queen of France at St Denis in November.

Mary was eighteen and Louis fifty-two. She was his third wife and the exhilaration of her youth may have been too much for him. He died three months after their full marriage, freeing Mary up to marry the love of her life, the jouster Charles Brandon, Duke of Suffolk. He and the king were drinking buddies; his father had been killed in hand to hand combat with Richard III at Bosworth. None of this mattered in the hypocrisy of Henry VIII. He was furious at Mary's behaviour and Brandon's since he had been trying to get his own first marriage to Anne Browne annulled in order to marry her much richer aunt. Anne's convenient death in 1512 released him, but the rich aunt ploy was abandoned in favour of his eight-year-old ward, Elizabeth Grey. Today, we find this situation distasteful, but it was standard at the time. Wardship came about when children of high-status families were orphaned; they were taken into the protection of another well-connected family. There is no suggestion of child molestation from Brandon. On the contrary, he enjoyed the company of adult women and, while waiting for Elizabeth to 'come of age' (in sexual terms, perhaps fourteen) he spread his macho net far and wide, even pitching his cap at Margaret of the Netherlands.

As Duke of Suffolk, a title conferred on him by Henry in 1514, Brandon was a catch. Handsome, athletic and titled, Mary fell in love with him but bowed to the political dictates of her brother and Thomas Wolsey who arranged the French marriage to cement relationships between the previously warring countries. Bizarrely, Henry sent Brandon to France to collect the widowed queen, which seemed to be tempting fate too far. In a whirlwind courtship, Mary and Brandon married in secret in the Palais de Cluny in Paris in March 1515.

Cleverly, the 'French queen' as she was called for the rest of her life, had waited the necessary forty days to be sure she was not carrying Louis' child before marrying Brandon. She also won the sympathy of the new king, François I, Henry's great rival in European politics. She was not prepared to play the marriage game as a pawn in her brother's realpolitik and Henry had promised her that, should the French marriage collapse, she could marry for love. Mary and Brandon made their union public

when they married at the Church of the Observant Friars in Greenwich in May. The king's fury took the form, as it would often years later, of him making financial gain; he fined the couple heavily and they were banished from court. Forgiveness came much later but there was no question of the money being returned. It may be that Brandon got off lightly. Marrying a royal princess without the king's consent could be construed as treason; there were those who demanded his head. But this was 1515; the traumas of the king's 'great matter', the break with Rome and the dissolution of the monasteries lay in the future. For those who believed them, however, the omens were there; Catherine of Aragon had given birth to four children by this time. One was stillborn; the others, all boys, died within weeks or days. All Henry could do was to remain optimistic.

Ironically, bearing in mind Mary's impetuous love for Brandon, she rowed with Henry over his love for Anne Boleyn, seeing her as an ambitious, scheming upstart. Unable to move Henry, she retired to her country estates, dying at Westhorpe Hall, Suffolk, in 1533. Marriage seems to have been something of an obsession with the now-widowed Charles Brandon, however. He married another ward, the fourteen-year-old Catherine Willoughby, who was already betrothed to his son, Henry.

In the next generation, marriage and the avoidance of it became a central issue again. Whereas Henry VIII had become a serial bridegroom to achieve a son, his daughter Elizabeth avoided the notion like the plague that regularly ravaged her kingdom in order to preserve her own power. It was universally accepted at the time that, with marriage, power, wealth and superiority lay with the husband. Had Mary Tudor lived and produced an heir with Philip of Spain, he would undoubtedly have become king of England, in name as well as reality. This, Elizabeth would never accept – 'I will have but one mistress in this realm and no master'.

She was probably seduced at fourteen by her protector Thomas Seymour – although this may have been malicious court gossip – and was a notorious flirt for the rest of her life. She was not above using her sexuality to smarm around ambassadors, politicians, even servants. Long after her prime, she continued to wear low-cut dresses that revealed too

much cleavage and slapped on the powder to make her look younger. She undoubtedly had a close relationship with Robert Dudley, the Earl of Leicester and it was probably sexual. Apart from the suspicious death of Dudley's wife, Amy Robsart – who broke her neck falling down three stairs! – the real reason for Elizabeth not marrying him was that he would have been king in all but name and the power of the Tudors would be gone forever.

The long-suffering William Cecil, Lord Burghley, the queen's most loyal elder statesman, begged her to make a suitable marriage. The foreign suitors were lined up over the years and Burghley worked hard to make the various matches reality. They all failed. The Duke of Savoy and Philip of Spain were too Catholic for a woman who was trying to establish a broad, but largely Protestant, Church of England. Sir William Pickering was a handsome soldier, but had no intellect – Elizabeth herself was very bright – and was not, anyway, very much interested. The Earl of Arundel could have been her father in terms of age. The Duc d'Alençon, when he arrived with much pomp, was greeted with affection by the queen, who actually gave him a ring. Negotiations with him dragged on until 1581, by which time Elizabeth was 48. She decided by then that marriage was impossible. Eric of Sweden was Lutheran, possibly insane and was murdered with arsenic in 1569. Charles of Austria was a better bet but he was Philip of Spain's cousin and there were, again, religious objections. Henri of Valois, Duc d'Anjou, was eighteen when Burghley suggested him. He was rabidly Catholic however, the son of the terrifying Catherine de Medici and was deeply involved in the massacre of 40,000 Protestants in Paris on St Bartholomew's Day, 1572. Elizabeth kept everybody, Burghley included, guessing throughout her forty-five year reign, delivering her clever 'answers answerless' to any awkward questions about her marriage, the succession and everything else.

We cannot accurately analyse historical characters as though they were lying on a psychiatrist's couch, but there is little doubt that Elizabeth was a bitter and vengeful woman. In denying herself a marriage for love and children, she did not see why anybody else should have those things. Her own family members in particular might produce male heirs to challenge her position. This is borne out in the case of the queen's cousin, Katherine

Grey. Her elder sister, Jane, was the 'nine days queen', a political pawn if ever there was one and the heroine of innumerable historical novels. The sisters went through a double wedding – unusual in the sixteenth century – in May 1553 at Durham House in the Strand, later the London home of Sir Walter Ralegh. Katherine's husband was Henry Herbert, the Earl of Pembroke, but with the fall of 'queen' Jane the following year, Pembroke had the marriage annulled; it was wise to be as distant as possible from the Grey family. Since her father, Henry Grey, Duke of Suffolk, was beheaded for his part in Wyatt's rebellion against Queen Mary, Katherine was alone.

That seclusion did not last for long. She fell in love with Edward Seymour, the Earl of Hertford and should have asked Elizabeth for permission to marry him. In the event, perhaps knowing the queen better than we do, the couple married in secret in November or December 1560 at Hertford House, Cannon Row in London. Six months later, the marriage was declared 'no marriage' and Elizabeth refused to believe it had actually happened. The only witness was Seymour's sister, who had died and the officiating priest had conveniently disappeared. Too late, Seymour was sent packing by the queen on diplomatic business in France. Once Elizabeth discovered that Katherine was pregnant, she had her imprisoned in the Tower, where she herself had been held as a frightened princess, and demanded that Seymour come home.

There could be no clearer evidence of Elizabeth's paranoia and her views on marriage than her hounding of the couple. She had them interrogated and although it was not used in this instance, the queen had the sole right to order torture to unlock secrets. At the Tower, the deeply sadistic Richard Topcliffe had any number of very nasty implements designed to loosen tongues – sometimes literally. Elizabeth wanted to know who the witnesses to the wedding were. There was nothing the queen liked more than uncovering conspiracies, especially if they were aimed – as they all were – at her.

The birth of Katherine's child in the Tower – Edward, later Baron Beauchamp – caused a sensation. Henry VIII's law of succession still stood, so the baby was technically Elizabeth's heir. She calmly ignored this, reminding everyone of the Grey family's treasonable habits and declared the boy illegitimate.

SEXUALITY AND ITS IMPACT ON HISTORY

The marriage and succession problem came to a head when the queen fell ill with smallpox in 1562. Her Privy Council, spearheaded by Burghley, pushed for her to name Katherine as her heir; the alternative was Robert Dudley as Lord Protector. Mercifully for all concerned, Elizabeth recovered and the status quo was restored.

The vengeful queen refused to release Seymour and his family from the Tower. She even had the Lieutenant arrested because he had failed to prevent another pregnancy! Not even the arrival of a particularly virulent outbreak of the plague moved the queen. Katherine begged to be allowed to take her family out of London for their safety, but Elizabeth refused. Instead, she lashed out against Katherine's younger sister, Mary, when she married in secret (for obvious reasons) in 1565. This couple, too, were arrested and separated.

Katherine never fully recovered. Separated as she was now from her husband and children, she died in January 1568 at Cockfield Hall, Yaxford, Suffolk. She was twenty-seven and her marriage to Seymour would not be recognized as valid until 1608 by which time Elizabeth had died and the Tudor dynasty had died with her.

In another sense, Tudor marriages were nearly as haphazard as ours today. Lord Burghley's first wife, Mary Cheke, was the sister of a Greek scholar but she had no dowry and her mother kept a pub. His son, Robert, the deformed 'pygmy' who Elizabeth laughed at but came to rely on after his father's death, fell head over heels for Elizabeth Brooke, who was not put off by the fact that he stood well under five foot tall. She was 'silent, true and chaste' as all Tudor wives were supposed to be, but she died just seven years into the marriage. William Shakespeare may have regretted his marriage to Anne Hathaway. She was older than he was and may well have been pregnant by the time they married. He certainly spent a lot of time apart from her, Anne in Stratford and Will in London. On his death, he famously left her his 'second best bed'.

But nothing was as strange as the marriage custom of the Egyptians. The forerunners of the gypsies, these wild families, travelling the country, feared and risking the hangman's noose, had various traditions that 'honest, law-abiding folk' in Tudor England found repellent. Thomas Harman in *Caveat for Common Cursitors* wrote, horrified:

'For I put you out of doubt that not one amongst a hundred of them are married; for they take lechery for no sin, but natural fellowship and good liking love.'

And divorce, such anathema to everyone else in the Tudor world, was straightforward. The parting couple merely shook hands over the body of a dead horse and went their separate ways.

Chapter 5

'These Bloody Days'
The Relationship Between
Anne Boleyn and Thomas Wyatt

Judith Arnopp

The bell tower showed me such sight
That in my head sticks day and night.
There did I learn out of a grate,
For all favour, glory, or might,
That yet circa Regna tonat. (around the throne it thunders).'

History tells us that Wyatt watched from his prison cell at the Tower of London as Anne Boleyn and those accused alongside her were executed. His poem, *These Bloody Days,* both supports that tradition and records the experience.

Anne Boleyn's story is a familiar one; her entry into the English court, her impact on the King as his infatuation quickly mushroomed into an obsession. For the sake of possessing Anne and begetting a male heir, Henry VIII put aside Catherine of Aragon, although she had been his queen of more than twenty years and given him many children, of whom just one daughter survived. At odds with Spain, and the Pope, Henry eventually broke with Rome, becoming head of the church in England and plunging his country into religious uncertainty. When his closest friends tried to make a stand against him, he destroyed them. Henry's infatuation for Anne is undisputed; the letters he wrote during the seven-year courtship still exist, evidence of undeniable passion. Anne's feelings for Henry are less clear. Her letters to him 'disappeared' and some sources claim it was ambition

and not affection that prompted her to accept his proposal of marriage. Some even believe that Anne was guilty and deserved to die, having committed adultery with those arrested with her: her brother, George Boleyn; Henry's friends Francis Weston, Henry Norris, William Brereton; and the musician, Mark Smeaton. Two other men were also arrested and taken to the Tower; courtier Richard Page and poet Thomas Wyatt.

The accusation was indecency with the queen, but, thanks to Thomas Cromwell, Wyatt and Page escaped the axe. There is a lingering tradition that believes Wyatt should have gone to the scaffold, and that a relationship between him and the queen did indeed take place at some point before her marriage. Wyatt's poetry upholds this theory. His poem, *These Bloody Days,* speaks of the horror of the arrest, his imprisonment, the death of his friends, and the mutilation of the queen, and infers that he never again discovered perfect peace.

After his release from the Tower, Wyatt returned to his duties overseas. The remainder of his life was spent in service to the king. For long periods of time, he was far from court, acting as both a foreign diplomat and spy. The experience seems to have altered Wyatt. After the death of the queen, he never settled but put aside his courtly pastimes, as if contentment eluded him, as if he was running away, perhaps trying to forget.

Wyatt's early poetry, written during Anne's rise and heyday, adhered to the Courtly Love tradition, a light-hearted form of entertainment to leaven the boredom of long hours spent at court 'waiting' on the king and queen. As Henry grew more dangerous, and those affiliated with Anne became entangled in her downfall, Wyatt's work altered. His poetry became autobiographic, perhaps offering the poet an outlet for emotion, a voice in a court silenced by terror.

Several of his poems suggest Anne Boleyn was indeed more to him than just his queen. Although it is clear that some sort of relationship existed between them, historians are split as to the nature of the attachment. Some believe his poetry has been misinterpreted and were all part of an innocent game, part of court life. Others believe that at some point prior to her marriage to Henry, Anne and Thomas were lovers.

The study of history is a mixture of facts, speculation, and mystery. As historians, we should question everything. There are no certainties; we are totally reliant on opinion, the agenda of the scribe, and the person

behind the scribe holding the purse strings. Is the report an accurate account of events, or propaganda? Is it their own opinion, or were they paid, or pressured into recording an untruth? Of course, truth itself is very subjective; a dozen people witnessing the same traffic accident will all recall it differently, from varying perspectives, each laying the blame upon another. As we will find, the Catholic view of Anne Boleyn is very different from the Protestant, and the opinions of her friends opposite to that of her enemies.

In the study of poetry, we have to proceed with even greater caution. There is an on-going dispute as to whether or not poetry should be regarded as historical proof at all. Even with a good knowledge of the past, sixteenth century poetry is much more easily misinterpreted today. Wyatt's poems were not written with twenty-first century analysis in mind. He was not writing history. His verses were of the moment, scribbled in haste to please a temperamental monarch or to idle away a tedious hour. We have to ask questions. Why was the poem written? Who was it written for? What was the poet's political stance or the possible political repercussions? Poetic analysis should be approached with caution. Even Wyatt himself wrote a few verses on how his work was misconstrued during his lifetime.

> 'Me list no more to sing
> Of love nor of such thing
> How sore that it me wring:
> For what I sung of spake
> Men did my songs mistake.
>
> My songs were too diffuse
> They made folk to muse.
> Therefore, me to excuse,
> They shall be sung more plain,
> Neither joy nor pain.'

Nevertheless, even to the most sceptical mind, some of Wyatt's work does seem to be autobiographical and hint at an attachment to Anne Boleyn. But we should always remember that poets are artists, prone to invention,

or what we have come to think of as 'poetic licence'. And we must not forget that court poets sometimes fulfilled a different role. As Jon Robinson in his book, *Court Politics, Culture and Literature in Scotland and England, 1500-1540,* says,

> 'Poets may at times have been guilty of what the modern mind may perceive as fawning sycophancy, their verse, at times, deliberately crafted to please the powerful at court. The court poet is likely, however, to have seen it differently, as an accepted means of obtaining or protecting his position, perhaps even as the fulfilment of his duty as his sovereign's servant.'

The aim of the poet is to appeal to the senses, evoke emotion; the aim of an historian is, or should be, the opposite. My inner historian urges me to dismiss Wyatt's poems as pretty remnants of the Tudor world that cannot possibly be taken as historic evidence. But my inner poet, my creative side, knows that poets often write directly from the heart, drawing on private emotions that can only be conveyed in verse.

The office of 'poet' enables opinions or feelings to be aired that could never be discussed openly; a poem can conceal facts just as it can reveal them. Much of Wyatt's work can be read as a criticism of the court, hinting especially at those in high office; perhaps his 'love' poems also stem from personal experience.

Determining if Wyatt's poetry is evidence of his love for Anne Boleyn or merely an example of Courtly Love is no simple matter. The debate has been underway since the sixteenth century. Their names are often linked in fiction, and casual study of his surviving verse is very seductive; one should be wary of reading more into them than perhaps he intended. One must look deeper, examine the context in which he wrote, and consider the people he lived amongst.

Whatever his motives were, Wyatt's poem *These Bloody Days* transcends time, transporting the reader directly to the dark and dangerous days of 1536 when, in a historically unprecedented manner, a queen of England was put on trial and executed for crimes against the king.

Despite rumours of premonition and foretelling, nobody alive at the time could have foreseen what was to happen. In terms of violence, up until this time, Henry VIII's reign was unremarkable. 1536 marked a

turning point; before May that year, there was no outward sign of the tyrant he was to become. Queens had been put aside before; most would have expected Anne to learn from Catherine of Aragon's mistakes and relinquish all claim to both Henry and queenship and enter a nunnery. Anne's execution would have made an immense impact on nobility and peasantry alike but those close to the heart of the matter would have felt it most. For the first time, real fear entered the hitherto joyous court of Henry and, even today, Wyatt's poem resonates with that horror.

Thomas Wyatt's near escape, his closeness to Anne Boleyn, the gruesome scenes he witnessed are stark in his poem, but was Wyatt, in fact, mourning the loss of his queen or an old lover?

> 'These bloody days have broken my heart.
> My lust, my youth did them depart,
> And blind desire of estate.
> Who hastes to climb seeks to revert.
> Of truth, circa Regna tonat. (around the throne it thunders)
>
> The bell tower showed me such sight
> That in my head sticks day and night.
> There did I learn out of a grate,
> For all favour, glory, or might,
> That yet circa Regna tonat.'

He chooses words that are simple but revealing. The poem is almost stripped bare of description, yet each line evokes great sorrow, great horror, and speaks of Wyatt's helplessness in the face of Anne's fall. One can imagine Wyatt lying sleepless, tossing and turning at night while he tries to expel images from his mind he wishes he'd never witnessed; ugly nightmarish terror that he cannot erase.

Whether or not this poem represents a heart-felt record of his experience or is simply a fiction is a matter for debate. Henry's court had suddenly become a dangerous place. Perhaps this poem was an attempt at recording a historic event that might, just possibly, filter through the propaganda that surrounded the court, and offer a feeble defence of Wyatt's friends and the injustice of their deaths.

'THESE BLOODY DAYS'

The poem spells out the dreadfulness of the executions. He tells us he cannot unsee the bloody truth of that sunny day in May. But the poem is not just a reaction to his own narrow escape. It is a tortured cry in the dark. It is easy to assume it is Anne's death, the loss of his lover that he is grieving, but the poem is not just for Anne. There is an underlying sense of guilt; perhaps an unwritten acknowledgement that he should have died with them. Today, there is a condition known as 'Survivor's Syndrome' in which sole survivors of a traumatic incident cannot come to terms with being the only one spared.

Wyatt had lost a large part of his social circle. The men who died alongside the queen were his companions. He had joked with them, ridden to the hunt, wined and dined with them, vied with them for the attentions of the court women. His poem mourns the death of friendship, the loss of innocence, the sudden severing of youth, laughter, and levity, not just the execution of an anointed queen. Of all the poems of the period, this is the one that brings on the chills, conveying some sense of the horror that began on that sunny day in May 1536.

Many novels depict Anne and Thomas as childhood playmates, and since their homes of Allington and Hever were just twenty miles apart, there is likely to be some grain of truth in this. The Boleyn and Wyatt families were of similar social status, moving in the same circles, but whether interaction led to the formation of a close 'friendship' is unrecorded. Whether that supposed friendship, in fact, ever developed into something deeper is, although possible, still more uncertain.

Anne was about twelve years old when she left England for Brussels to become maid of honour to Margaret of Austria; Thomas would have been around ten. She did not return to England until 1521 as a vibrant young woman. By that time, Wyatt was already wed to Elizabeth Brooke and the father of a son, later to find infamy of his own as the leader of Wyatt's rebellion against Mary in 1554. Anne's hand was destined for her cousin, James Butler, 9th Earl of Ormond.

When Anne arrived at court, Henry VIII was ostensibly securely married to Catherine of Aragon. The King was already frustrated by the lack of an heir, and Wolsey had tentatively suggested that Catherine of Aragon could be put aside to allow Henry to form an alliance with a European princess. What Henry's private thoughts were on this is not

known, but it is clear that, at this juncture, nobody (apart from Wolsey) had any idea that he would ever consider replacing his queen.

Anne's arrival at court did not go unnoticed. More than one account states that she was distinctive in appearance from the other women there; the foreign mannerisms and fashions picked up overseas seemingly exotic against the staid backdrop of Catherine of Aragon's household. Anne presented a challenge, fresh quarry for the gentlemen intent on pursuing the game of Courtly Love, but Anne could not have expected to attract more than the passing interest to the King.

There is no contemporary record of Anne and Wyatt's first meeting as adults, but his grandson, George Wyatt, in his *Life of Anne Boleigne*, and writing long after the events, provides an imagined account of their first known encounter:

'The knight, in the beginning, coming to behold the sudden appearance of this new beauty, came to be holden and surprised somewhat at the sight thereof; after much more with her witty and graceful speech, his ear also had him chained unto her, so as finally as his heart seemed to say, I could gladly yield to be tied for ever with the knot of her love.'

Despite the passion of this fictionalized meeting, George Wyatt was writing to exonerate his grandfather of misconduct with the Queen. He presents a relationship that is sedate and contained entirely within the bounds of Courtly Love. Thomas died before his grandson was born, but George may have been recording some oral family tradition, or relying on the now outmoded lines of his grandfather's poetry, or perhaps he had information we are not party to. Either way, even if the description of this meeting came directly from Thomas Wyatt himself, the words only prove her beauty and his devotion, nothing more. George Wyatt's account is not evidence of a full romantic relationship between them.

Henry VIII, eager to restore life and vigour to the court he inherited from his father was enthralled with all ideas of chivalry. Shortly after his accession to the throne, he encouraged a return to the old medieval values, and Courtly Love saw a resurgence of popularity. Courtly Love was a chivalric game, a 'pastime' quite extraordinary to the modern day. The rituals of love – wooing, dancing, the exchange of verse and declarations

of devotion – were played out, but on the whole, they were empty games, falling far short of physical consummation. No carnal relationship was intended. The tradition was so popular that Henry himself wrote a song about the game:

'Pastime with good company
I love and shall unto I die.
Grudge whoso will, but none deny,
So God be pleased, this live will I.
For my pastance
Hunt, sing, and dance.
My heart is set
All godely sport
To my comfort.
Who shall me let?

Youth will have needs daliance,
Of good or ill some pastance.
Company me thinketh then best
All thoftes and fantasies to digest.
For idleness
Is chief mistress
Of vices all.
Than who can say
But "pass the day"
Is best of all?

Company with honesty
Is virtue, and vice to flee.
Company is good or ill
But every man hath his free will.
The best ensue,
The worst eschew,
My mind shall be.
Virtue to use,
Vice to refuse,
I shall use me.'

SEXUALITY AND ITS IMPACT ON HISTORY

Courtly Love was a platonic love, an idealized re-enactment of the chivalric days of old. Eric Ives, in his book *The Life and Death of Anne Boleyn,* describes it in the following passage:

> 'The courtier, the "perfect knight", was supposed to sublimate his relations with the ladies of the court by choosing a "mistress" and serving her faithfully and exclusively. He formed part of her circle, wooed her with poems, songs and gifts, and he might wear her favour and joust in her honour ... in return, the suitor must look for one thing only, "kindness" – understanding and platonic friendship.'

Human nature being what it is, some courtly relationships did develop into something more intense, but the percentage that culminated in either sexual consummation or marriage can only be guessed at. According to George Cavendish, who was a contemporary of Anne and Wyatt, Anne's clandestine and very short alliance with Henry Percy was the result of the traditional game of love.

> 'The Lord Percy would resort for his pastime into the queen's chamber and there would fall in dalliance among the queen's maidens, being at the last more conversant with Mistress Anne Boleyn than with any other, so that there grew a secret love between them.'

Another far more famous courtship of Anne that also sprang from the Courtly Love tradition was that of Henry VIII himself. In the early days, it was undoubtedly a game akin to all the others; he showered her with gifts and poetry and, initially, his intentions were probably chaste, but as we all know, his affection grew into something more demanding, and far more dangerous.

Anne resisted the king's overtures for many years, claiming she would not be his mistress. Many interpretations of this have been put forward; her refusal may have been a cold-blooded political ploy to lure the King into marriage; she may have been virtuous, holding a legitimate desire to go to her wedding a virgin; or perhaps he didn't appeal to her. Perhaps her heart lay elsewhere and could not be purchased with jewels and poetry.

Some believe that when the king's attention toward Anne took a more serious turn, there was another devoted suitor watching from a distance as his 'unattainable' sweetheart was stolen by the king. This man was Wyatt, a married man, unable to offer Anne anything more than a clandestine affair.

George Wyatt reports that early on in Henry's courtship of Anne, Wyatt playfully stole a jewelled locket from her and wore it as a trophy. During a game of bowls, a dispute arose between the king and Wyatt, both of them claiming to have won the shot. Wyatt said the shot was his, but the king denied him. 'Wyatt, I tell thee it is mine.' He then pointed to the wood, using the finger that bore a ring belonging to Anne. Wyatt, recognising it, replied, 'If it may like your Majesty to give me leave to measure it, I hope it will be mine.'

Wyatt, removing Anne's jewel from around his neck, used it to measure the distance and the King grew furious when he saw it and abandoned the game to go in search of Anne for an explanation. The two unfairly matched men, ostensibly arguing over a game of bowls but, in reality, squabbling over the possession of Anne Boleyn.

This incident shows Wyatt in direct competition to Henry; his hope wavering, his standard flagging beneath the stronger suit of the king. The story, if true, adds weight to the possibility that a relationship between Anne and Wyatt crumbled when Henry made his intentions known. Further credibility is added when one considers that shortly after this incident, Wyatt was sent abroad on diplomatic business. Was Henry clearing his path of rivals to her affection? It is tempting to think so.

Anne was caught between the affections of two men, both married, and so neither of them a welcome prospect to a chaste woman. Anne, as all women of status, desired above all a good marriage, but the king, with his own desire uppermost, clearly had no intention of encouraging her to marry elsewhere and was in no position to offer it himself. All he could offer was the position of mistress, which Anne refused. Some interpret this as wanting more, holding out for an offer of marriage and a crown. Becoming mistress to a king is very different from succumbing to the overtures of a knight. Most women, finding themselves in such a position, would have favoured Henry's offer over Wyatt's, but Anne held out, refusing to go to his bed unmarried, and has been condemned for it ever since.

SEXUALITY AND ITS IMPACT ON HISTORY

Wyatt's poetry affirms the idea that he and Henry were rivals. The evidence seems to be there, hidden in plain sight. If Wyatt was indeed forced to relinquish his attempt to persuade Anne to become his mistress, then the matter is quite consciously addressed in his poem, *Whoso list to hunt*.

> 'Whoso list to hunt, I know where is an hind,
> But as for me, hélas, I may no more.
> The vain travail hath wearied me so sore,
> I am of them that farthest cometh behind.
> Yet may I by no means my wearied mind
> Draw from the deer, but as she fleeth afore
> Fainting I follow. I leave off therefore,
> Sithens in a net I seek to hold the wind.
> Who list her hunt, I put him out of doubt,
> As well as I may spend his time in vain.
> And graven with diamonds in letters plain
> There is written, her fair neck round about:
> Noli me tangere, for Caesar's I am,
> And wild for to hold, though I seem tame.'

The speaker in this poem is defeated, disempowered, and plain miserable. He has no alternative but to withdraw his suit and clear the way for 'Caesar.' '*Noli me tangere* (Touch me not), for Caesar's I am' states plainly that his courtship (of the unknown woman) was terminated solely because the object of his desire had become the property of the king.

Although Anne is not named, we suspect, and contemporary readers would have surmised, her identity and empathized with the poet. But is the woman in the poem really Anne, or do the clues seem so obvious because we desire it to be so?

There were countless women who may have dallied with Wyatt before moving on to the king's bed. While this lovely poem is not wholly convincing of any physical relationship with Anne, the sentiment is intriguing. The 'Caesar' in the poem is dangerous, possessive, and predatory, and one cannot help but wonder if the king ever laid eyes on it. At this period, Henry was usually depicted as a golden-haired god, but

he now appears for the first time as a tyrant akin to Nero, depriving Wyatt of his lover.

The complexity of this interpretation is that, by tradition, courtly love was *supposed* to be unrequited. It was part of the game. Wyatt was himself married and unable to offer Anne any more than the game entailed, but neither was Henry free. At the time of writing, the best Anne could hope for was to become the king's mistress; at this stage, the idea of supplanting his wife and queen would not have entered her head. Furthermore, if we are to suppose that the alleged relationship with Wyatt took place before Anne caught the attention of the king, we have to consider whether she would have risked her reputation on an improper relationship with Wyatt, or anyone else for that matter.

In 1522, when Anne's sister Mary became Henry's mistress, she was already married to William Carey. It is possible that Mary had previously also enjoyed a short, discreet affair with the King of France. After her affair with Henry ended, she lived quietly, bringing up her two children until the death of her husband from the same sweating sickness that afflicted Anne in 1528. In 1534, the now widowed Mary unwisely married William Stafford, a man of lowly station, a marriage that earned her the displeasure of both Henry and Anne, who was by this time queen.

Many historians and fiction writers have claimed that Anne's reluctance to become Henry's mistress was her knowledge of his treatment of Mary when their affair ended. It is not unreasonable to believe that Anne learned from Mary's experience and thought it wiser to maintain her virginity until she married. Sex outside marriage, even with a king, could have had a detrimental effect on a subsequent marriage. Anne's carefully considered refusal of Henry, who could have provided at least some reward for her services, reinforces the idea that she was too clever to ruin her future by succumbing to Wyatt's overtures of love. It is one thing to be the king's mistress but quite another to enter into a physical union with a mere knight.

While I don't hold with the belief that Anne set out to ensnare the King into marriage, I do believe she was ambitious and would have been reluctant to jeopardize her future. When she first caught the King's eye, her father, Thomas Boleyn, was negotiating her betrothal to Ormond and would have been keen to avoid any scandal that might scupper the

arrangement. Her romantic attachment to Henry Percy was quickly nipped in the bud by Wolsey, and unless Anne was particularly light of nature, it is unlikely she would go on to indulge in anything more than flirtation with Wyatt. If a relationship existed between Anne and Wyatt at all, it must have been during the period before she attracted Henry's interest, and after, or during, her brief romance with Percy.

Although *Whoso list to hunt* can be interpreted as an indication of a relationship between them, it could have equally been borne of a one-sided affection or, like others written in the courtly love tradition, been the result of the poet's boredom on a wet afternoon. Eric Ives maps the typical day of an English courtier thus:

> 'Out of doors, when not engaged in war or training for the pseudo-war of the tournament, the gentleman was busy with its substitute, hunting. Indoors – dancing, music, poetry, good conversation and the game of courtly love.'

Imagine; the king is busy in the council chamber, his courtiers are idle, waiting for his return. Pretty, well-bred women and handsome, hot-blooded males are thrust together, cooped up indoors with nothing to do but await the pleasure of the king. What better way to alleviate the boredom than a little harmless flirting? Lovelorn lines were part of the game and, although Wyatt's are more convincing than those of his contemporaries, we cannot be certain the emotion they contain was genuine or requited. Perhaps we read too much into them because he was a better player and a more accomplished poet than his contemporaries.

As mentioned earlier, in 1527, around the time that Henry made his intentions toward Anne serious, Wyatt took a trip overseas; some say on the king's business, some say to escape the pain of losing Anne. In 1532, having returned to court, he accompanied Anne and Henry to Calais for a meeting with the French king and, it seems that by this time, he may have been recovering, or recovered, from his wounded heart.

> 'Sometime I fled the fire that me brent
> By sea, by land, by water, and by wind,
> And now I follow the coals that be quent

From Dover to Calais, against my mind.
Lo, how desire is both sprung and spent!
And he may see that whilom was so blind,
And all his labour now he laugh to scorn,
Meshed in the briers that erst was all too-torn.'

The poem above has been read as a retrospective account of Wyatt's loss of Anne, the pain he suffered as he sought any means 'by sea, by land, by water, and by wind' to escape. The line 'Lo, how desire is both sprung and spent!' suggests that, at the time of writing, his affection for her had waned, if one ignores the erotic connotation that can be put on the phrase.

If we are to believe that any physical union once existed between them, it was now clearly over, but even an admission of past romance would have been dangerous. Henry wasn't one for sharing his women, and any suggestion of carnal knowledge of Anne was enough to damage both her reputation and her standing as future queen. Had Wyatt truly cared for her, would he not have been better to have kept very quiet and not broadcast his feelings in verse, however well disguised?

For a while, there were two queens at Henry's court: Catherine in one part of the palace, and the unwed, uncrowned Anne in another. The courtiers were divided, hedging their bets between the old queen and her possible future replacement. Anne's court, compared with the piety of Catherine's, was a vibrant place. The younger members of court flocked there to explore the 'new' entertainment, literature, and religion. Anne embraced conversation, music, and dancing, and surrounded herself with young, quick-witted friends. Part of the fun was to circulate poetry, adding to it, embellishing it, or qualifying it. One example of this is the *Devonshire Manuscript* – the first example of men and women writing together in the English tradition.

The *Devonshire Manuscript* has long been used as evidence of love between Wyatt and Anne. It is a volume of poems, once belonging to Anne's cousin Mary Howard, mother of Henry's illegitimate son, Henry Fitzroy. It contains (among others) inscriptions by Mary herself, Margaret Douglas, and Madge Shelton. Wyatt's brother-in-law, Sir Anthony Lee, is also involved, but not the hand of Wyatt himself – the quantity of his

poetry used by others in the manuscript only illustrates his popularity as a poet, not any personal involvement.

The manuscript was circulated among the circle of friends now referred to as the 'Devonshire Group.' Various poems by a number of different poets were penned by a variety of hands. Some of the poems and verses that are included are, as Eric Ives upholds, undoubtedly biographical and have, in the past, been linked to Anne.

> 'Am el men
> An em e
> As I haue dese
> I ama yowrs an'

Early critics saw the last line as evidence of Anne's involvement, cataloguing it as a personal reply to a poem written in a similar vein, believed by some to be written by Wyatt's hand:

> 'That time that mirth did steer my ship
> Which now is fraught with heaviness,
> And fortune bit not then the lip
> But was defence of my distress,
> Then, in my book, wrote my mistress:
> I am yours, you may well be sure,
> And shall be while my life doth endure.'

Agnes Foxwell went so far as to confirm the inscription 'Am el men' as being in Anne's handwriting. Others concurred, transposing the second and fourth letters of each line and seeing it as a riddle, but this has now been dismissed, by Eric Ives and others:

'Unfortunately for romance, very little of this stands up to close scrutiny. There is no evidence that Wyatt ever handled the Devonshire Manuscript; its Wyatt poems represent the taste of Mary Fitzroy and her circle. Nor is the evidence for Anne at all convincing. "That time that mirth did steer my ship" is assigned to Wyatt by only some modern editors. The "signature" is a couple

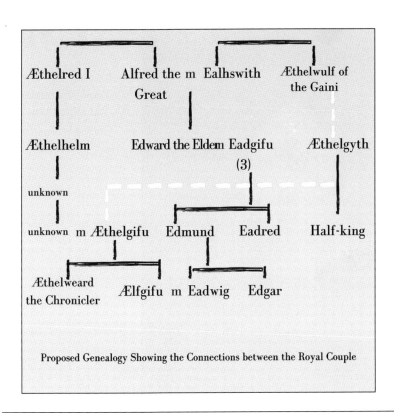

Proposed Genealogy Showing the Connections between the Royal Couple

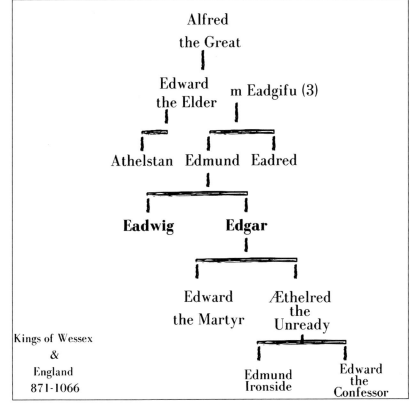

Kings of Wessex
&
England
871-1066

Glastonbury Abbey, England – Photograph by Jessica Cale.

Raglan Castle, Wales – Photograph by Jessica Cale.

Westminster Abbey, site of royal marriages and burials for centuries – Photograph by Angela Lownie.

The ruins of Quarr Abbey, the burial place of Cecily Plantagenet, wife of Thomas Kymbe, squire of the Isle of Wight – Photograph by Carol Trow.

Tower Green – Photograph by Hunter S Jones.

Ruins at Holyrood in Edinburgh, Scotland – Photograph by Gayle Hulme.

Holyrood Abbey ruins
– Photograph by Gayle
Hulme.

Inside the Chapel
Royal at Stirling
Castle where Mary,
Queen of Scots was
crowned and James
VI & I was
christened –
Photograph by
Gayle Hulme.

Stained glass fo King henry VIII and
Jane Seymour at Cardiff Castle, Wales
– Photograph by Jessica Cale.

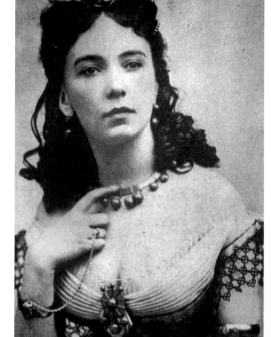

Cora Pearl, 1854. Original
photograph by André-
Adolphe-Eugène Disdéri
(1819-1889).

Catherine Walters, circa 1860. Phtographer unknown. Public Domain.

Lillie Langtry, 1885. Photographed by William Downey (1829-1915). Courtesy of The National Archives UK. Public Domain.

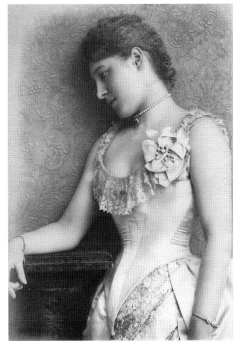

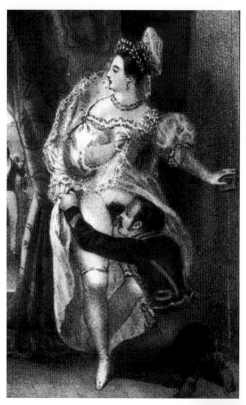

Illustration by Achille Deveria, (1800-1857) Public Domain.

Storyville, generally called 'Raleigh Rye Girl'. Attributed to E. J. Bellocq, circa 1912. Public Domain.

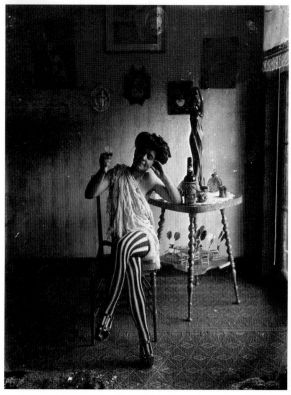

of letters written to test a pen. The expression of goodwill is a mere doodle and is certainly not in Anne's hand. As for the riddle, not only is it hardly intelligible in solution, on the page the lines are randomly scattered, probably not written at one time and possibly by different writers. They are better understood as casual exercises, the last two, clearly part-versions of phrases such as "as I have deserved" and "I am yours and ever will be" - expressions of courtly love as stock as the greetings on any Valentine card.'

Even Wyatt's riddle to which the answer is 'Anna' cannot be tied convincingly to the queen. At best, it can be seen as a light-hearted ditty, written on a whim about Anne, but it proves no relationship. Given Wyatt's appetites and self-confessed lack of chastity, there could have been any number of women named Anna among his acquaintance. Again, although it is tempting to grasp this as proof of something illicit between them, it cannot be accepted as concrete evidence.

> 'What word is that that changeth not,
> Though it be turned and made in twain?
> It is mine answer, God it wot,
> And eke the causer of my pain.
> It love rewardeth with disdain:
> Yet is it loved. What would ye more?
> It is my health eke and my sore.'

The most persuasive poem of all is the universally famous *They flee from Me*. Again, the woman is not named; she could be any member of the royal household, but the idea of Anne Boleyn creeping barefoot into Wyatt's chamber is very evocative. The image has tempted modern-day romantic novelists to heavily embroider the barest of facts, injecting one short-lived hour of happiness into Anne's tragic story. Objectively, it is unlikely to have been so:

> 'They flee from me that sometime did me seek
> With naked foot, stalking in my chamber.
> I have seen them gentle, tame, and meek,

That now are wild and do not remember
That sometime they put themself in danger
To take bread at my hand; and now they range,
Busily seeking with a continual change.'

The poet here is wistful, passive, almost paralyzed as he recalls a love now passed. He likens love to an animal, once tamed but now wild again, a relationship that has become too dangerous to pursue. Notice the way he stresses how the woman actively sought his company, putting 'themself in danger,' entering *his* chamber. But now that he knows their love to have been fickle, they have abandoned him for other, better things.

'Thanked be fortune it hath been otherwise
Twenty times better; but once in special,
In thin array after a pleasant guise,
When her loose gown from her shoulders did fall,
And she me caught in her arms long and small;
Therewithall sweetly did me kiss
And softly said, "Dear heart, how like you this?"'

The languor grows to a dreamlike state as he remembers the erotic moment when she removed her gown, held him in her arms, and kissed him. Could this really be our Anne Boleyn? Again, he puts the onus on the woman; *she* was the one seeking him and now *she* is the one who has left. This woman is no shrinking violet but an unchaste Diana on the hunt. The tables are turned and the male hunter has become the quarry and, conversely, it seems he was a willing victim and longs to be chased again. As Catherine Bates points out in her book, *Masculinity and the Hunt*:

'What the speaker really desires is to be the other's desire, except that, having once succeeded briefly in that aim, he has now decidedly failed.'

The speaker in the poem savours the encounter with slow, sensuous, dreamlike recollection, as if he cannot believe the encounter really happened. In the first line of the third stanza he evokes, and dispenses with, the medieval dream poetry tradition; as if he cannot believe it ever

truly happened, he assures us (and perhaps himself) with the words: 'It was no dream: I lay broad waking.'

Abandoned and lovesick, the speaker wonders what lies in store, not just for himself but for the woman who has forsaken him:

> 'It was no dream: I lay broad waking.
> But all is turned thorough my gentleness
> Into a strange fashion of forsaking;
> And I have leave to go of her goodness,
> And she also, to use newfangleness.
> But since that I so kindly am served
> I would fain know what she hath deserved.'

Although much of this poem fits the fabled tradition of Anne and Thomas' prorogued affair, it is not evidence enough. It could be wishful thinking, or just as easily concern one of his many mistresses, or his estranged wife, Elizabeth Brooke, whom he divorced for adultery in 1525. Although the recurrent theme of a love lost is once again present, there is, unfortunately, nothing that categorically proves the woman is Anne.

Since Wyatt's poetry as a whole is the main evidence produced to support a love affair taking place between them either before or during Anne's marriage to Henry, it is flimsy indeed. In some poems, he mentions a 'brunet' and, although it was more fashionable to be blonde, Anne was surely not the only dark-haired woman at court. The 'brunet' poem is believed to feature Anne because Wyatt altered the original that read, 'Her that did set our country in a roar,' to 'Brunet, that set my wealth in such a roar.'

The inference here is that, since Anne was the only 'brunet' to have set the country into a 'roar,' Wyatt was concealing her identity to safeguard her reputation. But, unfortunately for our purposes, there were many other women in Wyatt's life.

Retha M. Warnicke, in her essay in *Albion*, vol 18, no. 4 in 1986, believes Wyatt may have meant 'county' rather than 'country,' inferring 'Kent' rather than 'England'. It would make perfect sense if the 'brunet' in question was his estranged wife whose family, since the break-up, had been pursuing Wyatt for financial support. Since by the time this poem

was written, Anne was already dead and Wyatt was happily settled with his final mistress, Elizabeth Darrell, his ex-wife fits the context of the poem equally as well as Anne.

'If waker care, if sudden pale colour,
If many sighs, with little speech to plain,
Now Joy, now woe, if they my cheer disdain,
For hope of small, if much to fear therefore;
To haste to slack my pace less or more,
Be sign of love, then do I love again.
If thou ask whom; sure, since I did refrain
Her that did set our country in a roar,
Th'unfeigned cheer of Phyllis hath the place
That Brunet had; she hath and ever shall.
She from myself now hath me in her grace:
She hath in hand my wit, my will, my all.
My heart alone well worthy she doth stay,
Without whose help, scant do I live a day.'

Warnicke also highlights the irony that of all the men arrested alongside Anne, the only one popularly believed by modern historians to be in any way guilty is Wyatt, the one who got away.

In speculations about his involvement with Anne, no one has hitherto focused on how an investigator of Cromwell's diligence, power and energy could find the evidence to convict and execute five innocent men for having carnal relations with Anne while releasing without further ado the only guilty party, who had actually been placed in custody. The example of the treatment in 1542 of the convicted husband and lover of Catherine Howard is a compelling reason for arguing that if the king and his minister had any reason to believe Wyatt and Anne had been lovers, the poet would never have left the tower alive.'

When considering any historical conundrum, the subjects' characters should always be considered. As Warnicke points out, Cromwell was far too wily and assiduous to have let a guilty party slip through the loop. His duty to the King was paramount and, friend or not, had Wyatt cuckolded Henry, Wyatt would have joined the others on the scaffold.

A short examination of Cromwell's agenda illustrates that, in helping Henry rid himself of Anne, he also served himself. Four of the men who died alongside Anne had offended him in some way, and the fifth, the musician Mark Smeaton, was of little account. Cromwell was in no position to favour his friends. His manipulation of the truth in order to release Henry from an unwanted marriage was a risky business. The escape route Cromwell took exposed the King to the ridicule of being cuckolded by his closest friends. Luckily for Cromwell, nobody dared laugh out loud and, for the time being, he went unpunished.

Later in Henry's reign, after the failure of Cromwell's favoured match between the King and Anne of Cleves, Henry had his revenge. Finding himself trapped in an unwanted marriage with an unappealing woman, Henry stood by while Cromwell's enemies brought him down. Despised by the council, the fall of the lowborn Cromwell presented an opportunity the council could not resist. Cromwell spent the last few days before his execution writing letters from the Tower in which he begged mercy from the king whom he had served unswervingly for many years. Condemned to death by laws of his own making, his pleas fell on deaf ears and Henry sacrificed his most faithful, and most unscrupulous, servant.

If Cromwell was too wily to let a guilty man live, then surely Anne was too clever to commit adultery. She was well aware of the demands upon her to produce a legitimate heir; she was intelligent enough to persuade the king of many things, and often used her wit to sway him to her point of view. But the one thing she could not do was produce a child from thin air, and she was unlikely to be daft enough to try. Up until she caught the King's eye, Anne was largely free of enemies but, once his intentions became clear, even before she became queen, hostility toward her flourished. Since her death, and more noticeably in modern times, Anne has become an enigma; in history, fiction, and film, she either has become the archetypal wronged woman or witch incarnate. Hilary Mantel, in an interview with the Guardian newspaper in May 2012, describes the phenomena of Anne Boleyn as follows.

'Anne Boleyn is one of the most controversial women in English history; we argue over her, we pity and admire and revile her, we reinvent her in every generation. She takes on the colour of our

fantasies and is shaped by our preoccupations: witch, bitch, feminist, sexual temptress, cold opportunist. She is a real woman who has acquired an archetypal status and force, and one who patrols the nightmares of good wives; she is the guilt-free predator, the man-stealer, the woman who sets out her sexual wares and extorts a fantastic price. She is also the mistress who, by marrying her lover, creates a job vacancy. Her rise is glittering, her fall sordid. God pays her out. The dead take revenge on the living. The moral order is reasserted.'

In fact, we know very little about the real Anne. Even her portraits were painted after her death, possibly copied from an original. We don't know the exact year she was born, reports of her appearance range from the exotic to the deformed; even her hair colour is described variously. We know she was keen for religious reform and education; we know she was a champion of William Tyndale and the new learning. She possessed a copy of the English Bible; she coached Henry, as far as she dared, in the new religion, and we know she liked to dance. She was chaste, or at least was keen to be seen as such, and we know she kept the King dangling for years before finally sharing his bed shortly before their marriage.

Less overtly pious than Queen Catherine, Anne nevertheless was very religious. As queen, she kept a temperate household, maintaining a strict watch over her women. But Anne was young and vibrant; she loved to perform in court pageants, she loved clothes, holding a preference for yellow, and she indulged in courtly games, embracing wholeheartedly the chivalric game of love, a game in which the chief rule was chastity.

When it began to look as if the king was seriously considering making her his next queen, Anne's enemies, largely made up of the supporters of Catherine of Aragon, began to move against her. Eustace Chapuys, both Spanish ambassador and spy at Henry VIII's court, worked diligently for Catherine's cause and did all he could to disparage Anne. His duty was to keep Catherine on the throne and maintain the Catholic faith in England. Even after Anne became queen, Chapuys refused to acknowledge her; for many years, they never met face to face. It is said that his grasp of the English language was poor, compelling him to rely on interpreters, but this did not prevent him from spreading detrimental

rumours, naming her a 'whore' and a 'concubine,' and accusing her of using witchcraft against the King.

Yet, after having worked against her for years, at her trial, Chapuys seems to have mellowed. Anne's fall, coming so swiftly after the death of Queen Catherine, received a surprising epitaph from her old enemy, and the Spanish ambassador's report is tinted with pity. After her trial, he reported back to his Spanish master that Anne 'totally denied' the charges and met all questions with 'a plausible answer.' Of the men accused alongside her, he wrote:

'Only the groom confessed that he had been three times with the said whore and concubine. The others were condemned upon presumption and certain indications, without valid proof or confession.'

Perhaps, with Catherine dead and Anne no longer a threat, Chapuys had grown tired of the fight, or perhaps with the game won, he was sickened by the blatant injustice of her trial and disappointed by the King's ruthlessness. As Alison Weir puts it in *The Lady in the Tower*:

'Although everyone rejoices at the execution of the concubine, there are some who murmur at the mode of procedure against her and the others, and people speak variously of the king, and it will not pacify the world when it is known what has passed and is passing between him and Jane Seymour. Already it sounds ill in the ears of the people, that the king having received so much ignominy, has shown himself more glad than ever since the arrest of the whore …

Chapuys was Anne's contemporary, writing from the heart of events. He had a job to do and, as a result, his writings against Anne are sometimes harsh; his reports are biased and easily dismissed as such. Nicholas Sander's, written in the reign of Anne's daughter Elizabeth I, are fascinatingly vitriolic. Despite the ludicrous claims, Sander's descriptions of Anne have been harder to shake and they continue to crop up both in fiction and non-fiction. Even though he never laid eyes on Anne, being an infant at the time of her execution, Sander was the most ferocious of Anne's detractors. His agenda was political, striking against Elizabeth by

way of her origins, emphasizing the evils of Henry and his court, and demonizing both parents:

> 'Anne Boleyn was rather tall of stature, with black hair, and an oval face of a sallow complexion as if troubled with jaundice. She had a projecting tooth under the upper lip, and on her right hand six fingers. There was a large wen under her chin, and therefore to hide its ugliness she wore a high dress covering her throat.'

Sander was a Catholic recusant, writing while in forced exile. Some historians view his work as a valuable example of the Catholic point of view; others dismiss it as entirely slanderous. And toward Anne, he was slanderous indeed. Hostile both to the queen and the new religion she championed, Sander did not hesitate to strike low, unashamedly defiling Anne's already stained reputation.

It is from Sander that we get the witch figure, an obscene depiction of evil depravity. He presents a monstrous figure with six fingers on one hand, a large growth on her neck, his picture of her so outrageous, one wonders how such a woman, whose sexual habits apparently matched her looks, ever attracted any man, much less a king.

In the Tudor period, physical deformity was believed to mirror the soul, and Sander's agenda was to demonize Anne and all that she stood for. Of all the negative traditions about Anne Boleyn that can be laid at his feet, the worst is probably the idea that Anne was Henry's own daughter, allegedly begot during an illicit affair during Henry's youth with her mother, Elizabeth Boleyn. This infers, quite plainly, that Elizabeth was the offspring of her own sister and father, and that furthermore, Henry, having also conducted an affair with Mary, had slept with all the Boleyn women.

In his book, *De origine ac progressu schismatis Anglicani (Of the Origin and Progression of the English Schism),* Sander states that Thomas Boleyn, on learning of Henry's infatuation, hurried to court to tell the king that his marriage with Anne could never go ahead because she was Henry's daughter, whom Boleyn has raised as his own. This confessional visit to the king mirrors one he also alleges Wyatt made a short time later to inform Henry of Anne's lack of chastity. Sander would have us believe that the fastidious Henry, armed with the knowledge that Anne was his

own daughter and, moreover, a woman of loose morals, ignored both warnings and married her anyway.

In a time of intense superstition, a wen and extra finger would have been enough reason for Henry to shun Anne. Deformity was seen as a mark of evil, as if a person's true nature could not be contained beneath a fair face or figure. If a woman was by nature tainted, then that evil would manifest itself physically. Unfortunately, Sander's descriptions of Anne were taken up and repeated by a few of his contemporaries, but his report remains the most vitriolic. Anne's looks were not fashionable in an age when it was desirable to be plump and blonde, but she was distinctive; dark eyed and vivacious. One contemporary recorded her appearance as:

> 'Not one of the handsomest women in the world; she is of middling stature, swarthy complexion, long neck, wide mouth, bosom not much raised… and her eyes which are black and beautiful…'

Religious reformer Simon Grynée said she was 'young, good-looking, of a rather dark complexion, and likely enough to have children.'

It was Sander's slur upon the name of Wyatt as well as that of Boleyn that prompted George Wyatt to write his grandfather's memoir. It is unfortunate that his attempt to clear her of the slander results in an Anne Boleyn whose saint-like qualities are almost as unlikely as Sander's demon. George Wyatt, writing long after the events, makes no mention of a wen or goitre, although he does in a small way uphold the idea of the sixth finger:

> 'There was found, indeed, upon the side of her nail upon one of her fingers, some little show of a nail, which yet was so small, by the report of those that have seen her, as the work master seemed to leave it an occasion of greater grace to her hand, which, with the tip of one of her other fingers, might be and was usually by her hidden without any least blemish to it.'

Sander also claimed Anne was sent to France as a child because she was involved in a sexual relationship with the family butler. His book reads like a scandalous Sunday supplement.

SEXUALITY AND ITS IMPACT ON HISTORY

There are, surprisingly, modern-day detractors who continue to uphold many of the above accusations. G.W. Bernard, in his book *Fatal Attractions,* published in 2011, sees Anne as conniving, ambitious, and immoral. He says she wasn't particularly religious, upholds the view that she slept with the men accused alongside her, including her brother, George. He also reverses the idea that Anne withheld sexual favours from the king until they were married and claims it was Henry who showed restraint because he was keen that any child be seen as legitimate.

None of these claims is convincing; neither can they be upheld with evidence. One has only to read Henry's letters to Anne to understand the depth of his passion. Henry was not by nature the prude he is often depicted to be. Despite there only being one acknowledged royal bastard (Henry Fitzroy, the son of Elizabeth Blount) there were clearly other mistresses. Henry simply learned that it made more financial sense not to acknowledge any further children born of his philandering.

His relationship with Anne's sister, Mary Boleyn, coincided with the births of both her children, unacknowledged as such yet widely believed to be the king's offspring. Further evidence of Henry's nature is found after the arrest of Catherine Howard where the chronicles speak of him drowning his sorrow in the company of other women.

Henry's attraction for Anne may well have resulted in the downfall of Catherine of Aragon, but surely the blame must lie not with Anne but with Henry and his relentless determination to have her. Henry was not used to, and did not appreciate, being refused; maybe the novelty of craving something forbidden added a fillip to his dealings with Anne but, again, that is not Anne's fault. It was Henry's decision to dispense with his barren wife and marry a commoner; it was not the other way around.

Bernard's belief that Anne slept with those accused with her is also easily demolished. Records prove that on the dates she was accused of indulging in adultery, she was often elsewhere, either with the king, or, in one case, still recovering from the birth of Elizabeth. Why, having just given birth to a healthy child and with no reason not to be confident of bearing many more, would she feel the need to leave her childbed to indulge in adulterous sex with a lowly court musician? The scenario is not only unlikely but beyond comprehension.

Bernard also suggests that the need for Anne to produce a son became

so pressing that she slept with her own brother, but then because of its 'unnatural provenance,' the pregnancy miscarried. This idea was indeed raised during Anne's trial, but few at the time believed it, and Bernard is the only modern historian I have come across who gives it any credence today. Of all Anne's alleged admirers, why would a pious woman, with all the sixteenth-century fear of damnation and the devil, select her own brother to provide her with a child? The accusation of incest was clearly plucked from the air to further taint her with evil, to add cohesion to the smearing of her name. It was clearly a fiction and has long since been debunked. It is a shame that, in the absence of substantial evidence against her, a few historians continue to drag us backwards in our attempts to understand the events surrounding Anne's trial.

If we take an objective look at Anne's character, or the various views of her, on one hand we have an intelligent, pious woman, eager for reform, politically astute, battling bravely to provide the King with an heir. On the other, we have a conniving, depraved, manipulative monster whose agenda is to bewitch the King, bring down the Roman church, and tarnish the royal bloodline of England. Somewhere, in the midst of this, lies the real Anne, but not one report, whether it be to her detriment or her praise, accuses her of stupidity.

Only a fool would cheat on the king, especially within days of giving birth to Princess Elizabeth who, despite fictional accounts, was accepted and welcomed by Henry. Even when her position became dangerously precarious, Anne's focus would have been on conceiving her next child, the son she had promised the king; a legitimate heir of the king's body, not a misbegotten bastard of an incestuous union.

As to her sexual adventures before her marriage to the king, which, as we see later in the case of Catherine Howard, were equally crucial to her security, if there existed any small shred of evidence that could have been used against her, you can be sure Cromwell would have seized upon it and turned it to his advantage.

That does not mean, of course, that there was nothing at all between Wyatt and Anne; perhaps the relationship was one-sided, perhaps it existed only in Wyatt's head. Perhaps it was platonic, scarce begun before Henry entered the stage. No man likes to be snubbed, even by a king.

Some biographers have accused Wyatt of revelling in poetic misery.

That may be a little harsh. Whether the subject of his poetry is Anne or another mysterious unnamed woman, the emotion behind his words seems genuine. He clearly knew the agony of love.

I think we can say Thomas Wyatt was a man who, judging from his poetry, was unfortunate in love but who understood love. I think we can say he suffered, and I think we can say he was a victim of the times he lived in – yet another victim of Henry VIII. He died, most unromantically, of a fever in 1542, just six years after Anne and, in a letter written to his son in 1537, he described his life as, 'a thousand dangers and hazards, enmities, hatreds, prisonments, despites, and indignations'.

The names of Anne Boleyn and Thomas Wyatt will forever be linked, but a love affair, however fleeting, will never be proven. It is a pleasant fiction, and should be enjoyed as such. The times Anne Boleyn and Thomas Wyatt lived in were 'bloody days' indeed. They were two people who took centre stage in a mighty drama and Wyatt's poetry takes us as close to the tragedy surrounding the throne as it is possible to go.

Did he love Anne? I think the evidence is small, but he very well might have. If, indeed, his poetry is directed at Anne, then the affection seems to have been one-sided for Anne has left no trace of it. In the absence of any written evidence from Anne, there is nothing to suggest she returned the sentiment. She was either too ambitious or too wise.

While Wyatt is remembered widely as one of our greatest poets, a reformer of both metre and style, he was also a gallant courtier, a brave foreign diplomat and spy. Although loyal to his king, he was twice accused of treason, faced imprisonment, and a brush with execution.

Anne went to the scaffold with her reputation in tatters. She died violently, accused of treason, harlotry, and incest. She was a pioneer of the new religion and new learning, and yet is remembered only for immorality, for bewitching a king, and, by cuckolding him, instigating the first instance in English history of the execution, some might say butchery, of an anointed queen.

Chapter 6

The Marriages of
Mary Queen of Scots

Gayle Hulme

On 8 December 1542, inside the ancient walls of a Scottish palace, a little girl was born who would, by her life, her death, and her marriages, leave behind one of the most compelling and enduring episodes of the Tudor era. This story is a tale of solemn treaties, broken promises, infatuation, love, hate, and murder. From the time of her birth, this child had one factor that was to be her greatest advantage, but ultimately her catastrophic undoing: a strong claim to the throne of England.

The little girl who took her first breath at Linlithgow Palace was Mary Stuart, later known as Mary Queen of Scots. She was the daughter of King James V of Scotland and the French Marie de Guise. Perhaps more importantly, though, she was also the great-granddaughter of Henry VII of England and therefore had a claim to the neighbouring kingdom of England.

Her royal mother had previously given birth to two sons, both of whom sadly died in infancy. The untimely death of Mary's brothers meant that until Mary's mother produced another living male child, Mary was the heir to the kingdom of Scotland.

As is often the way with royal history, external events took over. In November, before the birth of Mary, James V and his armies had been involved in a disastrous battle with the English at the Battle of Solway Moss. King James is recorded as having been taken ill on 6 December and he eventually succumbed to his illness and died at midnight on 15 December, just six days after his daughter's birth. Some historians and

contemporary sources have recorded that he died of an ordinary fever, with others quoting that due to the nature of his recent defeat, he suffered a complete nervous collapse and lost the will to live. It is said that shortly before his death he turned his face to the wall and said, 'It came wi a lass, it'll gang wi a lass' or, in other words, the Stuart line had begun with a girl and would end with a girl.

With her father's death, the infant who had been a princess for six days was now a queen. This change in status marked an extremely significant interest in Mary with two questions being the top of everyone's list; who would rule in her place during her minority and who would she marry?

The uncertainty after the king's unexpected death without a male heir threw the landscape of Scottish politics into turmoil. With only an infant queen on the throne, the first of many power struggles over Mary began. Who would act as regent or Governor General until Mary could take up the reins of her kingdom? The position was a very attractive one, and as such, the holder became all but king. The pursuit of the highly prestigious, powerful, and lucrative appointment was hotly contested with morality and truth cast to the winds.

James Hamilton, 2nd Earl of Arran, was recognized as being next in line to the throne after Mary and therefore thought he was entitled to the position. However, Cardinal Beaton staked a counterclaim that James V had stipulated in his will that he wished a council of four nobles – Huntly, Moray, Argyll, and Arran – to rule with Cardinal Beaton being head of the council. After much wrangling and arguing, Arran renounced the documents produced by Beaton as forgeries and, with the support of Protestant reformers, assumed power over the little queen and the country.

Matters now turned to who Mary would marry. To our modern eyes, it seemed ridiculous to be discussing the marriage arrangements for a baby. However, this was commonplace for royalty in the sixteenth century. Binding political alliances between countries were often sweetened with the rulers paying huge sums and negotiating for years to secure dazzling marriages to one another's offspring. This cemented familial relationships and ensured any children born of these arranged marriages would have loyalties to both countries. It didn't, of course, always please the couples and so infidelity was rife.

This was particularly significant for Mary, now Queen of Scots.

Naturally, her French mother, Marie de Guise, favoured a French match for her daughter. However, this plan was a non-starter as the French queen, Catherine de Medici, although having been married for ten years, had not produced a single child.

An alternative option put forward by Henry VIII of England was that Mary would become betrothed to his five-year-old son Prince Edward. Henry used everything at his disposal to bring about the match, even bargaining with captured Scottish nobles that they could go home once he had their oath that they would support and actively advance his plans on their return to Scotland.

There were several reasons why this policy made sense for Henry and England. Mary was a great-granddaughter of Henry VIII's own father as his sister Margaret Tudor was James V's mother and therefore any claim to rule England in her own right would be neutralized on her marriage to Edward. Another advantage to this was that once Edward and Mary were married, all Mary's possessions would become Edward's property, in other words, Scotland, and all her wealth would become a crown possession of England.

A marriage treaty between the two children would also help to secure England from French invasion. Henry knew that the Scots-French relations were good and he was anxious that France should be stopped from using the Scottish coastline to land an army that could potentially defeat England.

Although Scotland was a poor country, there were still riches to be plundered. The Catholic Church at the time collected revenues of £330,000 per annum, whereas Royal lands brought in a miniscule £17,000 in comparison. Henry VIII, having embarked on a policy of dissolving the monasteries in England, envisioned annexing the same practice in Scotland and of course taking the lion's share of the spoils.

Marriages between sixteenth century royal princelings and princesses were only concluded after often lengthy and protracted negotiations. Treaties and agreements had to be settled and exchanged together with money in order to secure the woman's financial future should she find herself a widow.

There were two treaties, known as the Treaties of Greenwich, which were signed between England and Scotland on 1 July 1543. The first dealt

with securing peace between the two countries and the second was the binding agreement that Mary, now Queen of Scots, would become betrothed to Henry's son Prince Edward.

The accord between England and Scotland was not to last. A point of constant disagreement was that Henry wished Mary to be brought up under his supervision at the English Court. Mary's mother Marie de Guise implacably refused to send her daughter south or for that matter to allow her to be passed around her guardians' homes. Another perpetual point of contention was Henry's insistence that Scotland should sever its 'auld alliance' with France.

Along with the above disputes, there were further destabilising factors in play by early 1543. On 19 January, Catherine de Medici gave birth to a son. The Dauphin's birth provided Mary's French mother with an alternative and much more palatable match than Prince Edward of England.

Then, in April, Mathew Stuart, Earl of Lennox and grandson of James III, returned from France to challenge the regency and the pro-Protestant/English policies of the Earl of Arran. Having lived most of his life at court in France and served with the French army, Lennox's allegiances were not surprisingly favourable to a Scottish/French and Catholic alliance. He claimed he was the rightful heir to the Scottish throne after Mary. His argument for this was that Arran's father had never been properly divorced from his second wife and therefore Arran's mother and father's marriage was invalid. This would have barred Arran from the succession of Scotland due to his illegitimacy.

Lennox even wanted to marry Mary's mother and she did nothing to rebuff him. In a clever move to secure her daughter's safe passage from the vulnerable Palace at Linlithgow to the ancient stronghold at Stirling Castle, she used Lennox and his men as an escort.

Public opinion in Scotland was changing with the nobles and the population at large growing restless and tired of Henry VIII throwing his weight around. Cardinal Beaton and Lennox persuaded the self-serving, biddable, and weak-minded Arran to ditch his pro-English affiliations and turn his back on reformed religion. Relations between the neighbours continued to disintegrate until, in December 1543, the Estates of Scotland rejected the Treaties of Greenwich. Furthermore, Arran became a staunch supporter of the Scottish/French faction and gave his permission as

Governor General for a French marriage alliance between Mary and the Dauphin of France.

As for Lennox, his efforts and the assistance given to Marie de Guise in her flight from Linlithgow did nothing to help his cause. After attempts to heal the resentment between Lennox and Arran over the regency failed, Lennox turned his coat and pledged his allegiance to Henry VIII and England. Henry even sanctioned Lennox's marriage to his popular niece Margaret Douglas.

Naturally, when Henry VIII was informed that the Scottish Parliament had formally broken the Treaty of Greenwich and that the Dauphin of France, rather than his son, was to marry Mary, he was furious. With the treaty in tatters, there was no chance of him uniting the two crowns or gaining enough control over Mary or Scotland to get them to break their ancient alliance with France.

Henry was not a man to be defeated and what occurred next has become known as the 'rough wooing'. If Scotland would not honour her agreements through diplomacy, then Henry would use savage brutality to force the recalcitrant Scots to comply with his will.

The first sign of Henry and England's wrath came when Henry sent Sir Gilbert Dethick, the Richmond Herald, to the Privy Council of Scotland, demanding the return of the Scottish nobles he had allowed home under licence after the Battle of Solway Moss. However, this was nothing compared to the physical reprisals he was about to unleash on noble and ordinary-citizens alike.

He ordered his former brother in-law, Edward Seymour, 1st Earl of Hertford, to take an army north to Edinburgh in May 1544. He was charged with executing a 'scorched earth' policy. Henry's orders were specific and chilling:

'Put all to fire and sword, burn Edinburgh Town, so raised and deface when you have sacked and gotten what you can of it, as there may remain forever a perpetual memory of the vengeance of God lighted upon them for their falsehood and disloyalty.

'Do what you can out of hand … to beat down and overthrow the castle, sack Holyrood House, and as many towns and villages about Edinburgh as you may conveniently. Sack Leith and burn

and subvert it and all the rest, putting man, woman and child to fire and sword without exception, where any resistance shall be made against you.

'Pass over to Fife and extend like extremities and destructions in all towns and villages.'

In other words, burn everything you can, kill everyone who stands in your way, plunder and steal whatever you wish, and make sure the violence is so terrifying that they will never forget it.

Hertford carried out Henry's orders with ruthlessness. Edinburgh took two days to burn. The pier at Leith was broken up and the English soldiers looted the merchant ships docked there. Holyrood House was sacked, the Abbey Church was destroyed, and no mercy was shown when even the royal tombs of James V, his first wife and his infant sons by Marie de Guise were left in ruins. The only building that survived this terrible onslaught was Edinburgh Castle itself.

Cardinal Beaton was seen as the root cause of Scotland's treachery. The English blamed Beaton's 'sinister enticement' of the Regent Arran for the Scots' duplicity. Being unable to apprehend Beaton himself, the English did the next best thing, which was to destroy the castle of Lord Seaton for placing Beaton at liberty to agitate Arran and the Scottish nobles against the Treaty of Greenwich in favour of a French and Catholic alliance.

Evidently, even this wasn't enough to satisfy Henry, who felt no compunction about the vicious assaults. Indeed, he saw himself as totally justified in his awful retribution against the Scots for their dishonesty. Swiftly on the heels of the May devastation, he ordered Hertford to lead a further attack in November 1544. This time, the fertile Tweed Valley with its wealthy abbeys and prosperous industry was targeted. In keeping with the depravity of the first attack, this time, the English set their forces upon the home of the Earl of Angus, where the tombs containing the remains of his Douglas ancestors were desecrated.

By 1543, Mary's kingdom was in turmoil. At this time, there were two definite factions starting to appear. There were those who favoured making an alliance with England in order to stop the carnage and violence of the rough wooing. Some Scottish reformists saw alliance with Henry's

England as a vehicle for peace and religious reform. The other side were men hell bent on preserving the old religion and further strengthening relations with France.

For many in Scotland, patience was running out and a way to curb the 'greedy pack' in the Catholic Church was seen as imperative. These men felt the church was neglecting the sick and destitute in favour of their own avarice. Later in the decade, behaviour of clerics had degenerated so far that it was deemed necessary to pass laws stating that priests could not engage in illicit relations with women, or indeed support or promote the offspring of such liaisons. The country's internal peace was a powder keg on the edge of combustion and it wouldn't take much friction for it to explode with seismic force.

As reformist teachings began to spread, the Scottish nobles started to grasp the truth, that giving land and money to the clergy would not lessen their time in purgatory or guarantee them a place in heaven. Naturally, they felt aggrieved and felt entitled to have their land and money back. Those loyal to Cardinal Beaton and the Church, guided of course by self-interest, were keen to retain the luxurious, abundant lifestyles they had grown used to.

Matters came to a head on 29 May 1546 at St Andrew's Castle, where Cardinal Beaton was engaged in entertaining his mistress. Tempers were running hot after the cardinal and his cohorts had sanctioned and watched the burning of George Wishart, a Protestant minister, just two months earlier.

Keen to avenge their mild mannered and god-fearing friend, a gathering of angry Fife lairds posing as masons smuggled themselves into St Andrew's Castle. They stole the keys from a suspicious porter, threw him into the moat, and went on to clear the castle of people. On reaching Beaton's locked door, the gang relented on their threat to burn him out of his room, but once inside brutally stabbed him to death anyway. Beaton's last words were, 'Fie, Fie, I am a priest, all is lost.' Or in other words, if men are prepared to kill priests, then all is lost. Not content with ending Cardinal Beaton's life, his attackers mutilated and defiled his corpse, with one particularly callous attacker urinating in the dead man's mouth; they then stripped the body and hung it from the castle walls. The attackers then barricaded themselves within the castle to avoid capture by the authorities.

If Cardinal Beaton's killers, now besieged within the castle, thought Henry and the English would suddenly come to their aid, they were wrong. Although the English did suggest several heavily stacked diplomatic solutions, no practical help or assistance ever arrived and a long siege ensued with the Castilians receiving their supplies by sea. If the Castilians believed that the death of Henry VIII in January 1547 would bring them any relief or upturn in their fortunes they were mistaken. With Henry's son, the 9-year-old Edward VI sitting on the throne, it was his uncle Hereford, now Lord Protector of England who held the political power and he was happy to continue with the dead king's policy. All in all, the siege was a massive backfire. Instead of bringing the marriage of Mary Queen of Scots and Edward VI closer, it sent the Scots frantically fleeing to the French for help.

Although there is no official parliamentary record it is believed that on 8 September 1547, Arran arranged a Convention at Monktonhall where he requested permission to extend a formal offer of Mary's hand in marriage to the Dauphin of France in exchange for the French king's help in expelling the English from Scotland.

The French did eventually agree to help and by a combination of naval bombardment and battery from cannons mounted at St Salvator's tower and the nearby cathedral tower, the siege of St Andrew's Castle was finally broken by August 1547. With the French having honoured their part of the bargain, it was time for the Scots to hand over the agreed military strongholds and allow their queen to begin preparation for her new life in France.

However, even after the death of Henry VIII in January 1547, the English were far from finished. Not even a month after the siege of St Andrews was over, the Scots found themselves on the losing end of an overwhelming English defeat at Pinkie Cleugh in Lothian. The Scots were estimated to have lost 6,000 men, while English casualties amounted to around 500.

The catastrophic loss of life, together with the English occupation of several Scottish strongholds, prompted Arran to call a council in November, followed by a Parliament in January to discuss the French marriage. This was not without self-interest on the part of Arran. Always a man on the lookout for himself, he did very well out of the marriage

negotiations securing the Duchy of Châtellerault from Henri II of France and the promise of a prestigious French marriage for his own son James.

On 7 July 1548, Parliament agreed to the marriage between Mary Queen of Scots and the Dauphin of France and the Treaty of Haddington was signed at the Nunnery of Haddington. It was agreed that the young queen would be transported to France, and that France would be given control of a number of military strongholds that remained in Scottish hands. The French, for their part, agreed that the King of France would defend Scotland as he would his own territories, while still respecting Scotland's sovereignty.

So it was that the five-year-old Mary boarded her future father-in-law's royal galley at Dumbarton on 29 July 1548. However, in keeping with her betrothal, it was not plain sailing and inclement weather meant that the royal retinue only reached the sea on 7 August. Even when the fleet did eventually reach the sea, they were tossed about by treacherous conditions. The fraught and hazardous journey took eighteen days to reach the port of St Pol-de Léon in Brittany. It seems everyone on board, except the young Mary, had suffered from dampened sprits and seasickness.

Once the party had recuperated after their sea travels, the royal train began to make its two-month journey by land and river towards Henri II's Château de Saint-Germain-en-Laye. The magnificent royal palace was just twelve miles outside of Paris and only a few miles away from the temporary royal nursery at Carriéres-sur-Seine. The royal children, Francis, Elizabeth, and Claude of Valois, were under the care of Jean and Françoise de Humiéres. The de Humiéres may well have supervised the day-to-day care of the royal siblings, but overall control was firmly in the hands of Henri II's long-time mistress Diane de Poitiers.

By the time Mary had arrived at her new home, accompanied by her maternal grandparents, the Duke of Guise and Antoinette of Bourbon, on 14 October, Henri II was already describing her in glowing terms in a letter to one of his one hand picked and high ranking nobles, Anne de Montmorency, Constable of France as 'the most perfect child I have ever seen'. He frequently referred to her as '*ma fille la Royne d'Ecosse*' or 'my daughter, the Queen of Scotland.' If anyone was in any doubt over his affection, he demonstrated it further by giving instructions that Mary was to share the rooms of his daughter Elizabeth and that she should be

given precedence and honour over both his daughters. She was, after all, about to be betrothed to the Dauphin of France and she was an anointed sovereign in her own right.

Mary was honoured and feted everywhere she went with the court, and the public revelling in the romantic notion of this pretty, vivacious, but persecuted child queen being rescued from warring, honourless nobles in Scotland and the relentless threat of English kidnapping and forced marriage to Edward VI. By October, the scene was set for '*la petite Royne*' and her intended to make their public debut at a major dynastic occasion.

The decision taken by the King to publicly present the couple together for the first time at the well-attended wedding of Mary's maternal uncle Francis, Duke of Guise and Anne d'Este was no coincidence. The bridegroom was a member of the powerful Guise family and the bride was the highly educated and cultured granddaughter of Louis XII of France, and a cousin of Henri II himself. The long-awaited wedding was the perfect vehicle to show the assembled emissaries and diplomats from around Europe how perfectly formed, energetic, and well suited the Dauphin and Mary were.

This was a highly stage-managed piece of Renaissance public relations and nothing was left to chance. Under the keen eye of Mary's Scottish Governess, Lady Fleming, Madame de Humiéres, and ultimately Diane de Poitiers, both children were thoroughly schooled in the intricate solo dance they were to perform and even the gentle kiss that was expected at the end. The steps and mannerisms required to convince the onlookers that they had a natural affinity for one another were practised to perfection. All the effort was worth it; their dance and the kiss were performed with aplomb and the whole audience was charmed and captivated by the romance and innocence of the moment. All except one, as the English Ambassador still managed to scowl cynically through the whole performance.

The rest of Mary's childhood in France passed by with all the contented luxury a European princess could expect. Mary learned to speak and write French as well as any native-born French woman. She was housed and clothed at great expense with all the honour and prestige due her rank. Her life consisted of dancing, hunting, reading, religious devotions and sewing. She was comfortable in the company of Lady

Fleming and Princess Elizabeth, and to everyone's relief, she and her future husband Francis got along well.

When Mary was fifteen and Francis fourteen, arrangements and financial settlements for the couple's union required finalising. This included the signing of agreements outlining details of what property and revenues Mary would be due if she was left a widow, with or without children. One of the most important issues for Scotland was the status of the country should Mary depart this life without children.

Keen to protect Scotland's independence and the security advantages that the French alliance provided, a party of eight Scottish commissioners travelled to Paris in the weeks before the wedding. They undertook the journey in order to confirm that after the Queen of Scots' marriage, her home country would retain its autonomy and sovereignty as previously agreed in the Treaty of Haddington.

Mary was now of an age to act independently of Henri II in matters concerning Scotland, and so she sought advice from her grandmother, Antoinette de Bourbon, and her Guise uncles. In her naivety and inexperience, she did not realize that her French relatives had little or no experience of Scottish politics or of the religious tensions in Scotland at that time. The Scottish commissioners left France after the wedding with a personally signed document from Mary that stated, amongst other things, that 'the freedoms, liberties, and privileges of the realm and laws of the same, and in the same manner as has been kept and observed in all Kings' times of Scotland before'.

What Mary failed to disclose to the Scots was that some days before, on 4 April, she had signed three polar opposite documents, one of which was in direct contravention of Scots Law. The first document stated that, should she die without an heir, France would gain Scotland, together with Mary's rights to the English crown. The second document legislated that on her death without an heir, France would have claim to one million pieces of gold from Scotland in respect of their defence of the realm and Mary's household in France. The third document, which was signed by Francis and Mary, flew in the face of Scots Law as it stated that any subsequent agreements made between Mary and her Estates were not legally binding.

Was this the first evidence of a naïve and weak monarch avoiding

confrontation and childishly trying to please everyone? Or, of a woman, who, after ten formative years in France, now saw her future so firmly embedded as Queen Dauphine of France, that she need not consider any other eventuality?

By the time of Mary and Francis's marriage the French had been periodically fighting the Italian Wars since 1536. This was in an attempt to stop the Holy Roman Empire led by the Haspburg dynasty dominating the whole continent. Matters were made worse when Charles V, The Holy Roman Emperor gave the rule of Spain over to his son, King Phillip II. Then in 1557 Phillip managed to persuade his wife Mary I of England to commit English troops and arms to fighting the French. However, even though years of expensive wars with the Italians, the English, and the Spanish had brought France to the edge of financial disaster, Henry II was determined that his son and heir's wedding would be a magnificent occasion. The elaborate and dazzling sight of the first Dauphin in two hundred years to be married in France would provide the people with a perfect theatrical distraction from the country's humiliating defeat by the Spanish and English at Saint Quentin in northern France in August 1557.

Henri wanted it shouted loud and far that once his son was married to the rightful heir of England, France would, according to Henri II's Master of Requests (lawyer responsible for petitions to the king) Michel de l'Hôpital at a post-wedding banquet, gain England 'without murder and war.' Another post-wedding orator, the celebrated poet and joint leader of the prestigious literary group La Pléiade, Joachim du Bellay, said, 'Through you, France and England will change the ancient war into lengthy peace that will be handed down from father to son.' In other words, France will gain England through Mary and her Valois children and will take possession of the English crown. Once again, just like Henry VIII had tried to do, Henri II was using Mary's occupation of the Scottish throne and her rights to the English Crown to further his own dynastic ambitions.

The wedding itself took place on Sunday 24 April 1558 at the door of Notre Dame Cathedral in Paris. The cathedral sits on Île de la Citè in the middle of the River Seine and a twelve-foot high walkway was built to bridge the short distance between the palace of the Archbishop of Paris and the church doors. It also provided a great vantage point for the public

to witness the procession of the sumptuously dressed royal party as well as the wedding service.

The bride had chosen her wedding clothes for vanity rather than to comply with convention. She donned a shimmering lily-white dress to enhance the colour of her red hair and pale skin. With white being the colour of French mourning, it seemed that this Queen, Dauphine of France, was set to do things her way from the beginning.

Not only was the dress white, it had also been embellished with diamonds and jewelled embroidery. Around her neck she wore a gift from her father-in-law, known as the 'Great Harry' because it contained the King's initials. However, Mary's crowning glory was quite literally the crown placed on her head of loosely worn hair. The crown was so heavily adorned with precious stones that it was rumoured to have cost 500,000 crowns. In fact, it was so heavy that during the public banquet later that Sunday a servant had to hold the crown over Mary's head when the weight became too much for her to bear.

Once the couple had taken their vows underneath an antique arched canopy of blue azure, decorated with gold embroidered fleur–de-lys, they proceeded on a gold carpet towards the Royal Closet inside the cathedral. On reaching the private chapel, a silver veil was held over the newly married couple as they knelt to hear the nuptial Mass.

A full five days of celebrating in front of Europe's ambassadorial elite followed. There were banquets, jousts, and elaborate masques with moving ships as props, all designed to show off France's wealth and standing. Henri II pulled out every stop and spared no expense to show that France was a major player and that one day soon his Valois descendants would rule all over the continent. However, Henri II did not live long enough to see any of his plans come to fruition. On 30 June 1559, despite the pleas of his wife not to joust, the King went into the lists and sustained an injury when a piece of splintered lance became lodged in his eye. The injury became infected and, ten days later, he was dead.

With the court still in deep mourning, Francis and Mary were crowned at Rheims in a sombre and respectful ceremony. However, there were two significant destabilising blows about to fall that would drastically alter Mary's carefully planned future. The first of these fell in June 1560 when

her mother, Marie de Guise, died at Edinburgh Castle. Marie had been her daughter's resolute protector, confidante and selfless guiding light all her life. The second came six months later when her young husband, despite Mary and Catherine de Medici's nursing, succumbed to a short, painful illness and died. Still only eighteen, she had been, in the short range of less than two years, a wife, a queen, and a widow. Tradition in France was for Queen Dowagers to spend forty days in seclusion, mostly to establish whether they were pregnant or not. Mary observed this tradition, even though it was never clear whether Francis ever had the maturity or health to consummate his marriage.

When she emerged after forty days in the same condition she entered, her position in France became uncertain. Francis's mother Catherine de Medici had been appointed regent on behalf of her ten-year-old son Charles, who was now king. What was certain, though, was that Catherine de Medici had had enough of the powerful Guise family and wanted all of them, Mary included, out of her court. On the very first day of her widowhood before she entered seclusion, Mary surrendered the crown jewels of the Queen of France to her mother-in-law.

Mary had three options; she could accept one of the many marriage proposals arriving from foreign princes, return to Scotland, or stay in France as Queen Dowager in direct conflict with her former mother-in-law. Unsurprisingly, Mary was not keen to stay in France with the now formidable Catherine de Medici as her enemy.

The alternative proposed by her Guise uncles was for her to marry the heir to the Spanish throne, Don Carlos. This match would once again ally Scotland and potentially England with Spain and perhaps give the opportunistic Guises a path back to power in France. Catherine de Medici was implacably opposed to this plan and went on to use all her influence with King Phillip of Spain to thwart the match. Her daughter Elizabeth had just married Phillip and she was emphatic that her daughter would not be eclipsed in Spain by Mary, or that her son's kingdom in France would not face a threat from a Spanish-Scots-Anglo alliance.

The only feasible choice for Mary was to return home to Scotland and take up the reins of sovereignty in the land of her birth. On the other hand, returning to Scotland was not going to be straightforward either.

In August 1561, the eighteen-year-old Mary boarded a French galley

bound for Scotland, but it was a starkly different country from the one she had left as a small child. In July 1560, only a month after the death of Mary's mother, a peace treaty, known as the Treaty of Edinburgh, was signed between Scotland, England, and France. The terms of the peace were that the 'Auld Alliance' would be abolished, the Catholic French would leave an increasingly Protestant Scotland, that the King of France would stop using the English arms and that the French would recognize Elizabeth I as the rightful Queen of England. To add further to this, on 17 August 1560, the Scottish Parliament ratified the Confessions of Faith. This piece of legislation changed the official religion of Scotland to Protestantism and denied the authority of the Pope in Rome. How would Mary, herself a Catholic, fare in trying to lead a fractured nation of Scots whose infighting and backbiting was legendary?

In truth, the next four years of her reign in Scotland were relatively quiet in comparison to the events that would unfold on her next marriage.

Once back in Scotland, Mary began to write letters to her 'good sister' Elizabeth in England. The main point of these communications was to have Elizabeth name Mary as successor to the English throne, but always wary of preserving her own security, Elizabeth reverted to type and dissembled. She had not forgotten her own imprisonment in the Tower of London when, as heir to her sister Mary, she was implicated in the Wyatt rebellion and only narrowly escaped with her life.

As well as Mary's desire to be named Elizabeth's heir, there was another matter high on her agenda; marriage. She had not given up the idea of marrying Don Carlos, but the matter was fraught with problems. Elizabeth in England and the Regent of France, Catherine de Medici, did not want Scotland to be allied with a big European player like Spain. Mary herself had reservations as a foreign marriage could mean leaving Scotland to reside abroad with her new husband, and leaving the tribal and often lawless Scots without a monarch was risky.

Elizabeth did however propose a solution to the problem of Mary's marital status. She suggested that Mary should marry her favourite courtier, Robert Dudley, in return for being named her successor. Elizabeth knew she could never marry Dudley herself, but also knew his loyalty to her was so strong that he would never allow Mary to attempt to usurp the English throne. Elizabeth even elevated Dudley to the Earldom

of Leicester so he would be of sufficient rank to marry a queen.

This tore at Elizabeth's heart. Leicester had been a confidant since before her accession and many historians believe he was the closest man to her. On his death, she was so overcome with grief that she locked herself into her rooms for days and only left when her chief minster William Cecil had the door knocked down. Indeed, fifteen years later at the time of her own death, she had about her a letter from Leicester marked with the words 'his last letter'. Leicester for his part was outwardly and quietly compliant, but he did not want to go to Scotland and was, along with William Cecil, trying to advance another young man at Elizabeth's court who did have royal blood.

The candidate who fitted the bill was the son of the Earl of Lennox and his Countess, Lady Margaret Douglas; Henry Stuart, Lord Darnley. Darnley was three years younger than Mary, but he was tall, handsome, and educated. Perhaps more importantly, he was, like Mary, a great grandchild of Henry VII of England, a Roman Catholic, and most significantly, as a man born in England, Henry VIII's ban on foreigners inheriting the crown would not apply. A marriage between the two would join together the two strongest claims for the crown of England.

In 1563, Elizabeth was tired of the Catholic Lennox's meddling in dynastic and religious matters at her court and she had asked Mary to allow Lennox to return home from exile in England. Mary agreed and cajoled her hesitant nobles to acquiesce to the repatriation of Lennox. Uncharacteristically vacillating between the Dudley and Darnley match, Elizabeth realized too late that Darnley could potentially accompany his father home to his estates, which Mary finally restored to Lennox on 16 October 1564. By early 1565, Mary issued Darnley a passport and he was by his father side in Scotland and far out of Elizabeth's reach.

Mary was besotted with Darnley from the very start, describing him as 'the lustiest and best proportioned long man that she had seen'. She seemed completely oblivious to any of his narcissistic or sociopathic shortcomings. Indeed, her own uncle, the Cardinal of Lorraine, had described him in 1558 as a 'polished trifler' and he was not in the minority when it came to pointing out Darnley's arrogance, stupidity, and insufferable attitude of entitlement. When Mary's ambassador Melville was asked what he thought, his answer was blunt:

'No woman of spirit ... would choice of such a man that was more like a woman than a man for he was very lusty beardless and lady faced.'

What he did have was a cast iron claim to the English crown, together with all the abilities and skills that Mary admired and engaged in herself. He could recite poetry, dance, play music, hunt, and hawk.

In 1565, the progression towards the marriage moved at a fast pace, even though Elizabeth had sent Nicholas Throckmorton north to break up the match. Mary was aware of her cousin's plan and feared that both Lennox and Darnley would be summoned back to England. Throckmorton's mission looked to be failing when he wrote to Elizabeth in May that Mary had bestowed upon Darnley the honours of Lord of Ardmanch, Earl of Ross and Duke of Rothsay. These were the titles that were normally reserved for the sons of Scottish kings, so no one was in any doubt that Mary was deadly serious about marrying Darnley.

Although the official date for the marriage is given as 29 July 1565, Thomas Randolph, Elizabeth's Ambassador in Scotland, wrote to her on 16 July telling her that Mary and Darnley had been married in secret with only seven people present on 9 July. Why was there need for such secrecy? Was Mary afraid that Elizabeth would find a way to stop the wedding? Lennox and Darnley had already, on Mary's insistence, defied Elizabeth's command for them both to return to England.

Whatever the circumstances of the wedding ceremony, Mary and Darnley were definitely married by 29 July 1565 in Mary's private chapel at Holyrood. The signs of failure were ominous from the very start with Darnley not even staying to attend his own nuptial mass. Insult followed insult and even though Mary had indulged Darnley's wishes by granting him the title of king, only two Scottish nobles, Atholl and Morton, paid him any respect at the couple's wedding banquet. Others, like Mary's half-brother, Moray, Argyll, and Châtellerault refused the queen's direct summons and did not attend at all.

Thus began the notorious rebellion known as the Chaseabout raids, so called because the rebel and royal forces spent the next two months crisscrossing Scotland in pursuit of each other but never actually engaged in open battle. The end came with Moray and his fellow rebels fleeing

into exile in England. The firmly Protestant Moray may have fled the country, but there remained in Scotland a significant number of nobles who hated Lennox and Darnley, and as time progressed, the divisions would have grave implications.

In England, Elizabeth and her council were seething and had decided that they would never recognize the marriage of Mary to Darnley or accept Darnley as King of Scotland. Elizabeth went further, sending a special envoy north with orders to only speak with Mary and to completely ignore Darnley.

If Mary thought that Darnley was going to be satisfied with a role as co-ruler of Scotland, she was gravely mistaken. His arrogance and lust for power would lead him to fly in the face of Mary's established and reiterated policy of religious tolerance. He engaged in religious meddling behind Mary's back, not because he was a devout man of religious conscience, but because he wished to appear to be a strong king in front of the Pope and the other Catholic monarchs of Europe. His double-dealing was laid bare when Mary's uncle, the Cardinal of Lorraine, arrived in Edinburgh in February 1566. The Cardinal brought with him a congratulatory letter from the Pope expressing his pleasure that the king and queen had restored the Catholic religion in Scotland. To inflate his own ego and massage his vanity, Darnley, along with David Rizzio and others, were creating explosive divisions between Protestants and Catholics, which Darnley had neither the leadership nor the cunning to navigate.

By the autumn of 1566, Mary was slowly beginning to recognize that the warnings she received from Elizabeth and others about Darnley's character were not exaggerated. The relationship was floundering, largely due to the fact that he had showed his true colours as a venomous, self-absorbed drunk who could not curb his tongue. Talk of the couple's vicious arguments and his carousing with women and allegedly with Rizzio, who was thought to be a Papal spy, were the talk of the palace, Edinburgh, and beyond. At Christmas that year, Randolph wrote to Leicester, 'I know for sure that this Queen repenteth her marriage, that she hateth him and all his kin.'

The catalyst for the breakdown seems to have been the fact that Darnley, no longer content with being co-ruler, wanted the Crown

Matrimonial, which would have ranked him higher than Mary herself. Clearly, now that she was aware of his failings, she refused him the higher status and rubbed salt in his already open sores by demoting him from co-ruler status and denying him the use of royal arms. Naturally, for a man with Darnley's self-importance and inflated sense of entitlement, this provoked a furious response. The only solace for Mary was that by Christmas, she suspected she was pregnant.

Darnley was facing a series of dilemmas; Mary had seen through him and would not grant him dominion over her. The incumbent Protestant nobility hated him and would never support him as king. Even the child Mary was carrying was a threat to his taking full control of the kingdom. If Mary should die giving birth to her child and the child lived, it would be the infant who would inherit the Scottish crown, and the best Darnley could hope for was governor until his child came of age. With no allies, Darnley faced a stark choice. He could accept his hollow position as king with no power or he could seek to make alliances with the banished Protestant Scottish nobles, which included Mary's half-brother, James, Earl of Moray.

Predictably, and buoyed up by the support of his father and his maternal uncle, George Douglas, he chose the latter and articles were drawn that, on the return home of the exiled nobles, he would be granted the Crown Matrimonial with full parliamentary control. Darnley, for his part, would as king restore their status in Scotland, pardon their transgressions against the Crown, and see that the next Parliament did not confiscate their considerable lands. He also agreed to cast aside his misguided Catholic principles and join the cause of Protestantism. The timetable to effect this action was short, as a Parliament was due to sit on 12 March 1566, prepared to formally confiscate the titles and lands of all Darnley's potential cohorts.

Adding even more pressure to the situation was the fact that Mary, in an attempt to get the Pope to support her claim to the English throne, had pronounced publicly at a banquet that she was the rightful Queen of England. She was also at this time actively supporting, again to impress the Pope, the return of the mass to Catholic Scottish churches. The conspirators had no time to lose and messengers were dispatched in February to parley with Moray.

There was another agitator in this nest of conspirators against Mary and this was John Maitland, who had previously been Secretary of State to the queen. Maitland was thoroughly aggrieved that David Rizzio had wheedled his way into Mary's favour and had usurped his position as a confident.

Rizzio was an Italian musician who became close to Mary as her Private Secretary and her near constant companion. He was also close to Darnley, being involved with him in the plot to resurrect the mass in Scotland, as well as being rumoured to be his lover.

Darnley was insanely jealous of the time Rizzio was spending with his wife and also, according to Lord Ruthven, blamed Rizzio for Mary not granting him the Crown Matrimonial. Maitland saw this as a perfect opportunity to begin pouring poison into the gullible and impressionable Darnley's ear. He convinced Darnley that Rizzio was responsible for misguiding him into restoring the Catholic faith in Scotland and, worst of all, and with no regard for Mary's reputation, Maitland persuaded Darnley that Rizzio was secretly sleeping with his wife and that the child she was carrying was Rizzio's bastard.

The plot was thickening fast. The exiled nobles had agreed to Darnley's terms. On the success of the plan that Darnley would be king, the nobles would retain their Scottish titles and goods and the religious status quo that was established on Mary's return in 1561 would resume. Most chilling of all, the cause of all the ills in the kingdom, the very root, the Papal spy and Mary's 'most special servant' David Rizzio would be chopped down and assassinated. They had their plan, their scapegoat, and on Saturday 9 March 1566, a scene unfolded in front of Mary that would haunt her forever.

According to Lord Ruthven, Darnley could not suffer Rizzio any longer and, at one point, his temper was running so hot, he threatened to carry out the deed himself. As the plans for the murder were being drawn up, Darnley was adamant that Rizzio would be slain in the presence of his wife in her own chambers. His reasoning was that Rizzio's habit was to take supper with the Queen in her own chambers and that if they chose the morning or some other place within the palace, he might have means of escape. The plan was to ambush the man in the course of his regular duties and ensure all possible exits would be blocked. Mary's chambers

were on the second floor of the palace above her husband's, with a private staircase connecting them. With only one other public staircase as a route to elude the gang of assassins, Rizzio would be well and truly cornered.

So on the night of Saturday 9 March 1566, with a party of accomplices standing guard at the palace gates, Darnley allowed his fellow plotters to enter his chambers while he proceeded up the private staircase to join his wife at supper in a small room adjoining her bedchamber. Also present for supper were Rizzio, Lady Argyll, and several other guests. Darnley joined his wife and placed his arm round her waist in what must have appeared, considering the state of the marriage, an incongruous act. Meanwhile, the other conspirators, including the Earl of Morton and Lord Lindsey, concealed themselves and waited on the other side of the door.

Lord Ruthven was the first to enter the room, alarmingly with a steel cap on his head and wearing amour. He asked Mary to give up Rizzio to them as 'for he hath been over-long here'. In answer to Mary when she enquired as to why she was required to give up her servant, whose presence she had requested, Ruthven went on to explain that amongst other things, Rizzio had besmirched her honour and her husband's but did not elaborate on the rumours of infidelity. To add to his faults, he was the cause of Darnley not receiving the Crown Matrimonial. He laid the blame for Mary banishing her nobles firmly at Rizzio's door and then finally accused Rizzio of receiving bribes to the detriment of Darnley.

What happened next must have been truly terrifying for Mary, who, at the time, was six months pregnant. An astonished Rizzio had moved from his original place and was now cowering by the window behind Mary, and his hands were firmly gripping the pleats on her skirt. Lord Ruthven instructed Darnley to take hold of his wife and as Mary stood, the truth of her husband's unusual visit must have dawned on her. She asked him, 'What do you know about this?' Darnley, ever the immature coward, stood stock-still, denied all knowledge, and did nothing.

Matters then escalated as Ruthven made a lunge for Rizzio, who was at this time exhibiting all the signs of a man facing a violent and inescapable death. The next event was the storming in of the men standing by the privy stairs. Once they heard Ruthven's prearranged verbal sign 'Lay not hands on me, for I will not be handled,' they barrelled into the small room, sending the supper table and lighted candles flying towards

a tapestry. Were it not for the speed of Lady Argyll's reactions in catching the one remaining lit candle, fire might also have been added to the melee.

With the whole room in complete chaos and full to bursting with men, some of who were pointing pistols and daggers at Mary's belly, Rizzio's fingers were eventually forcibly released from her skirts. He was dragged screeching bloody murder and pleading for his life through her bedchamber, the presence chamber, and finally to the head of the staircase, where his murderers began their work in earnest. In an uncontrollable frenzy of violence, Rizzio was brutally beaten and stabbed over fifty times. Even though Darnley did not strike a single blow, one of his comrades made sure that as Rizzio's life ebbed away, Darnley's dagger was stuck firmly in Rizzio's ribs. As if the callous killing of an unarmed man wasn't bad enough, later on that evening, his bloody corpse was kicked down the stairs.

The immediate recriminations consisted of a terrified Mary upbraiding Ruthven and Darnley for their actions. She threatened Ruthven that if the kingdom came to grief or if she or her child perished, she would make sure that all her influential and powerful European relations would seek revenge on her behalf.

When Mary turned her attention to a dazed Darnley, his flimsy excuse was to whine that Rizzio had caused all the problems within their marriage. He complained that he was the reason they spent no time together and that as a man, he was humiliated because she occupied a higher station in life than he. Like a child who is unable to take responsibility for their actions or recognize their own transgressions, he asked Mary, 'What offence have I made you that you should not use me at all times alike?' Mary's answer was short and bitter. She told him she would never again behave like a wife to him, sleep with him, or look on him with any kindness until he experienced the same pain she was now suffering.

Later, when her ladies arrived to comfort her, she did weep but quickly dried her eyes and uttered, 'No more tears now. I will think upon revenge.'

In the days that followed, Mary managed to muster all the emotional and physical strength she possessed. Darnley's feeble personality had descended into hysteria when Mary explained to him that neither of them was safe. Once Mary had planted the seed of his own demise, he started

to imagine his own horrific murder, realising that when his former allies found out he had turned his coat, they would seek retribution for his cowardice. Mary skilfully played on these weaknesses in order to convince Darnley that if they were both to avoid becoming prisoners at Stirling Castle, or worse, being murdered by the rebels, then escape from Holyrood was vital.

Was Mary showing compassion for her husband's plight or concern for his safety? What was more probable is that the privy stair from her apartments to Darnley's provided a concealed and clandestine escape route. By Sunday, Mary had cunningly been able to convince the nobles that in order to avoid losing her baby, she must be allowed to leave the palace. The nobles agreed to her removal, but only if she signed a document pardoning them. A bond was duly drawn up for her to sign the next day and the guard was relaxed in order that she could depart.

However, at midnight on Monday before the pardoning bond could be signed, the midwife assigned by the nobles for Mary colluded with her when she feigned an urgent pregnancy-related illness. Darnley and Mary then fled down the privy stairs, through the domestic passageways, and out into the night where Lord Erskine and others were waiting with the horses she had requested through Lady Huntley. The couple then embarked on a five-hour overnight dash to the safety of Dunbar Castle twenty-five miles outside Edinburgh. The ride took its toll on Mary. Not only was she sick several times, but her husband chided her to keep up, callously telling her that 'if she lost this baby, she could soon be pregnant with another.'

It took Mary nine days to recover her strength and muster support, so by the time she re-entered Edinburgh, she did so with her husband beside her and with an army of 8,000 men behind her. The nobles had failed to secure their pardons, and the rebellion had collapsed. Mary was back in the seat of authority, and with the impending birth of her child, her status as sovereign looked assured. Darnley, on the other hand, had the look of a whipped schoolboy. He had lost on all counts and was fast running out of cards to play. He was still only a king consort with no hope of Mary ever granting him the Crown Matrimonial. As for Mary, having now been victim to the very worst of Darnley's vile characteristics, began quietly discussing a way to divorce him without maligning her child's legitimacy.

At this point, for Darnley, his marriage being in tatters was the least of his worries. He knew that men who reneged on documented conspiracies with ruthless individuals, who were willing to commit treason and premeditated murder, had placed him in a precarious position and did not often live long enough to regret their actions. He had talked a tough game, but when push had come to shove, his shocking lack of guile or fortitude had been thoroughly exposed. He may not have known when the first strike of reprisal would fall or what form it would take, but he knew the time of reckoning was fast approaching.

As for Mary, still deeply cautious and fearing that she could still be the victim of a murder plot, moved herself to the impenetrable protection of Edinburgh Castle to await the birth of her child. For her security and peace of mind, she even asked the resolute monarchist, the Earl of Argyll, to take up residency in the room next to her own.

On the morning of 19 June 1566 after a long, difficult labour, during which Mary was allegedly forced to sniff pepper to expel the infant, she was delivered of a prince. The baby was named James and on delivery of the news to Elizabeth I, she sullenly replied, 'The Queen of Scots is lighter of a bonny son and I am but of barren stock.' Mary had triumphed over her rival in producing a 'very goodly child' who was male, of undisputable legitimacy, and whose parents were both the great grandchildren of Henry VII of England.

Prince James was left in the care of his nurse at Edinburgh Castle for the first few months of his life. That was until something unknown sparked paranoia in Mary that her son was about to be abducted by his father. She smartly returned to Edinburgh from her break at Alloa and had Prince James escorted by armed guards to the more secure fortress of Stirling Castle. Clearly the thought that Darnley could take possession of James, depose her, and rule in the child's minority was a chilling prospect.

The marriage was falling to pieces and, although on the rare occasions when they were together, Mary tried to keep up appearances; Darnley failed to exercise what little sense of propriety he possessed. On one occasion, he refused to enter Holyrood until Mary sacked her counsel. The only way she could end the outrageous scene he was making was to bodily pull him through the gates. Public arguments were new, but

Darnley's complaints were the same, and Mary's humiliation was turning to desperation.

His behaviour ranged from his usual inebriation to throwing childish tantrums and flying into jealous rages when Mary did not show him one hundred per cent attention in public. He was even threatening to leave the country and never return. These threats and outbursts made everyone's blood run cold. An unpredictable and petulant Darnley at home was bad enough, but never mind him being let loose in the Netherlands to set up a rival court. As the year wore on and he continued to randomly lash out, it was obvious to everyone that he was turning into a very unpredictable and dangerous liability.

Darnley was in such bad favour at court in December of 1566 that during the expensive and glittering three-day celebration of his son's christening, he brooded in his own rooms at Stirling Castle, while the Earl of Bothwell filled his shoes by welcoming the ambassadors. Everyone commented on his absence during the celebrations, but nobody missed his histrionics. Regardless of the baby's father not being present, the christening went ahead as scheduled in line with the Catholic rites, all apart from the fact that Mary would not let the priest wipe saliva on the baby's ears and nostrils. However, there is anecdotal evidence from experts at Historical Scotland that believe Mary forbade a more fundamental practice than this saying 'I'll nae have a poxy priest spitting in my bairns mooth' or in other words she doubted the hygiene of the cleric and didn't want him to spit in the child mouth.

Even before the December christening, Maitland was canvassing support amongst some of the prime Scottish nobles with regard to Mary divorcing Darnley. Even though the Darnley situation was intolerable, Argyll and Huntly both advised Maitland that if Mary divorced Darnley, leaving him at liberty could potentially allow him to wreak even more havoc than he was at present. Undoubtedly a more radical solution would have to be found for his removal. He had no difficulty convincing the easily combustible Earl of Bothwell of what was necessary. Bothwell hated Darnley with a passion and perhaps saw this as his chance to usurp Darnley's position as Mary's husband.

Maitland was treading a precariously thin line. He eventually obtained the support of Argyll and Huntly for the radical action in exchange for

parliamentary confirmation of their ancestral lands in undisputed perpetuity. The next step, however, was trickier still. When he tentatively broached separation from Darnley with Mary, she was open to the idea of a properly obtained annulment, which did not stain her reputation or her child's legitimacy. What she would not countenance was the idea of Darnley being tried for treason on fictitious charges that could lead to his execution. She baulked and sternly rebuked Maitland when he hinted that if the Earl of Moray objected to more extreme methods of dealing with the difficulty, he might be encouraged to just 'look through his fingers'.

The next person to join the plans for the removal of Darnley was the Earl of Morton. Even though the earl had received his pardon from Mary for his part in the Rizzio murder, his rage at Darnley's betrayal was still red raw. He had vowed to have his revenge on him and was heading home with unbridled murderous intent towards the queen's husband. Darnley, after all, had embroiled him in the Rizzio murder, deceived him by escaping with Mary, and had never shown any intention of honouring the bond he signed, agreeing that the plan to murder Rizzio was his alone.

While Mary remained in Edinburgh at Holyrood, her husband had taken to his sickbed in Glasgow. His insatiable lechery had finally caught up with him and he had a deplorable case of second stage syphilis that required a harrowing six to eight week course of treatment with mercury. Having Darnley out of her sight and located in the middle of Glasgow, which was a Lennox stronghold, was, in Mary's opinion, an extremely treacherous state of affairs.

She decided to go to her husband's side and arrived in Glasgow on 22 January 1567. She had already anticipated that convincing Darnley to return with her was going to be a challenge, and so she lied through her back teeth in order to persuade him to come back to Edinburgh. She whispered sweet words of love and promised that she would nurse him back to health. Mary sprang the final honey trap by telling her husband that once he was well, she would sleep with him again. Mary's cajoling worked perfectly and Darnley, at his own request, was installed at the Old Provost's Lodgings at Kirk o' Field just outside Edinburgh by 1 February.

By Saturday 9 February, the plotters had their victim right where they wanted him. They had gunpowder, which the fickle Sir James Balfour had already procured and then moved from his brother-in-law's house

next door. The conspirators had also put together a team of willing accomplices hiding in the cellar to bed down the lethal amount of explosive powder. So while Mary, Argyll, and Huntly kept company with Darnley on the second floor, the cellar and Mary's bedroom directly below were packed with the gunpowder that would later destroy the house.

Mary left the house at about 11pm in order to attend a wedding masque for two of her servants. Darnley having now recovered and feeling amorous, wanted her to stay and fulfil the promise she had made in Glasgow, but she was insistent she would not go back on her word to the newlyweds.

At approximately 2am, the slow fuses were lit and the Old Provost's Lodgings were razed to the ground. The 'crack' was so loud it woke Mary at Holyrood nearly three quarters of a mile away. The plot was successful in that Darnley had been killed; not by the demolition of the house, but by being strangled. Both Darnley and his close servant Taylor were found in their nightshirts, laid out on the ground under a tree on the outside of the city wall that ran directly behind the house. There were no marks on the bodies that suggested either man had been caught in an explosion. All that remained near the bodies were a chair, a length of rope, a cloak, and a dagger belonging to Darnley.

Of all the explanations put forward, the most plausible seems that Darnley, being alarmed by some commotion or usual disturbance in the house, decided to escape through a window using the rope that had been tied to the chair. Then, once on the outside of the city walls, they were accosted by the Douglases, who, although they were his mother's kinsmen, were still smarting from his duplicitous behaviour during and after the Rizzio affair. They promptly strangled Darnley, who according to witnesses, heard him cry out for his life – 'Have mercy on me, for the love of Him who had mercy on all the world.'

The effect of the murder on Mary's physical and emotional health was profound. Her first thought was that the plot was designed to have killed her as well, and much like her response after Rizzio's death, she feared the murders, having failed at their first attempt, would now be turning their attention to finishing the job. She once again removed herself to the unshakable security of Edinburgh Castle.

SEXUALITY AND ITS IMPACT ON HISTORY

On the 11 February, just one day after Darnley's death, Mary ordered an investigation into the crime. There were several reasons why it was imperative for Mary to find the truth without delay, the first being that the longer it took to apprehend and punish the murders, the more her anxiety would grow over her own safety. Another significant factor was the protection of her reputation. The lengthier the process with the conspirators still at large, the more her subjects were inclined to believe the gossip that she actually condoned, or worse, was complicit in her husband's death.

Ordering the investigation brought Mary into direct, if unspoken opposition with her Privy Council. The difficulty in conducting a credible investigation run by the Privy Council was that half the Privy Councillors were guilty of the crime, with the other half secretly condoning it. More obstacles were created when Bothwell, as the Sheriff of Edinburgh, forbade anyone to search the collapsed house for clues. He also issued orders that no one was to examine Darnley's corpse for evidence. These deliberate obstructions, together with the suppression of eyewitness testimony and the destruction of evidence, made the process impossible. There simply was no appetite or benefit to anyone other than Mary in capturing and administering justice on the perpetrators of the crime.

The only serious attempt to bring Bothwell to justice was made by Lennox. The queen, his daughter-in-law, granted him permission to bring a private petition before Parliament on 12 April. The wily and cunning Bothwell knew that for the trial to have any chance of success, Lennox would have to appear personally before Parliament to pursue his case. So in order to intimidate Lennox, Bothwell had 4,000 men loyal to him pack the town of Edinburgh. Needless to say, Lennox, who was outnumbered and outmanoeuvred, saw the danger and did not present himself at the trial. The case inevitably failed and Bothwell was publicly acquitted, even though one observer commented that 'it was heavily murmured that he was guilty thereof'. Bothwell had escaped justice and the next part of his plan was to take possession of Mary in marriage.

The first step in Bothwell's plan to become King of Scotland was to garner support and then have the Scottish nobles and bishops sign a bond, which amongst other things, promoted a match between himself and the queen. Known as the Ainslie Bond, it contained clauses such as 'destitute

of a husband in which state the commonwealth may not permit her to remain'. A further example was '… and his other good qualities might move the Queen to select him as a good husband'. One or two present may have had misgivings about promoting such a recklessly aggressive man to kingship, but eventually all signed except for Atholl, Maitland, Moray, and Argyll. In signing, they agreed that Bothwell was innocent of Darnley's murder and that they would support and promote the match. This was all the encouragement Bothwell needed to press on with his plan.

Mary, on the other hand, was showing signs of mental fatigue. The back and forth drama played out by her fractious and deceitful nobility was perhaps one of the reasons why she was allowing Bothwell's advances. She confessed later in a letter that she felt the only way she could contain the divisions in her realm was to have her authority fortified by a man. Bothwell was nothing if not an authoritarian, but he lacked the ability to know when to back off. He was rash and often engaged his brawn before his brain had time to assess the situation and it made Mary uneasy in his company.

The accord between Bothwell and Morton did not last and, by April, they had rekindled their old enmity. This time, the bone of contention was the terms of the Ainslie Bond. Both Argyll and Morton were disgruntled that Bothwell was attempting to set himself up as King. Bothwell, for his part, knew that if he did not act quickly, support for his proposed marriage from the other signatories could rapidly vanish.

The crunch for Mary came on her journey home after visiting Prince James at Stirling Castle. She unwittingly kissed her infant son for the last time and left Stirling on the morning of 24 April. She was four miles outside of Edinburgh and about to cross the River Almond, when Bothwell appeared at the head of 800 men. After inventing a tale of impending danger in Edinburgh, Bothwell took Mary's bridle and escorted her to Dunbar Castle, where the gates were securely locked behind her.

Having so far been unable to obtain Mary's consent to marriage because of his suspected involvement in Darnley's murder, his remedy was to employ a more compelling and brutal method of persuasion. Knowing her disposition well, he did not shrink from carrying out a

despicable act of violence. He guessed correctly that once he had violated her honour by raping her, she would have no choice but to marry him. Of course, as was the way in Scotland, rumours were circulating that this story had been fabricated by Bothwell and Mary in order to spare the queen any derogatory comments or difficult questions about why, after a period of just under three months, she had married one of her previous husband's murderers.

Mary and Bothwell returned to an Edinburgh in uproar over her forced marriage and captivity. Matters were made even more tense when Bothwell's existing wife made no objection whatsoever to the dissolution of their union. The divorce was granted on a belt and braces basis. The Protestants ruled in favour of Lady Bothwell because of her husband's adultery with Bessie Crawford, one of Lady Bothwell's maids. The Catholics opted for divorce on the grounds of an improper dispensation between two people within the forbidden bounds of affinity. Both judgments were a ridiculous scandal. If Bothwell had committed adultery with Bessie Crawford, then surely the queen had also committed adultery with him. Equally on the Catholic side, the cleric who gave the original dispensation also granted the divorce on the grounds that it was improper.

While most people grumbled behind their hands one cleric, John Craig, voiced his view of Bothwell's behaviour directly to the Privy Council and refused point blank to officiate at the wedding:

> 'I laid to his charge the laws of adultery, the ordinance of the Kirk, the law of ravishing, the suspicion of collusion between him and his wife. The sudden divorcement and proclaiming with the space of four days and the last suspicion of the King's death with which the marriage would confirm.'

Predictably, Bothwell's response to these commonly held opinions was a threat to hang the Minister. Despite Bothwell's protestations, this was an opinion widely held by all strata of society with the responsibility firmly placed at Bothwell's door.

Although the nobles at Stirling had bonded together to free the queen from Bothwell's clutches, to protect Prince James and pursue Bothwell as the chief defendant in the murder of Darnley, the Protestant marriage service went ahead as planned in the Great Hall at Holyrood on 15 May.

There was no levity, no banquets or masques. Mary's wedding clothes were fashioned from old clothes, which had been altered and amended for the occasion. There were no lavish gifts from the bride to the bridegroom.

There was to be no honeymoon period to this marriage and Mary was thoroughly despondent from the beginning. She cried and fought with Bothwell on a daily basis and on one occasion she was so overwrought she asked for a knife to stab herself, and on another threatened to drown herself. For the devoutly Catholic Mary to be threatening suicide is a clear indicator of the revulsion she felt at her current circumstances.

There were incessant disagreements or 'jars' when Bothwell used language so foul about the activities she took for her pleasure, that the English Ambassadors refused to commit it to the paper in their dispatches to Elizabeth and Cecil. Bothwell complained bitterly about the gifts she gave to other people and Mary wept continually at the thought of how he humiliated her by continuing to keep company with his ex-wife Jean Bothwell.

Within a month of the wedding, Mary, Bothwell, and the Confederate Lords were edging closer to a showdown and it ultimately came on the sweltering hot day of 15 June at Carberry Hill, just two miles outside Musselburgh. Both armies arrived at the site with similar numbers and there ensued acrimonious verbal back and forth where the Lords offered to desist if Mary would surrender the felon who had murdered Darnley. Mary then made a counter offer that she would pardon all concerned for their rebellion if they gave up their claims and their treason against her.

As the drawn-out negotiations continued well into the day, dehydration, blistering heat, and the poor strategic position of Mary's troops caused her forces to gradually dwindle. By the time Bothwell had stopped belligerently offering single combat and all parties realized that the negotiations were futile, Mary's forces only numbered approximately 400. Knowing there was no way she could win, she surrendered to the Lords on the terms that Bothwell would be allowed to escape and go into exile. The compromise was accepted. Mary, in effect, became their prisoner and she never saw Bothwell again. Bothwell escaped to Norway, was imprisoned for past misdemeanours, and died in a state of insanity ten years later.

SEXUALITY AND ITS IMPACT ON HISTORY

The Queen was taken back to Edinburgh that day and lodged at the Provost's Lodgings. The next day, a warrant was issued for her arrest and she was committed to the castle at Lochleven in Fife, where, weakened by her various ordeals, she lost the twins she was carrying. More misery was to come when she was forced to sign documents in which she gave up her throne in favour of her infant son, made Moray regent, and appointed Morton et al. as temporary governors until Moray arrived from France. Her spirit held and she refused to sign until Lindsay, the man who had previously held a pistol to her pregnant belly, threatened her with either death by drowning or a slit throat.

However, Mary, Queen of Scots was not done yet and, with the help of a young man named Willie Douglas, Mary managed to escape the clutches of her jailors by having Willie steal keys and row her across the Loch in the only boat that had not been stealthily sabotaged.

After issuing a rallying cry for troops at Hamilton, Mary advanced towards Dumbarton and eventually engaged her enemy at Langside near Glasgow. She was making a brave stand to recover her kingdom from Moray. Unfortunately, the attempt failed and Mary made the rash miscalculation of fleeing to England in the hope that her 'dear sister' Elizabeth would assist her. Had she been able to escape to France where she had money and lands, she might have retained her freedom.

The plan of asking Elizabeth for help was a spectacular backfire and in the years to come, Mary became the focus of every Catholic plot to depose Elizabeth from the throne of England. The issue of what to do with the Scottish Queen was a very prickly one for Elizabeth. On one hand, Mary, like herself, was a God-anointed Queen and therefore not her own subject to command. On the other hand, as Mary was often suspected of colluding with Elizabeth's own treasonous subjects who were trying to either depose or assassinate her, Elizabeth's position was never safe while Mary was alive.

After nineteen years of close imprisonment, Mary made her last and fatal attempt to take the English throne when she exchanged incriminating letters with a young Catholic named Antony Babington. The letters detailed a plot to murder Elizabeth and have Mary take her place. They were intercepted by Elizabeth's spymaster, Sir Francis Walsingham, and signalled the end for Mary. At her trial, she was found guilty of treason

and executed on 8 February 1587 at Fortheringhay Castle. There was no quick dispatch for Mary and the executioner took three attempts to remove her head. Perhaps even more macabre was the fact that Mary's little terrier dog had, in a final act of loyalty and companionship, hidden himself under his mistress's clothes. The poor little animal had eventually to be boldly lifted away from Mary's bloody corpse.

In the early hours of the morning before her death, Mary wrote to her former brother-in-law, King Henri in France, stating that she was dying for her Catholic faith and that if she had her choice, she would wish to buried in France where she had the honour of being queen. She also mentioned her son, who she had last seen at Stirling when he was ten months old: 'As for my son, I commend him to you in so far as he deserves, for I cannot answer for him.'

Although her son James did not intercede or plead for her life, he did ascend to the English throne in 1603 as King James I of England. Perhaps we have an insight into how he felt by the tomb he built for his mother in Westminster Abbey, which far outstrips the opposite tomb of his predecessor Elizabeth I.

When all is said and done, Mary Stuart was a woman who, for the first eighteen years of her life was feted and spoiled, and unlike her cousin Elizabeth in England, never knew one moment of anxiety. The graceful and beautiful young widow who returned to govern the lawless and continually self-destructing Scotland had never needed to cultivate any political survival instincts and it allowed self-serving and unscrupulous individuals to play on her naivety.

Undoubtedly, as all humans do, she made huge mistakes, but as we are all a product of our nature, upbringing, and environment, perhaps we can look through time and sympathize with a woman who was far from loved and cherished as all human beings deserve, was pushed around from pillar to post, and cruelly used by men who either wished to usurp or bask in the right of sovereignty that an accident of birth had given her.

Chapter 7

Succession, Confusion and Ramifications: Who Should Wear the Crown?

Dr Beth Lynne

The Succession to the Crown Act 2013 in Great Britain ended succession of the first-born male, allowing an older sister to attain the crown of a monarch. Previously, the first-born daughter was placed behind her younger brothers, unless, of course, as in the case of the current Queen Elizabeth II, there are no brothers. Under the recently proposed law, the Princess Royal, the Queen's daughter, is placed twelfth in the line of succession behind the Prince of Wales and his two sons and will only drop further with more births, as it will not matter if Prince Harry has sons or daughters if he does ever procreate. Previously, the princess was tenth. The Duke of York, who was fifth, dropped to sixth. This act also allowed those who married Roman Catholics to remain in line for succession (originally enacted to avoid papist philosophies from entering the realm) and enabled those who were outside of the line of succession by six or more to marry without permission from the sovereign.

The old rules of succession, had the new rules been applied, might have created a different history in England. Imagine if Henry VIII had not succeeded his father, Henry VII, since his sister Margaret Tudor was older than he was. There might have been no break with Rome over Henry VIII's divorce, Catherine of Aragon would have been just another widow (from her marriage to Arthur), and Anne Boleyn might have lived to be an old woman!

Through history, scandals and mishaps abound due to the rules of

primogeniture and succession. In this essay, a brief look at the reigns of some of the Tudors—Lady Jane Grey, Mary Tudor, and Elizabeth Tudor—will illustrate some of the confusion that resulted from unclear succession rules.

For such a short reign, nine days in all, in July of 1553, much controversy has arisen. Bloggers still argue about what a difference Jane could have made, had her reign not been, quite literally, cut short. Certainly, with her devout Protestant leanings, Jane could have altered the course of history had she maintained the throne. But the fact remains that her ascent to it was the topic of much strife, and wrongly or rightly, the outcome remained the same, causing echoes through the history of England.

Jane was born in 1537 in Leicester. Her parents were Henry Grey and Lady Frances Brandon. She was their eldest daughter and the great-granddaughter of Henry VII. At age ten, Jane went to live with Thomas Seymour – a rather scheming bastard and brother of Jane Seymour, Henry VIII's third wife – and Catherine Parr, the recent widow of Henry VIII and new bride of Seymour, presumably to receive a good education as well as to possibly secure a match through Seymour for Jane to Edward VI. It was most likely here that Jane developed her religious leanings, as Catherine was a devout Protestant, verging on what was often seen by the court as heresy.

Catherine Parr died on September 5, 1548, six days after giving birth to a daughter, Mary. Jane stayed on with Thomas Seymour, but he was beheaded in 1549 for treason. Jane returned to her family, who persuaded her to begin to pay attention to her social life rather than her studies. They wanted her to marry, and to no less than the young king, Edward VI, close to Jane's age, a devout Protestant, and a cousin. However, Edward was, by 1552, very ill, and it would not be likely that he would wed any time soon. John Dudley, the Duke of Northumberland, King Edward's most trusted advisor, assisted in arranging Jane's marriage to his unmarried son, Guildford.

Jane was, by all reports, not happy with this marriage, presumably due to her fear of John Dudley, but she also possessed a common goal with Dudley. They were both devout Protestants and had no desire to see a Catholic on the throne, such as Mary Tudor, King Henry VIII's daughter

by Catherine of Aragon, Henry's first wife, whom he had divorced. Princess Mary was recognized as illegitimate by Parliament, as was her half-sister, Elizabeth, daughter of Ann Boleyn.

The dying Edward VI was of the same mind as Dudley and Lady Jane. He was also a devout Protestant and wanted to keep Mary off the throne. This would involve disregarding the will of his father, who specified the succession of Edward, then Mary, then Elizabeth, then the Grey line (Frances, Jane's mother, then Jane herself). Edward's 'Devise for the Succession' named Jane Grey as his successor. Edward died soon after and Jane ascended to the throne. She was fifteen years old at the time.

Public outcry was ferocious, as the original succession acts by Henry VIII were cited, and the demand for Mary to take her rightful place on the throne was called. Even Jane's father turned against her and joined in the fray to have Mary claim the crown. He was seen as insincere, however, and eventually executed for treason. John Dudley was also executed, and Jane and her husband, Guildford Dudley, were imprisoned in the Tower of London as Mary took her place as Queen. When Jane condemned Mary's reinstatement of Catholic mass at the court, Mary decided to suppress as much political opposition as she could and had Jane and her husband executed.

For that nine-day reign, so much drama has ensued and remained over the centuries. Certainly, in such a short reign, from such a young ruler, there was not much influence on arts and culture, but the speculation continues.

In a blog from AlternateHistory.com, speculation in this forum, https://www.alternatehistory.com/forum/threads/queen-for-more-than-9-days.303852, goes back and forth regarding Jane's brief reign.

A comment from 'Evan' goes as follows:

'Jane was an extremely staunch Protestant; among the few things she did during her nine-day OTL (original timeline) reign was make plans for more firmly establishing the Reformation in England. If she manages to stay on the throne, and if she manages to gain personal power despite her uncle-by-marriage Northumberland (both of which are long shots.)., I'm almost certain that would be the single hallmark of her reign.

SUCCESSION, CONFUSION AND RAMIFICATIONS

'To emphasize how strong her faith was: In OTL, after issuing the execution order, Queen Mary offered to let Jane live if she professed Roman Catholicism. Jane refused. (Evan, Jan. 22, 2014)'

This writer states that Mary might have let Jane live if she would have embraced Protestantism; certainly this was not possible. Although young, Jane's hallmark was her religious zeal. It was highly unlikely that she would truly embrace another religion. Had public support been behind her, the history of England would have been infinitely different, right down to the settling of the New World, where Protestants fled to escape religious oppression in the early 1600s. Additionally, along this line (of succession), Henry's will identified the Grey line as successors to the crown if Mary and Elizabeth died childless. This is indeed what occurred, and so had Jane and Guildford survived, would their children have succeeded the Tudors?

In the same forum, Nytram01 states:

'She was never Queen at all. She was never crowned and without going through a coronation she was no more a monarch of England than Louis VIII of France was. And when Mary was crowned Queen, the nine days Jane claimed to be Queen were recognized as unofficial and merely the proclamations of a usurper. I'm sorry, but it's an issue that annoys me greatly.' (Nytram01, Jan 21, 2014)

Sentiment often turns toward Mary Tudor, the Queen who earned the moniker of 'Bloody Mary,' although this name was attributed to her after her death. Speculation that Jane would have been just as 'bloody' often abounds.

Mary Tudor, half-sister of Henry VIII, was not only a devout Catholic at the time of much religious unrest in England, but also, through the Acts of Succession, next in line for the throne of England when Henry passed away in 1547. Unfortunately for Mary and her supporters, as seen in the preceding section, this was not to be. When Jane Grey refused to yield to Mary's request for her to renounce her religion and practice Catholicism, Mary had Jane executed.

Once again, as with Jane's reign, Mary's was also controversial.

SEXUALITY AND ITS IMPACT ON HISTORY

Speculation abounds to this day, as seen in this forum: http://historum. com/speculative-history/121804-saving-lady-jane-grey.html A writer identified as Cmbanalia posted:

> 'I bet if Jane stayed queen, Mary would [have] rebelled, had Jane won, her being a stout Protestant, Mary would [have] gone to the gallows. Many people would [have] been saved from Bloody Mary's tyranny' (2016).

It will never be known if this would have come to pass, but it is worth noting.

Mary's mother, of course, was Catherine of Aragon, Henry VIII's first wife. Mary was the only one of their children to survive into adulthood. Born in 1516, she was betrothed in marriage to her cousin Charles V in 1522, but that fell through when he married Isabella of Portugal. Mary was named Princess of Wales in 1525 by her father, who continued to try to negotiate a marriage for her while also attempting to produce a male heir for the throne. Frustrated by the lack of sons, Henry had his marriage to Catherine annulled on the basis of incest (Catherine had been married to Henry's dead brother Arthur), after breaking ties with the Catholic Church, and established the Church of England. He married the infamous Anne Boleyn, who pushed for Mary to be declared illegitimate and stripped of her title after the birth of Elizabeth. This move ultimately backfired on Anne, who was not around to suffer from it, being beheaded in 1536. Mary was denied access to her parents and never saw her mother again, although she was reunited with her father later in his life.

It was Henry's third wife, Jane Seymour, who urged the King to mend fences with his daughters Mary and Elizabeth, after giving birth to the King's only son, Edward VI. Henry agreed to do so only if Mary would recognize Henry as the head of the Church of England and also accept her illegitimacy. Mary was reluctant to comply to either of these demands, but in a time of beheadings and life imprisonments, it seemed as if she would have had little choice. She obeyed, but was marked as a source of religious conflict, which stuck with her throughout her eventual reign as queen.

Had Edward VI survived his teen years, no doubt Mary would have remained the strange old auntie who embraced Catholicism in a family

of Protestants, since Edward would have undoubtedly married (perhaps Jane Grey, even) and had several offspring eligible for the throne. Much of the speculation and alternative scenarios result in the issue of Protestantism versus Catholicism, and the Catholic movement being vanquished, which affects papal succession and the modern-day configuration of Rome, but that is another chapter in history altogether.

However, Edward's future was not to be, and due to his 'Devise for the Succession,' Mary was completely passed over in succession, although her popularity among her supporters allowed her to take the throne and depose Jane Grey. From here, Mary had few goals: re-instate Catholicism in England, re-legitimize her parents' marriage and thus her own legitimacy, and marry a suitable man to produce a Catholic heir. Otherwise, the throne would revert back to her sister Elizabeth, a Protestant.

Enter Philip II of Spain.

In 1553, Mary Tudor took the throne as Mary, the first crowned Queen Regnant of England, a queen in her own right. Rather than taking the advice of her counsellors, Mary left the issue of her marriage to Charles V, her cousin and former 'fiancé'. He felt that his thirty-seven-year-old cousin Mary would be an appropriate match for his son, Philip II, eleven years her junior. Mary was not sexually attracted to Philip, or anyone else for that matter; having been bounced around to potential marriage partners since infancy, then stripped of her title and rendered unsuitable for marriage at the age of seventeen left a mark on the woman, but her desire to produce a Catholic heir overwhelmed her distaste. The English people would not allow a foreign male consort to rule with their queen, particularly from the historically Catholic Spain, and rumours of Philip's infidelity caused by his constant journeys away from England (perhaps having to do with added responsibility from his father's abdication) fuelled the flames of gossip.

During the next few years of Mary's reign, following her marriage to Philip, several 'heretics' were burnt at the stake for their crimes against Catholicism. It was for this period that Mary earned her nickname of 'Bloody Mary', having approximately 300 Protestants killed. One wonders, however, what would have happened had Jane stayed on the throne. There might have been a larger loss of life in a resulting Catholic

versus Protestant war than Mary could ever manage to put to death.

Mary was still desperate for an heir. She presumably put aside her distaste for her husband and claimed that she was pregnant. Rumours of the birth of a son abounded throughout England and France, and crowds celebrated. These rumours were squashed once the infant was not seen and Mary claimed she was still pregnant and had miscalculated. However, once too much time had passed and no child appeared, the pregnancy hopes were abandoned by all.

It is unclear what Mary I actually died of – uterine cancer, which may have been the cause of her belief that she was pregnant for a second time, copying the symptoms of pregnancy or influenza, or even stomach cancer – but she did die on November 17 1158 at the age of 42. Had she produced an heir, perhaps that would have resulted in the death of her younger half-sister Elizabeth.

Elizabeth, Mary's half-sister through Henry VIII's second wife, the unfortunately beheaded Anne Boleyn, was two years old when her mother suffered her fate. She grew up, after much controversy, to be one of the most powerful and successful monarchs to rule England, during a reign of forty-five years.

As noted previously, Mary I died without an heir to the throne. Perhaps weak from her illness, she conceded that Elizabeth was rightfully the next in line, even after having imprisoned Elizabeth for a year under suspicion of harbouring Protestant rebels. Elizabeth's life up to that point had been fraught with upheaval and uncertainty.

On her father's remarriage, Elizabeth was declared illegitimate by her father and had a few stepmothers until her father's death in 1547. It was Henry's widow, Catherine Parr, who took Elizabeth in and educated her, with deeply Protestant learning. Catherine was responsible for uniting Mary and Elizabeth. Catherine also had been in love prior to marrying the King with Thomas Seymour, the brother of Elizabeth's father's third wife, Jane Seymour, an unscrupulous man who gave Elizabeth a little too much attention. It was rumoured that his behaviour with fourteen-year-old Elizabeth was somewhat inappropriate and when Catherine became pregnant, Elizabeth was sent away, possibly for her own safety, as evidence of letters between Catherine and Elizabeth that were warm and loving were exchanged. Catherine died after childbirth and Thomas began

to pursue Elizabeth as a suitor. This suit was rejected and a scandal erupted. Seymour was eventually executed for treason in 1549. Presumably, this scandal affected Elizabeth throughout her life and she remained unmarried and publicly a chaste, devout Protestant.

Elizabeth received a first-class education throughout her childhood and was known to be extremely intelligent, benefiting from not only the lessons provided by tutors and Catherine Parr, but also the teachers of her brother Edward when she visited at court. Edward and Elizabeth got along very well, both staunch Protestants and with similar political interests. While at court, men would often attempt to take advantage of Elizabeth much in the same way as Thomas Seymour had, as well as for political gain. Those who attempted to sway her politically were those who landed her in trouble with her half-sister the queen. Elizabeth's intelligence often kept her out of worse trouble and most certainly helped her remain alive at the hands of 'Bloody Mary.' Even though Mary did not have Elizabeth executed, she could not persuade Elizabeth to convert to Catholicism.

Once Elizabeth ascended the throne, she made the Church of England the official religion of England. Some tenets of Roman Catholicism were incorporated to prevent further turmoil in the country. Later, however, she became a little less understanding as plots were uncovered to place a Roman Catholic queen on the throne.

Elizabeth was known as the Virgin Queen, since she was never married and therefore assumed to be chaste all of her life. She was pressured by Parliament to marry to produce an heir, but she refused even though she received many proposals. However, she was rumoured to be more than friends with her childhood friend, Robert Dudley.

Dudley often purported to know Elizabeth better than anyone and said that she professed to never marry from the age of eight. At the time that Robert and his brothers were imprisoned for their father's attempt to grab the throne for his daughter-in-law (Jane Grey), Elizabeth was being held in the Tower of London as well. It was assumed that the two were carrying on a relationship at this time, although it should be noted that they were heavily guarded and it was not likely much was going on between the two friends. Speculation later led to rumours that Elizabeth and Dudley conspired to kill Dudley's wife, Amy, having become close at this time.

Robert Dudley was married to Amy Robsart in 1555. It was said to be a love marriage rather than an arranged one, but he lost interest in Amy when his feelings for Elizabeth became stronger. In 1560, Amy was found dead at the foot of the stairs of her home. She had been believed to be suffering from breast cancer and depression, perhaps aggravated by rumours of Robert and Elizabeth's alleged affair. It is possible she might have committed suicide or fallen by accident, but it is also possible that Robert murdered her, as evidence from coroner reports may indicate. It is widely believed that Robert poisoned her to be with Elizabeth. Modern controversy abounds, with much theory and conjecture surrounding Amy's tragic and suspicious death. For example, one blogger commented on this same forum:

'Amy had two head wounds. The ORIGINAL report says that one of them was "two thumbs deep". This is an incredibly bad head injury to sustain simply by falling down some stairs; she was obviously hit over the head. And Elizabeth DEFINITELY is historically recorded as telling the Spanish ambassador De Quadra that Amy was dead—the DAY BEFORE Amy actually died! And whilst Lord Dudley was certainly not stupid, he WAS ruthlessly ambitious. And ruthless ambition often makes people do stupid things! Amy was dying, but perhaps not fast enough for Dudley' (Jade, 2012).

But others disagree: Stevie, from the same forum, commented September 6, 2012:

'I don't think Dudley had anything to do with Amy's death. Say what you might about the man, he wasn't stupid, and he knew Elizabeth well. She would never have risked her reputation or her crown to marry a man who would be assumed a murderer, whether he'd killed his wife or not. Besides, if Amy was as ill and depressed as various people claimed, all he would have had to do is wait for her to die naturally.'

Yet another blogger commented with:

'Robert Dudley had to have known that "doing away" with his wife would certainly not have made Elizabeth any more enamored of him. In fact, I think he would have really risked her ire, her mistrust of him, and her sorrow. She was a Queen of the people... and I believe that included ALL of the people of England.' (Patricia Getz, 2012).

Indeed, Elizabeth was a well-loved monarch, and it seems farfetched that she might be part of a murder plot, thus risking her reputation and the crown. She publicly distanced herself from Dudley to keep the whiff of scandal away from her. In private, however, they remained close friends although their friendship suffered a great blow in 1578 when Dudley began an affair with and eventually secretly married a grand-niece of Anne Boleyn's, Lettice Knollys.

In 1588, Robert Dudley became very ill and eventually died later that year. Elizabeth missed him terribly throughout the rest of her life. Following Dudley's death, Elizabeth's court and contemporaries began to die, and she herself experienced failing health as well, but still continued to attend to the business of running England. Finally, she wore down and died, naming her third cousin James VI of Scots as King James I of England, thus ending the Tudor line and beginning that of the Stuart.

The Tudor line died with Elizabeth I, paving the way in 1603 for a new bloodline, the Stuarts, who stayed in power until 1714, ending with Anne's death, when the Hanover line took over, as all of Anne's heirs predeceased her. This line ended in the United Kingdom with Queen Victoria, who ruled from 1837-1901. Since 1917, the British royal family have borne the name Windsor, a change from the Saxe-Coburg and Gotha adopted by Edward VII, to take into account anti-German feeling in the country during the First World War.

Chapter 8

Lips of Flame and Heart of Stone The Impact of Prostitution in Victorian Britain and its Global Influence

Hunter S. Jones

In Victorian Britain, where madams and pimps were able to thrive in society and culture like never before in history, prostitutes and courtesans influenced art, and fashion with their enormous wealth and conspicuous spending. The Victorian Era was a historical period in search of sexual fulfilment during a time of social constraint. Ladies of the evening—from the highest echelons of society; the kept women, the sex-workers in 'houses of pleasure', down to the street walkers and common whores all had a place in the working world. The royals, and the rich and famous idled away their time—and money—on their peccadilloes, wild excesses, and inadvertently set the stage not only for the independent woman of the twentieth century but for the rise of celebrity status in popular culture. London became the focal point of business and opportunity. The city became an underground world in which the sexual repressions of the era led to a seamy underworld of depravity and licentiousness. Sex became a commodity.

The sun never set on the British Empire during the reign of Queen Victoria. The world had rarely known a woman to be such an influence on the cultural standards of her time. She influenced fashions, food, and standards of etiquette and was seen as a role model of morality and intellect in and around the world. The young Queen's choice to wear a

white dress at her wedding to Prince Albert in 1840 set the standards for weddings into the twenty-first century. With women following styles set by the young Queen, it is easy to understand how she set the tone for female behaviour across the globe.

Queen Victoria spent sixty-three years on the throne as the British monarch. Her reign from 1837 to 1901 is named the Victorian Era or Victorian Period. This period coincides with the peak years of the British Empire and was characterized with the rise of new artistic styles and literary schools as well as political and social movements.

England was a small, moderately wealthy country until the rule of Queen Elizabeth I changed history. Once the New World was discovered, the country and its queen utilized its naval advantage in order to establish colonies and trading companies. Eventually, it became a world power to be reckoned with. The citizens of the small country began to move to these foreign parts of the world. North America, Australia, and South Africa are prime examples of where these colonies began to claim a foothold, and consequently, vast wealth for England. Trade in the colonies of India, Africa, and the Caribbean were established. As England evolved into Great Britain, the colonies provided inexpensive raw materials for industry. By the time of Queen Victoria's death in 1901, Britain ruled approximately a quarter of the world, in both land and population. It was the largest empire the world had ever seen.

Great Britain was the cradle of the Industrial Revolution. The nation's prosperity continued throughout the reign of Queen Victoria. Many people believed in the moral standards of the Victorian ideals. Queen Victoria and her beloved Prince Albert set the tone for virtuous morality and values, which applied to all aspects of Victorian living. The era was marked by medical and technological advancements due to changes in population growth. During this period, industrialization made the country the richest in the world. Victoria's reign is regarded as the Golden Age of the Empire. This led to an immense wealth being accumulated by the upper classes at the centre of the Empire and to British society becoming divided; a working class emerged and urbanization increased.

The division between classes in the late eighteenth and early nineteenth centuries defined a woman's role, giving her no alternative but

the station to which she was born or which fate placed before her. Society was divided into class segments. A general overview of the divisions include Nobility, Gentry, Middle Class, Artisans and Paupers. Women of each class had their own specific standards and roles. They were expected to maintain these standards and not rise above their class standards and traditions.

The highest class was the nobility and gentry, who inherited land, titles, and money. They were expected to manage the home/estates and the households. A young woman from the late 1800s is noted as saying, 'Ladies were ladies in those days; they did not do things themselves. They told others what to do and how to do it.'

This lifestyle allowed for much time for entertainment in the form of formal parties and society balls, with the lady of the house serving as planner and hostess. Once a woman was married, her role was considered manager of the household, and she had less time to spend with friends. Though the life and trappings of an upper-class female might appear secure, that was not always the case. Land, titles, and money were inherited by the closest male relative—typically the eldest son. If there was no son to inherit, then the estate would go to a more distant male relative. As a result, many mothers and daughters were left extremely poor after the death of a husband and/or father. This inability to inherit and own property will be extremely important later in the century as Prime Minister William Gladstone's government passed legislation that reduced many of the legal inequalities between men and women via the Married Women's Property Act of 1882. After that, married women could own property inherited from a parent. The passing of the 1893 Married Women's Property Act completed this process, giving married women legal control of property which they owned, purchased or inherited.

Next in line was the middle class, consisting of physicians, factory owners, proprietors, and businessmen. Like their queen, these Victorians were in favour of strict morals, hard work, and correct societal etiquette and behaviour. The middle class could read, write and afford to purchase newspapers, magazines, and novels. Their prosperity challenged the status quo of the aristocracy and upper class in setting the political and economic agenda.

160

Women of this class were much like women of the upper class, although their family land holdings were not as extensive nor was the wealth as extravagant as the aristocracy and landed gentry. Women of the middle class held ambitions to 'marry up' into the upper classes, thereby gaining social prestige and wealth. The middle class was a broader social spectrum. It included everyone between the working classes to the lower gentry. Status was measured by how a family's money was obtained. Hence, some unmarried females might work in the family shop, while others might serve a role much like a woman of the upper classes.

Another distinction was women who were employed in jobs that took skill or thought, as opposed to physical labour. Women of this class often found positions in shops, or as bookkeepers. Often, these women were former upper-class women who had fallen into poverty due to the death of a father, husband, or brother. Many of these women became governesses to families to which they had previously held the same station.

One strata of society included the desperately poor, typically single women of the Victorian era. Most women were pronounced 'able-bodied' under the New Poor Law in 1834 and sent to work alongside 'lower' working class men in the factories and other places offering jobs of inhumane physical labour. Poor women were expected to work to support themselves. Another field of employment for this group was domestic service. Even the lowest middle-class family had at least one or two servants.

At the bottom of the system were the unemployed, destitute people in the city slums, a criminal class consisting of thieves, pick-pockets, and prostitutes. This group endured overcrowded accommodations in the cities, with no sanitary facilities. Child labour was common in early Victorian England. The workplaces were unregulated and the workers faced dangerous conditions in factories and mills. Crime and prostitution flourished in the teeming underworld of the more populated areas.

Where there are people with money and needs in a society, historically, prostitution has always been an option. However, with its increasing number of social problems and the rise of the middle class with their ideals of domestic morality, it was the Victorian Era that saw prostitution become a challenge in Great Britain, especially in London. In 1861 a new

volume added to the original 1851 edition of *London Labour and the London Poor* by Henry Mayhew mentions the rising dilemma. Mayhew's sociological articles collected in three volumes in 1851. A fourth volume was released in 1861 co-written with Bracebridge Hemyng, John Binny, and Andrew Halliday, on the lives of prostitutes, thieves, and beggars. This volume took a more general and statistical approach to its subject than Volumes One to Three. He wrote in Volume One: 'I shall consider the whole of the metropolitan poor under three separate phases, according as they will work, they can't work, and they won't work.'

Mayhew interviewed beggars, street-entertainers, market traders, prostitutes, labourers, sweatshop workers, mudlarks who searched the mud on the banks of the River Thames for wood, metal, rope, and coal from passing ships, and pure-finders, those who gathered dog faeces to sell to tanners. He described their clothes, how and where they lived, their customs, and made detailed estimates of the numbers and incomes of those practising each trade. The books make fascinating reading, showing how precarious lives were in the richest city in the world.

This is his definition of prostitution:

'Prostitution, professionally resorted to, belongs to the latter class [obtaining a living by seducing the more industrious or thrifty to part with a portion of their gains], and consists, when adopted as a means of subsistence without labour, in inducing others, by the performance of some immoral act, to render up a portion of their possessions. Literally construed, prostitution is the putting of anything to a vile use ... specially so called, is the using of her charms by a woman for immoral purposes.'

The rise of the middle classes appears to be the reason for the shift in Victorian morality. The aristocracy had long defied conventional morality; now the new money of the middle classes was attempting to model their behaviour on the upper classes, with the working classes taking their cultural cues from the upwardly mobile middle classes. The early Victorian period saw a distinctive culture of intimacy in which love and sex were considered the ideal and the essential state of marriage. But the later Victorians desexualized love and de-sensualized sex. As power and wealth of the middle classes increased, they sought not only to emulate

the unconventional sexual morals of the aristocracy and gentry, but at the same time present themselves as the epitome of sexual norms. It was a time characterized by a double standard of sexual morality benefiting the males in society, and a hypocritical attitude in public and private behaviour. For them, the passionless reproductive wife confined to private domesticity was the visual side of society while the husband was publicly conducting business. Yet privately, he was allowed to discover ways to satisfy his sexual needs. Polarization of public and private spheres became the foundation upon which the ascendant bourgeoisie constructed the family and its role.

Closer inspection reveals the darker side of society: the rampant prostitution including child prostitution; perversions—mainly rape, child abuse, ritual flagellation in public schools, the cult of the young girl, and pornographic production and distribution. Forces were at odds with the prevailing sexual mores of English society during the nineteenth century, a cauldron of ever changing attitudes and beliefs.

Changes came to women in the private sphere just as they hit men in the public realms of business and society. These shifts impacted the choices of women at home, at work, and on the streets. It was not a good time to be a woman. Women were caught in the constrictions of middle-class morality. For a woman to live an independent life meant that she was cast out by a society that had conditioned her into believing in the standards of class and conduct. They were trapped in the Victorian double standard. By the mid-nineteenth century, it was becoming difficult for women of the working class to find employment in decent professions. This meant jobs for shop girls, domestic servants, and factory workers brought long hours and very little pay.

Prostitution through choice was more common than prostitution through desperation as women sought ways of supplementing their incomes. Hence, brothel owners and individuals found opportunity in this chaos. It was the simple economics of supply and demand.

The issue of concern by the public and government regarded the prevalence of venereal disease among prostitutes. Although the suffering of prostitutes was not a concern of the government, the contagiousness of these diseases created the need for a response from them. The British military was reason for this problem. It was believed that the declining

health and effectiveness of the military was a result of prostitutes with STDs mingling with the armed forces. In response to the crisis, Parliament passed the Contagious Diseases Acts of 1864, 1866 and 1869. The legislation allowed the police to arrest women suspected of being prostitutes, and allowed the examination of them for venereal disease. This ushered in the era of 'The Great Social Evil' regarding 'fallen women' to certain social contexts that relate to, and frame, that concept. In particular, three Victorian documents dealing with prostitution will be examined.

The Times of 24 February 1858, published an anonymous letter entitled, 'The Great Social Evil.' In the article, the author claims she became a prostitute to escape the squalor of urban poverty. She describes a memory from her youth:

> ... 'some young lady who had quitted the paternal restraints ... would reappear among us with a profusion of ribands, fine clothes, and lots of cash ... then she would disappear and leave us in our dirt, penury and obscurity ... You cannot conceive, Sir, how our young ambition was stirred by these visitations.'

She further expounds on the conditions of poverty leading to an early education about sex, stating that by age 13, talking about sex was a common matter. According to her, sex was a shameless matter among the poorer classes and one of their few 'enjoyments.' Her curiosity led to sexual relations, and she decided to use her knowledge for monetary gain by following one of the girls she knew into the world at age 15. She notes that her case represents most prostitutes because they are mainly from the same class and background of poverty.

The latter part of the article calls out the upper class and questions their moral judgments:

> '"Why stand on your eminence shouting that we should be ashamed of ourselves? What have we to be ashamed of, we who do not know what shame is—the shame you mean? Will you make us responsible for what we never knew? Teach us what is right and tutor us in good before you punish us for doing wrong.'

The author states that the poor are abandoned by society until the upper classes needs something to blame; that the upper class creates and maintains the dire economic situations of the lower classes, which in turn leads them to prostitution. Then, they denounce prostitutes as the reason for the moral decay of society. This leads to attempts by those in power to punish prostitutes. In 1867, the Ladies National Association led by Josephine Butler began to work against the Contagious Diseases Acts. She had been subjected to the physical examinations and wrote:

'William Gladstone, prime minister and a devout church goer, was reported to make nightly forays into the streets of London to "rescue" fallen women. To his credit, he seemed interested only in talking with them.'

An act of legislation, The Criminal Law Amendment Act of 1885, provides interesting insights into the Victorian mind. The Act raised the age of consent from 13 to 16, and made criminal the act of drugging women for sex or abducting them for enforced prostitution in foreign lands. Yet, the verb *defile* is used numerous times within the legislation. Does this represent thinking in the Victorian Era? Rape or unmarried sex makes *women's* bodies dirty—*she* is ruined, soiled, and debased. The Victorian moral compass seemed unable to consider the way a man debases himself through these acts. Instead of focusing on the psychological and emotional harm of sexual violence, the language of the Victorians implies that the woman is at fault. The man, after serving his 'two years imprisonment, with, or without, hard labour' carries on with his life—no further penance need be done.

Another noteworthy Victorian study, the work entitled *Prostitution Considered in its Moral, Social, and Sanitary Aspects,* surgeon William Acton noted the evolution of prostitution. His series of calculations in 1870 focused on statistics of births and marriages in which he estimates that there are, '219,000, or one in twelve, of the unmarried females in the country above the age of puberty have strayed from the path of virtue.' Other sources cite over 80,000 street walkers and sex workers. There were three distinct categories: those who lived on the street, those who resided in brothels, and known kept women.

This graph is from the Metropolitan Police Office in November,1868:

Number of Brothels and Places			*	Total	Number of Prostitutes			Total
Where prostitutes are kept	Where prostitutes lodge	Where prostitutes resort			Well-dressed living in brothels	Well-dressed living in private lodgings	In low neighbourhoods	
2	1756	132	229	2119	11	2155	4349	6515

' Coffee houses or other places where business is ostensibly carried on, but which are known to the police to be used as brothels or places of accommodation for prostitutes

Although they did exist in some parts of the city, the dirty, intoxicated slattern found in back alleys – which had long been a symbol of prostitution – were no longer the depiction of a harlot.

Working class women could utilize their skills and parlay themselves into a lifestyle of fortune and status that most women of their class could not achieve. Likewise, the typical Victorian-era madam would not interact socially with lords and MPs. Yet Mary Jeffries did. She is the best-known madam of London's Victorian era. Aristocrats, politicians, and businessmen found their way to her establishments in Kensington, Chelsea, Gray's Inn Road, and Hampstead. She was once charged with running a disorderly house, but prostitution and running a brothel were not prosecuted often in England during much of Victoria's reign. Brothels weren't legally suppressed until 1885, when the Criminal Law Amendment Act was passed.

Jeffries was not the only woman with a dubious past who consorted with the upper classes. Sarah Rachel Russell, known as 'Madame Rachel,' was a con artist and fraud who was arrested at least once for procurement. She enjoyed fame as the purveyor of a cosmetic line she developed, which was known to whiten the skin. Aristocratic ladies converged on her boutique in London to purchase her facial products. She is known to have used blackmail in order to extort money and jewels from her wealthy clientele.

The madams and the courtesans represent the intersection between the Victorian elite and the world of the prostitute. The word *Victorian* has

become a euphemism for conventional, prudish morality, but the same MPs who warned against the perils of prostitution in a parliamentary debate might be out that same evening enjoying the attention of a young beauty at one of Mrs. Jeffries's establishments.

One cannot discuss prostitution in the Victorian age without mentioning the courtesans, the women who parlayed their charms into the role of mistresses of high-ranking members of royalty and the wealthy echelons of society. Catherine Walters, Cora Pearl, and Lillie Langtry are among the most notable, though there were many other women who achieved fame and independence. Their luxurious clothing, outrageous spending habits, and their beauty captivated the public. They often rode horses or took carriage rides along London's Rotten Row, where the public would gather in order to get a glimpse of them. With this, the rise of the working girls to what would be considered by today's standard as celebrity status is noted.

There is a sexual magnetism in some women that is impossible to capture on film or canvas, nor is it transferrable to the modern eye, yet their magic is legendary. What separated the wildly successful courtesans and mistresses of the Victorian Era, and made them a *cause célèbre* was simply the art of marketing themselves. Their uncanny sense of style, charm, and ability to create an image in the first wave of mass media photography and newspaper publications gave them wealth and fame. Cora Pearl lost everything due to her inability to sustain that image, Catherine Walters was the toast of London in her heyday, and Lillie Langtry had an allure that continues to be captivating.

Cora Pearl is believed to have been born in Plymouth, England on February 23rd, 1835, but she claimed 1842 in her later life. Her birth name is recorded as Emma Elizabeth Crouch, but her death certificate calls her 'Eliza Emma.' Her father was a musician named Frederick Nicholls Crouch, who wrote the song 'Kathleen Mavourneen,' which was extremely popular in the United States during the Civil War. Crouch lived beyond his means and he fled his creditors in 1847, abandoning his wife and six daughters. Her mother was Lydia Crouch, who soon found a live-in boyfriend who supported her children, too. Emma was sent to a boarding school in Boulogne, France in 1837 to be educated by nuns.

After eight years, she returned to England, moved in with her maternal grandmother, and went to work for a milliner in London. In her memoirs, she writes of having frequent lesbian affairs during her school days in France.

Emma rebelled against the strict moral code imposed on middle-class Victorian girls and the story is that she evaded her chaperone one afternoon, accepted a man's invitation to have cake with him, and he plied her with gin in order to seduce her. When she awoke from the tryst, she discovered a five pound note (almost £500 today) left by him in exchange for her sexual favours. That money led her to see the advantages of a career on the streets and she rented a room in Covent Garden in order to work as a street walker. She was twenty years old. Eventually, she started working at a brothel, the Argyll Rooms, which was a combination of a bar and dance hall, which offered cheap women for hire in its small hallways and alcoves. The owner, Robert Bignell, recognized Cora's potential and she became his mistress. The time spent with him showed her the advantages of money, and she established a taste for luxurious living. She was determined to practice her trade with the goal to become kept by men who had the financial means to keep her in luxury.

When she and Bignell visited Paris for a vacation, she fell in love with the place and decided to stay in order to learn the ways of the city. This is believed to be when she began using the name Cora Pearl. She rented a small room and survived as a street walker until meeting a pimp, Monsieur Roubisse, who established a better platform for her talents. He made her successful by utilizing her feminine wiles as well as honing her sense of business acumen. At the time of his death in 1860, Cora was the lover of Victor Masséna, the third Duke du Rivoli, who later became the Prince of Essling.

The Duke showed her all the trappings of opulence; money, jewellery, and servants (including a chef). He gave her funds for gambling and bought her the first horse she ever owned; eventually, she would acquire sixty. She became an excellent rider, and her equestrian skills and beauty attracted the attention of the French elite. Though the Duke remained her primary patron, she had other clients, including the Prince of Orange, the Duc de Morny, the half-brother of Emperor Napoleon III, and Prince

Achille Murat, grand-nephew of Emperor Napoleon I. In 1864, she bought the Chateau de Beauséjour and held parties, which became known for their extravagance. Her fee was 10,000 francs for an evening. At one party, she was presented at dinner on a huge platter carried by four men. She was notorious for dancing naked for her party guests, and she had a custom-made bronze bathtub, which she would fill with champagne and bathe with clients. When Cora did wear clothes, she wore the finest, most elaborate gowns created by Charles Worth, who is considered the first superstar fashion designer.

In 1865, she became the mistress of the distinguished Prince Napoleon, Napoléon Joseph Charles Paul Bonaparte, the Emperor's fabulously wealthy cousin. He lavishly supported her for nine years, gave her expensive gifts and several houses, including the palace les Petites Tuileries. She secretly kept other clients and charged them high fees for the thrill of cheating on the Prince's mistress. Only the wealthiest men in the world could afford her. Cora's sense of the theatrical made her a star and the centre of attraction at any event she attended due to her outrageous and uninhibited appearances. Her status soared to that of a celebrity during this time. She became well known for wearing heavy makeup and dyeing her hair and dog to match the elaborate outfits that filled her wardrobe. Cora appeared as Eve at a masquerade ball, wearing basically what the Biblical Eve is recorded to have worn. She was seen riding in a carriage with her hair dyed to match the lemon-coloured satin of the carriage interior. In 1867, a cocktail was named after her, and she took the role of Cupid in Offenbach's operetta *Orpheus in the Underworld,* dressed in a tiny diamond-studded bikini. She played the role twelve times, and the jewels brought 50,000 francs at an auction. This amount is approximately £5 million in today's market. She was a long way from the streets and alleys of Covent Garden.

Cora's downward spiral began with the Franco-Prussian War of 1870-71. The defeat of the French meant the end of the world she knew. Prince Napoleon fled to England with the Imperial family, and Cora went with him. The Grosvenor Hotel in London refused to let her stay because they were afraid of the risk a scandal would mean to their respectable establishment. Cora returned to Paris, but the post-war ennui was not the life she had once enjoyed. She met and began a notorious affair with a

man ten years younger, the wealthy Alexandre Duval. He became obsessed with her, and in less than a year, he had lavished his entire fortune on her. When his family refused to provide him with more money, Cora ended their relationship. His jealousy and rage led him to enter the house in which she was staying, with the intention of murdering her. Instead, the gun discharged while he was jostling with her servants, and he only shot himself in the side, fortunately recovering from the wound.

The public disapproved of the scandalous way Cora had handled the affair with the young man, and the government ordered her to leave France. From there, she moved to Monaco, and later secretly returned. But the party was over. In 1873, she began selling her properties, and the next year, Prince Napoleon ended their relationship and he cut off his financial support. By 1880, the chateau was the only property she owned, and she was forced to sell it in 1885. She returned to middle-class prostitution on the Champs-Elysées, and published her memoirs in 1886. Sadly, she was too discreet, and the use of disguised names meant the book didn't sell. By then, she was terminally ill with colon cancer and died on July 8, 1886, a sad end to the life of a woman of whom it had once been written in 1867, 'You are today, Madame, the renown, the preoccupation, the scandal and the toast of Paris. Everywhere, they talk only of you.'

After her death, Cora Pearl passed into obscurity. However, almost a century after her death, a British publisher found her original memoir, written during her decline in the 1870. The copy contained the real names of her lovers and provided the sordid details. When collector William Blatchford published the work in 1983 as *Grand Horizontal, The Erotic Memoirs of a Passionate Lady,* its lascivious, detailed descriptions of life during the Second French Empire rekindled interest in its author and has posthumously given Cora Pearl the fame she enjoyed in life. As fate would have it, the Grosvenor Hotel in London currently features the Courtesan's Boudoir – the Cora Pearl Suite.

Catherine Walters is called the last Victorian courtesan. She was not as flamboyant as many of her contemporaries, nor was she intrigued by fame. Catherine's early life is obscure, although it is known that she was born on June 13, 1839 in Liverpool, England, the daughter of Edward

Walters and Mary Ann Fowler. One of her lovers, the poet Wilfrid Scawen-Blunt, wrote in his diaries that Catherine's mother died when she was four and that the young girl had been sent to a convent school. She was small and slender, with grey-blue eyes and chestnut hair. In an age of opulence, she wore clothing that was modest and subdued. She was an accomplished equestrian, and riding remained one of the great passions of her life.

Only rumours remain to tell us the secret of where she learned to ride horses. For Catherine, riding was her entry into a better world. Catherine could ride and hunt as well as a gentleman. Throughout her life, she was selective, choosing her lovers because she enjoyed their company. And, the mystery of her childhood proved to play an important role as she grew older. She could keep secrets. Unlike other courtesans, like Cora Pearl, who wrote or revealed information about paramours, Catherine never sought revenge once the affair ended.

The young girl was blessed with exceptional beauty and a practical, down-to-earth nature. She was noted to be effervescent, outspoken, and bawdy. Her naturalness was one of her chief attributes as a courtesan; she remained affectionate and sympathetic. 'She had the most capacious heart I know and must be the only whore in history to retain her heart intact,' wrote the journalist and campaigning MP Henry Labouchere. Catherine possessed a spontaneous spirit and an easy-going personality, which enabled her to maintain the affection of her lovers for a lifetime. A biographer wrote that she possessed the quality of being loved. Her list of lovers read like a 'who's who' of the wealthy, powerful, and famous of Victorian Britain.

Her admirable equestrian skills led to an acceptance on the hunting field that she was denied in other social situations. Stories about her daring achievements include a bet at the National Hunt Steeplechase, which led to her jumping the 18-foot water fence after three other riders had failed. For this, she won £100. Catherine was celebrated as a 'horse-breaker,' who paraded in Hyde Park from the hours of five to seven. This was where she first captured the imagination of Londoners and received widespread attention. Her riding habit was cut to perfectly show the contours of her body. It was so tight that many wondered if she wore anything underneath it.

Catherine Walters became the mistress of George, Lord Fitzwilliam at the age of sixteen. He moved her to London, and when their affair was over, he gifted her with a generous yearly allowance and gave her another large payment, much like a severance payment in contemporary corporations. This arrangement seemed to set the pattern for later relationships; her wealthy patrons knew that she would never reveal their names, hence their payments ensured her silence. By this time, she was called 'Skittles' or 'Skitsie' by her close friends; yet again, the origin of the nickname is shrouded in mystery and rumours.

Spencer Compton Cavendish, Lord Hartington, the oldest son of the 7th Duke of Devonshire, became her sponsor by the time Catherine was nineteen. Her relationship with Hartington lasted four years and the couple appeared to have a great affection for one another. They each had a passion for hunting, which was the one activity they could share in public. He was a shy twenty-six-year-old when they first met, but he became an integral part of Liberal politics and was thought to be the ideal successor to Prime Minister Gladstone. While he conducted his duties in Parliament, he paid for Catherine to be taught by a governess, thus adding a polish to her manners. Before she was twenty, he purchased a house in Mayfair for her, bought horses, and gave her an annual stipend, which his family continued to pay her when he died in 1908.

In 1861, the future poet laureate Alfred Austin wrote a poem entitled 'The Season,' which mentioned Catherine by name. When the painting 'The Shrew Tamed' by Edwin Landseer was exhibited in 1861, it was assumed that she was the model for the woman in the painting because Catherine was the toast of London. A letter written to *The Times* in July 1862 described the crowd's anticipation while they waited for Catherine to ride through Hyde Park's Rotten Row in her skin-tight attire:

> "'Expectation is raised to its highest pitch: a handsome woman drives rapidly by in a carriage drawn by thoroughbred ponies of surpassing shape and action; the driver is attired in the pork pie hat and the Poole paletot introduced by Anonyma; but alas!, she caused no effect at all, for she is not Anonyma; she is only the Duchess of A–, the Marchioness of B–, the Countess of C–, or some other of Anonyma's many imitators. The crowd,

disappointed, reseat themselves, and wait. Another pony carriage succeeds – and another – with the same depressing result. At last their patience is rewarded. Anonyma and her ponies appear, and they are satisfied. She threads her way dexterously, with an unconscious air, through the throng, commented upon by the hundreds who admire and the hundreds who envy her. She pulls up her ponies to speak to an acquaintance, and her carriage is instantly surrounded by a multitude; she turns and drives back again towards Apsley House, and then away into the unknown world, nobody knows whither.'

When the relationship with Hartington ended, she followed him to New York, then had a brief tryst with Aubrey de Vere Beauclerk, and finally moved to Paris for a new beginning. She soon became one of the *grandes cocottes*. While others entertained with their wild costumes and theatrics, Catherine dressed like a lady, and her practical nature had to be noticed in the over-the-top dramatics in Paris at that point in time. It was noted that she had a certain allure which harkened to the elegance of London, and the days of riding in Hyde Park. When she appeared in the Avenue de l'Imperatrice, driving herself with two beautiful sparkling pure-blooded horses, followed by two grooms on horseback in splendid and elegant uniform.... every head turned, and all eyes were on her.'

Her reputation for discretion preceded her, and her rumoured clients included both the Minister of Finance, Achille Fould, and Emperor Napoléon III. Wilfred Scawen Blunt fell deeply in love with her to the point of obsession. He wanted Catherine to be exclusive, and the fact that she had other lovers set him on rages of jealousy. Their affair ended in scandal when the British Ambassador to Paris, Lord Crowley, discovered that Blunt had become engaged to his daughter while having an affair with Catherine. Blunt refused to marry the ambassador's daughter, hence he was dismissed from his position at the embassy. After their relationship ended, Catherine was Blunt's life-long obsession. She was the inspiration for his narrative poem 'Esther.' After several years, Blunt and Catherine resumed their friendship, which continued until her death.

After the fall of Napoleon III's Empire, Catherine returned to London,

where she divided her time between hunting and her Sunday gentlemen-only afternoon tea parties. The tea parties included William Gladstone, the Prime Minister. Her main patron was the Prince of Wales, who became deeply infatuated with the courtesan. After their affair ended, the Prince paid her an allowance, and he sent his own doctor to attend her whenever she was ill. Once, when he thought she was dying, he sent his private secretary to collect over 300 hundred letters that he had sent her during their romantic interlude. Catherine returned all the correspondence to the Prince, and in appreciation, he increased her stipend.

Catherine moved to Park Lane in 1872 and resided there for the remainder of her life. During the 1880s, although she called herself Mrs. Baillie for a time, there is no documentation to show that she ever married. Her final love affair was with Gerald de Saumarez, who was twenty-four years younger than she. During her life as a courtesan, her discretion and loyalty became the trademark of her career. There were many rumours about her involvement with titled, powerful, and wealthy men throughout her lifetime, but she never confirmed or denied the rumours. This gave her a great advantage over most women in the courtesan lifestyle, and made her a sought-after commodity. 'Skittles' died a very wealthy woman in 1920 at the age of eighty-one.

Oscar Wilde said he loved three women in his life. One was Queen Victoria, one was Sarah Bernhardt, the other was Lillie Langtry. Mrs. Langtry was a statuesque blonde with blue eyes, a perfect complexion, and an hourglass figure. Loved and admired by many, even the Prince of Wales, the world would eventually pay homage to the lady known as 'the Jersey Lily.' Mrs. Langtry crossed the Atlantic to act in American theaters with such success that even shoe shine boys on street corners knew that her name signified the ultimate in feminine beauty. By the time of her death in 1929, she achieved legendary status; everything she touched became history.

Lillie Langtry was born Emilie Charlotte Le Breton in 1853 on the English Channel island of Jersey to Dean William Corbet Le Breton and his wife Emilie Davis Martin. She was also educated by her brothers' tutor, which was rare in the Victorian Era. Her beauty was noted early in her life, and she was nicknamed Lillie due to the whiteness of her skin.

She received her first marriage proposal when she was in her early teen years. At 20, she married Edward Langtry, who owned a yacht, but whose wealth was not as great as Lillie and her father believed.

Once married, Lillie insisted on leaving Jersey and the Langtry's moved to London. Her striking height and understated elegance swept her into the world of high society. She soon became a Professional Beauty, which is equivalent to a supermodel by today's standards. Painted and admired by the most famous artists of the day, she was proclaimed 'The Jersey Lily' by Oscar Wilde. During this period, the aristocracy was fond of pranks and Lillie's boisterous nature and quick wit aided her dazzling ascent into the upper strata of British society. Edward, Prince of Wales, heard of her and a meeting was arranged at a social function. A friend told Lillie that the 'Prince was much interested in forming a possible friendship with you'. From this exchange, the affair of the Jersey Lily and the Prince developed. They became instant friends and Lillie became his mistress. Society knew that if the Prince of Wales was to attend a party, Mrs. Langtry had to be invited.

She was the first acknowledged mistress of the future king. Prince Edward had a house built for them in Bournemouth, the Red House, where they spent weekends together. She was introduced to his mother. Lillie remained married during the affair with the Prince, and was known to have had other lovers during their liaison. Rumours swirled about Lillie's potential lovers, among them the Earl of Shrewsbury, Prince Louis of Battenberg, and a gentleman named Arthur Jones. She eventually became pregnant by one of them in 1880 and a daughter was born in early March 1881. The fear of scandal led the Prince of Wales to distance himself.

The withdrawal of royal favour allowed the Langtry's creditors to collect on the substantial debt the two of them owed. Lillie had a love of finery, and lived beyond her means for most of her life. Mr. Langtry's finances could not support their combined lifestyle in the prestigious Belgravia and Park Lane areas of London. Lillie sold many of her possessions to assist in meeting the terms of the debtors, and was in desperate need of money.

Given Lillie's beauty and notoriety, her very close friend Oscar Wilde suggested that she try the stage. The concept of a society lady appearing

on stage was original, sensational, and scandalous. She auditioned for an amateur production at the Twickenham Town Hall. Following her favourable reviews at this first attempt at acting, she found an acting coach, and she made her debut before the London public, playing Kate Hardcastle in *She Stoops to Conquer* at the Haymarket Theatre in November 1881. The Prince of Wales remained fond of her, and his encouraging words helped immensely with her pursuit of a theatrical career. The critics didn't take her appearances seriously. However, Langtry was a capable actress who endeared herself to the public. What she lacked in talent, she compensated for with her flair for costumes, jewels, and her risqué display of legs. She enchanted the public and she performed to sell-out crowds. Lillie relied on her theatre income to support her extravagant lifestyle, which was supplemented by wealthy admirers and lovers, but she was high maintenance and she continued to worry about debt. Following her successful stage debut, she decided to embark on a theatrical career. The following year, she toured the United States for the first time.

The tour was sponsored by Henry E. Abbey, who advertised her appearance unlike any actress before her. She arrived in New York City, greeted by an enamoured press, and met by Oscar Wilde. Her performances sold out, with the opening night performance breaking the Wallack Theater's record, previously set by acclaimed actress Sarah Bernhardt. Lillie Langtry was a star. The production company decided to tour the United States based on the overwhelming public response. Before leaving New York, she started a passionate relationship with a wealthy, younger man – American banking and railroad heir, Frederick Gebhard, who accompanied her on her first tour.

The production was an enormous success; it seemed that the entire country was smitten by the beautiful actress. While the critics continued to discredit her acting, the American public couldn't get enough of her. She toured America five times throughout her life, and it made her a very wealthy woman.

The affair with Freddie Gebhard endured for eight years, with Gebhard asking to marry her. However, her husband refused to grant a divorce. Lillie broke off the relationship with Freddie following a return to England when he crashed into a room where she was entertaining the

Prince of Wales. Lillie ended the affair, saying that the American lacked proper respect for royalty.

She was extremely successful as an actress and continued the touring over subsequent years. Lillie became an American citizen in 1897 and divorced Edward Langtry that year while she lived in California. As an American citizen and land owner, she was finally given the longed for matrimonial severance. Following her relationship with Gebhard, she was linked in the press to various younger men of wealth, assorted royals and men in powerful political positions. William Gladstone's secretaries whispered that he demanded that Lillie's correspondence was to remain unopened until he could personally open the letters in private.

In 1899, she married Hugo de Bathe, who was nineteen years younger than she. Her husband inherited a Baronetcy, and on his father's death, and Lillie became Lady de Bathe. The couple retired to Monaco with Hugo eventually moving to Paris. Although they lived apart, the two remained married for the rest of Lillie's life.

British author Somerset Maugham wrote of meeting her and she told him of her love affair with Freddie Gebhard.

"'Who was he?'"
"The most celebrated man in two hemispheres," she said.
"Why?" asked Maugham.
"Because I loved him.'"

She remained a heart breaker with a number of young, wealthy lovers until her death. She was a business woman who found a way to become a property owner at a time when women generally could not own property or assets. Yet she owned a winery in California, theatres in two countries, and thoroughbred horses in the United States and United Kingdom. America's Judge Roy Bean named Langtry, Texas for her, called the town's saloon The Jersey Lillie, and named the town's opera house for her. He presided over legal cases in the saloon with a picture of Lillie on the wall behind his desk, such was the extent of her charm and appeal.

As celebrities in the first era of mass media, it was only natural for the ladies to not only capture the imagination of the masses, but to captivate

authors and writers of the era. Writer and poet Oscar Wilde refers to them throughout his various works as 'mechanical grotesques', 'marionettes', 'the dead', and 'manipulated, lifeless dolls'. But did he disdain the women or the men who purchased their services? His curiosity in female prostitutes is evident in his poem 'Harlot's House,' yet beautifully expressed in his poem, 'Impression Du Matin':

> 'But one pale woman all alone,
> The daylight kissing her wan hair,
> Loitered beneath the gas lamps' flare,
> With lips of flame and heart of stone.'

Not all artists viewed the women with the harsh criticism that Wilde is reported to have harboured. The fallen woman, viewed as a potential destroyer of the family unit by Victorian society, had many advocates in the artistic world. Artists – writers and painters – showed the condition of the prostitutes in a sympathic way, which educated their readers and viewers, no easy feat in a society obsessed with women's purity. This enabled the masses to learn that there were complex issues surrounding these women, and it was not always the woman's choice to lead an unconventional life. Often they had been adandoned by men, then left with no means of support or protection by society in which they lived. The fallen can only submit 'to the pressure of force…wielded, for the most part, by ignorant, and often by brutal men'. As written by Anonymous in *The Great Social Evil*, 'Setting aside 'the sin,' we are not so bad as we are thought to be.'

'The Lady of Shalott,' 'Goblin Market,' 'Jenny,' and 'The Defence of Guinevere' were written in this manner. All relate in some way to question the defined concepts of female sexuality. Tennyson's 'The Lady of Shalott' centres around the temptation of sexuality and the concerns regarding of women's sexuality and their place in the Victorian world. The world is viewed through a mirror, and her innocence is saved only by death. 'Goblin Market' by Christina Rosetti, the sister of the painter Dante Gabriel Rossetti, has various interpretations; feminist, homosexual, temptation by forbidden fruit, drug abuse, salvation, criticism of the rigid Victorian marriage and class system. Although it is considered overtly

sexual, the author of the narrative poem was noted as saying it was actually a children's book, thus leading to even more confusion and interpretation.

The poem 'Jenny' by Dante Gabriel Rossetti is in sympathy with the plight of a beautiful prostitute, naming the ways her room is unlike his because it lacks books. Rossetti's written images parallels two distinct worlds: Victorian society and the world the fallen woman must be contained:

> 'This room of yours, my Jenny, looks
> A change from mine so full of books ...'

Her thoughts are inaccessible and she must be viewed from an aesthetic point of view. His thinking evolves as he considers her beauty. Rossetti's creates a sympathetic point of view. He should think of Jenny as a fallen woman. Yet, he begins to see her in an emotional light:

> 'A rose shut in a book
> In which pure women may not look.'

The writer ascertains that Jenny's heart cannot and will not be understood by the judgmental Victorian mindset.

There are parallels between 'In Defence of Guinevere' by William Morris and the anonymously written 'The Great Social Evil'; both are sincere, both return judgment to those judging them, and both offer powerful retorts. Morris' Guinevere begins as shamed, yet she exposes her feeling in a very feminine although volatile manner of speaking, rather than the calm expected by a queen. Guinevere waits for Launcelot to rescue her, just as Victorian women had to wait for a man to come to their aid and rescue them from the constraints of society.

Pre-Raphaelite painters recognized the complexity of emotions and the circumstances surrounding the life of a prostitute. Holman Hunt chooses this concept with his painting 'Awakening Conscience' (1854), in which he addressed the popular Victorian theme of a sinner determined to repent; in this work, the sinner is portrayed as a fallen woman. Victorian critics adored unravelling all the symbols and clues in Holman Hunt's

depiction of his sinner as a kept mistress. He focuses on the hope for redemption and the beauty of a sinful life finding salvation instead of a punishment.

'Found' by Dante Gabriel Rossetti shows a cattle drover and his former beloved, who is now a prostitute, slumped against a wall. This unfinished painting focuses on the struggle between them as the man tries to lift her, but she appears to refuse to submit to him. The question of why she should resist him makes the viewer look at the drover's calf in the background, trapped and struggling within restraints. It seems that either the woman is entangled in her life, or else she refuses to be caught in the impositions of married life, which is represented by the net that holds the calf.

Brothels were noted as being well-decorated venues that were among the finest places to house prostitutes. The girls were found to be 'pretty and quietly, though expensively dressed.' and 'unaccompanied by the pallor of ill-health.' It is interesting that the documentation says the women who frequent dancing-rooms do not have the appearance of prostitutes, but look more like mistresses, suggesting that dancing-halls employed prostitutes of a higher class, beyond the common harlots. The writer does agree in principle with Wilde in that there is little substance beyond the façade and the physical appearance of these women. They are noted as being quiet, well behaved, and some have the ability to play piano and sing.

Various publications flourished in the Victorian underworld that served as a gentleman's guide to the brothels and prostitutes working in London. These brochures were consistently updated with house locations, specialties, ratings of various establishments, and offerings to be found in the brothel. More pornographic material was published during the Victorian era than at any time previously.

There was a brothel that catered specifically to the aristocracy. It was on the fashionable Marlborough Street and decorated like the finest of Parisian bordellos, which English aristocrats would have frequented when visiting Europe. The madam, Jane Goadby, selected the prettiest girls she could find, and trained them in seduction and etiquette. Many of these girls found exclusive patrons and eventually made the leap from prostitute to courtesan. In time, Mrs. Goadby's house became known as the Nunnery.

A guide was published about the Nunnery, which included a description of the establishment and the various specialties of the employees. It gave anonymity to the girls by leaving out letters of their names. It is interesting to see how the nineteenth century attempted to describe sexual positions and peccadillos.

'Mrs. Goadby, that celebrated Lady Abbess, having fitted up an elegant nunnery in Marlborough Street, is now laying in a choice stock of Virgins for the ensuing season. She has disposed her Nunnery in such an uncommon taste, and prepared such an extraordinary accommodation for gentlemen of all ages, sizes, tastes, and caprices, as it is judged will far surpass every seminary of the kind yet known in Europe.

'Miss B-nf-ld frequently mounted a la militaire, and as frequently performed the rites of the love-inspiring queen according to the equestrian order, in which style she is said to afford uncommon delight.

'Miss B-lm-t, on the other hand, while not at all pretty, compensated for her lack of looks by her mouth, which seemed by its largeness, prepared to swallow up whoever may have courage to approach her.

'Mrs. L-v-b-nm was left a pretty good fortune by an old flagellant, whom she literally flogged out of the world.

'Mrs. M- enacted scenes with herself as a schoolmistress with her two young beautiful tits [Victorian slang for young women], one about fifteen and the other sixteen, who are always dressed in frocks like school girls.'

Swell's Night Guides were also popular guidebooks for the man about town, and were published in the 1830s and early 1840s. The books described the clubs, pubs, and bars in which prostitutes were to be found. It lists theatres, noting their advantages; ones which allowed men behind the scenes to meet the dancing-girls, and ones that sold theatre boxes with locks on the doors to ensure privacy during purchased 'theatrical performances' with the actress of choice.

The books gave addresses for 'Introducing Houses,' where women

waited for clients. Some were the upstairs rooms of pubs, others masqueraded as respectable businesses, with a brass plaque on the doors – the sign of the professional middle-classes – claiming the house was a doctor's, or a milliner's, or a dressmaker's. The Guides were blunt about what was to be found at establishments. They also allowed us to see how men regarded the women.

This listing is for Mme Matileau's houses in Soho and Kensington:

'Nothing is allowed to get stale ... you may have your meat dressed to your own liking ... her flock is in prime condition, and always ready for sticking; when any of them are fried, they are turned out to grass ... consequently the rot, bots, glanders, and other diseases incidental to cattle are not generally known here.'

The seamier side of the business – besides utilizing women – is the trafficking of children. Estimates from the mid-1800s show prices to buy girls ranged from £20 for a working-class girl, age 14-18, to over £400 for an upper-class girl under twelve, a rare commodity. There was a market for sex trafficking in boys too. Mary Jeffries offered a variety of sexual services at her houses, including flagellation and sadomasochism, and was believed to be involved in white slavery and as well as prostitution of children of both sexes.

Homosexual prostitution, both male and female, was a common part of city life. The city had molly houses – places for men to dress in drag and meet other men, and there was an all-male brothel on Cleveland Street in which male prostitutes serviced male clients.

Victorians did not seem to have our contemporary labels of sexuality and sexual orientation. Male homosexual acts were considered the actions of over-sexualized men. Society believed that men needed to have sex; if they masturbated, they might go insane or develop epilepsy; if they couldn't find a woman to have sex with, a man would do; and two men having sex was unnatural but if it had to happen, choose a young man because they looked like women or girls.

Again, the Victorian Era mores were very complicated and hypocritical. We understand that none of the men buying male prostitutes were paying men to have sex with them because they couldn't find a woman. These men were paying because homosexual sex was what they

wanted. The Criminal Law Amendment Act of 1885 sent Oscar Wilde to prison for two years. It was a source of concern for those who bought sex with 'rent boys,' or male prostitutes. When the all-male Cleveland Street brothel in London was uncovered by the police, common gossip said that one of the clients was Prince Albert Victor, a grandson of Queen Victoria.

Men made their own destiny. A male prostitute could leave the profession when he wanted without spoiling his reputation. No one organized to reform male prostitutes the way that they did for 'fallen women.' Sexual ideology maintained that women shouldn't want it at all. The idea that a Victorian woman might possibly enjoy having sex with many men was contrary to the angel of the household cult. Even when a female prostitute was reformed from her 'vile' circumstances, she would never be admitted into polite society. The main difference between the perception of male prostitutes versus the female was how society viewed the power men exerted over women.

Although London cultural mores set the platform for sex workers, the epicentre of prostitution was Paris. Any sex worker who had a flair for the dramatic looked to Paris for inspiration. When the sun set in Paris, the gas lights began to flicker, and the clinking of glass signalled the start of absinthe hour in the cafes.

Enter the cocottes and courtesans. Welcome to the decadent side of the City of Light during the period between the Second Empire and the Belle Epoque. The elegance of day faded, replaced by the ladies of the night. They emerged from all quarters of the French capital, thousands of brightly dressed, giddy butterflies, looking to flirt and solicit clients on the cafe terraces and in cabarets in the Folies Bergère and Moulin Rouge, with Montmartre at the shimmering centre of the scene.

As prostitution in Paris boomed, the city's most celebrated artists set about capturing the exciting social phenomenon. The glitter dusting of sin and scandal worked well with the added dose of smut. Artists were drawn to the areas that prostitutes and courtesans frequented. In Paris, prostitution was the new modern structure. For the first time, people had moved from their villages and provinces, and openly shed their moral restrictions. The city was ever-changing and this attracted the artists, writers, and poets as well.

"'What is art? Prostitution,'" Charles Baudelaire declared in his *Journaux Intimes*. The population shift brought a change in attitudes. Authorities felt prostitution was a necessary evil to blunt the rampant nature of the male libido. French kings and aristocrats had kept courtesans and mistresses throughout history; but in Paris in the second half of the nineteenth century, the sex-for-sale business democratized public spaces.

In the latter half of the nineteenth century, prostitutes registered with the local police and were required to have regular medical checks. They worked in legalized brothels and *maisons closes* where pornographic scenes of heterosexual and homosexual relationships flourished to satisfy every whim. Many more worked the streets illegally. Their activity was focused around cafes and bars, where no 'decent' woman would enter without a male escort. Cafe terraces, visible from the street, were the domain of those who were soliciting. An orchid in her hair identified a woman as a prostitute. In red-velvet-curtained side rooms women in suggestive poses captured clients with their debauchery; the next move was to the boudoir for the remainder of the evening.

The streetwalkers who were forced by circumstance to make a living were at the bottom of the social order. Young female courtesans, often actresses or singers, were at the top, kept by powerful, aristocratic, or high-ranking protectors as a sign of wealth and virility. These hedonistic demi-mondaines were a subject of fascination for the upper class, as they were considered the epitome of fashion trendsetters. The courtesans were a distraction from the discontent spreading through France, with its high levels of alcoholism, disease, and social unrest. The higher-class prostitutes were entertainment. They weren't paid with money, but with diamond bracelets, estates, and racehorses.

Au Salon de la rue des Moulins, 1894 by Toulouse-Lautrec depicting the main hall of a famous Parisian brothel – a *maison close*. Paris, with its refinements and looser societal boundaries, set the perfect stage for the bohemian culture. It was a hard-partying world of absinthe, brothels, and nightclubs that stayed open all night. Cafes and clubs were filled with notable figures, like Oscar Wilde and Renoir. Edgar Degas' studio was in the same house as Toulouse-Lautrec's first apartment, and they painted some of the same people. Vincent van Gogh was another lost soul in Paris. He and Lautrec also became friends.

Henri de Toulouse-Lautrec's art is characterized by bold, confident strokes and reflect a love of life and a striking empathy for his subjects. He captured the vibrancy and seediness Montmartre nightlife with insight, and a touch of innocence. His portrayal of immorality and the theatrical are offered with playfulness and simplicity. He haunted bars, brothels, and dance halls in his pursuit of life. He was fascinated by physical prowess. He was fond of prostitutes, and the feeling was mutual. Prostitutes were his favourite models, and he often resided in brothels. 'Professional models always seem to have been stuffed, whereas these girls are alive. They stretch on the divans like animals,' he said. Like the photographer Balloq detailed the ladies of Storyville, Lautrec painted scenes of their daily lives, the mundane things like washing, dressing, and talking with affection and a nuanced beauty.

The societal shift of women's roles in Europe was also found in the United States during the Civil War and Reconstruction Eras. Displaced women found a way to survive in a society in the chaos surrounding them. They changed the societal and racial norms placed on women, and set the tone for the twentieth century.

Much like their counterparts in Paris, California's early prostitutes occupied a unique place in society due to the California Gold Rush of 1849. Women were held in high regard in the state's early settlement. Much like Paris, the women were considered a necessity and did not suffer many of the social constraints seen in the other locations. Once middle-class families with their strict Victorian standards moved to the state in the 1850s, the girls began to fall from favour, but the importance of women in California had a positive historical impact.

The Gold Rush saw massive numbers of men moving to America's West Coast with dreams of 'striking' it rich. Most speculators came with the same intent; to spend a short time in the area, then return home with their new-found wealth. Because of the rough conditions and the brief tenure of gold speculators, women were scarce because wives were left at home. The transitory nature of the population is the key to the lax social and moral restraints in the mining towns. This ephemeral atmosphere created an environment where people were not condemned for practices beyond the norm of Victorian ideals. A person's reputation was not at

stake in this fleeting, faraway place. This surplus of lonely men made prostitution a viable career option for women. In San Francisco alone, a source cites a male-to-female ratio of 50-1. Prostitutes occupied a privileged place in gold-rush society, with economic opportunity beyond what was offered to other working females.

Women were literally shipped in; very few came on the wagon trails of the Western Frontier. Labeled as entertainers, they had little or no money for passage. Once they arrived in California, they were hired by saloons, gambling halls, dance halls, or brothels, which paid for their ship passage once the ladies agreed to work for a set amount of time; usually six months. In the early 1850s, women were so scarce that prostitutes were not viewed as immoral, and they were highly desired as escorts. Men paid up to $20.00 a night for the privilege of having a beautiful woman sit at their table.

The premise was simple; the forty-niners, as the miners were called, would visit the nearest town on Friday nights for a weekend of pleasure, spending their gold dust in the local saloons and brothels. Once the miners returned to work, the prostitutes would deposit their earnings in the banks, order new clothes and mercantile goods. The local economies depended on the women.

Females from around the world flooded into California, with French prostitutes being the most sought after. The women suffered the same medical conditions and physical abuse which was part of sex work in the nineteenth century. But, other opportunities arose; women were increasingly hired to cook, clean, and take other types of employment. Female journalists and photographers flourished, as did dancers and actresses. Women could earn high wages simply because men needed them to do jobs they didn't want to do, or didn't have time to do.

Women became plentiful during California's Gold Rush. The strict ideology found in the United States during the era mingled with the influence of newly arrived foreign women. In this climate, freed of staid cultural restraints, women were willing to put standard Victorian values aside in order to make a living. Men respected them because they brought comfort and made a brutal lifestyle bearable.

Delegates at the first California Constitutional Convention adopted the state's constitution before statehood was granted in 1850. It reflects the high

regard for women. At that time, most American states utilized laws which were based on English common law; hence women had little or no property rights. The language in the California Constitution reflected the civil law and traditions influenced by the Spanish-Mexican legal systems. Debates ensued among the delegates. One said that giving women property rights ran contrary to nature, because men are the natural protectors. Others said that it would empower women and attract them to the state. A consensus formed which guaranteed the property rights of women. They gave married women very liberal property rights, considering the era:

'All property, both real and personal, of the wife, owned or claimed by her before marriage, and that acquired afterwards by gift, devise, or descent, would remain her separate property.'

This enactment set California apart from other states, with the majority of the U.S. continuing to struggle with outdated patriarchy laws well into the twentieth century.

Nashville, Tennessee was the largest city on the Western Front during the American Civil War. With over 100,000 troops passing through the city from its occupation in 1862 until the end of the war in 1865, there was a real problem with idle troops and prostitutes.

US Major General William Rosecrans believed Nashville was an ideal location for his troops. The placement of the city on the rail lines and the Cumberland River made for excellent movement of men and artillery. It appeared to be the perfect spot on the Western Front to gather troops, teach manoeuvres, and sharpen tactical abilities for the next round of fighting. Union troops settled into the city, and unexpected trade began to boom. The strong Yankee dollar took over the town. The next four years would see a very different Nashville.

Abandoned women began arriving from the industrial cities of the northern states, then from the war ravaged rural areas of the southern states. By 1862, the number of working women in Nashville had increased substantially from the 207 in 1860. Keep in mind that the early Union troops were young volunteers between the ages of 18-22, most of them were away from home for the first time. They were eager to spend their small wages on the soiled doves in the bawdy houses.

SEXUALITY AND ITS IMPACT ON HISTORY

By early 1863, Rosecrans and his staff were not only at war against the Confederate Army, they were at war with disease. Syphilis and gonorrhoea infections spread through the Union troops. The infections were practically as lethal to soldiers as combat at that time. Almost nine per cent of Union troops would be infected with STDs before the end of the Civil War. The only known way to treat infection was with mercury. Considering that the battle injury rate was eighteen per cent, the severity of this plague was alarming, with deadly consequences for General Rosecrans's command.

Capt. Ephraim Wilson described the first major attempt to control wartime prostitution:

> 'During the winter of 1862-63, the Army had a social enemy to contend with which seriously threatened its very existence ... the women of the town.'

Religious revivals known as the Second Great Awakening had swept across the U.S. in the mid-1850s. The result of this fervour, particularly in the North, saw women become involved in efforts, including temperance, the abolition of slavery, and other reform movements. Their cultured Southern sisters in Nashville were not far behind them due to the spread of STDs into the civilian population. Demands were made to clean up the city. Local physicians responded to the dilemma and a Dr Coleman ran an advertisement in which he announced that he had opened a Dispensary for Private Diseases. Another physician, Dr A. Richard Jones, opened a medical office offering the same service on Dederick Street.

Union officials decided on what they believed to be the easiest solution. Since they couldn't stop soldiers from visiting local prostitutes, something had to be done to move the girls out of Nashville. The movement to legalize prostitution in Nashville began in June 1863, when Brigadier General R.S. Granger noted that officers and medical staff petitioned him to 'save the army from venereal disease, a fate worse ... than to perish on the battlefield.'

Captain Wilson continued to document the situation. Fifteen hundred of them at a single time were gathered up and placed aboard a train and were compelled to leave and conducted under guard to Louisville:

'Louisville at first objected to receiving such a formidable array of unwelcome guests, but finally consented to do so, and Nashville was afterward all the happier and better off for their conspicuous absence.'

But the women had not agreed to this relocation plan and were soon back in Nashville.

Finally, in an attempt to regulate the spread of disease, a referendum was passed where prostitutes had to be examined, declared disease free, treated, and given a license to practice their trade. The Union Army in Nashville, Tennessee established the United States' first system of legalized prostitution.

The plan was simple. Each lady would register and receive a licence for $5, which allowed her to freely practise her trade. An army doctor examined the girls each week at an additional 50 cent fee, to ensure they remained disease free. Those who had caught a disease were sent to a hospital established specifically for them. Anyone found 'working' without a licence, or those who didn't appear for a weekly examination were arrested and sentenced to thirty days in jail.

Once suspicious of the military laws because of the treatment they had received, Nashville's soiled doves took to the new system with as much enthusiasm as those who established it. One doctor penned that they no longer had to turn to 'quacks and charlatans' for ineffective treatments, and eagerly showed potential customers their licenses to prove that they were disease-free.

When the war ended, the soldiers moved on, and the women went their way too. Nashville became the Music City in the twentieth Century and is now a global publishing hub. As for the ladies, they probably did a great deal to boost the morale of lonely soldiers far from home, and their money aided the city, especially as the war became longer and costlier than anyone ever imagined. These women offered their talents, and we have to admire their courage, feel their suffering, and acknowledge their ability to survive during this tragic era in American history.

The city of New Orleans has a colourful and tumultuous past. First settled by the French in 1763, it passed to the Spanish and was given back

to France before being included as part of the United States' Louisiana Purchase in 1803. Lying where the Mississippi River meets the Gulf of Mexico, the city has always been a hub of trade. Its unusual history makes the area unlike anywhere else in the United States. As with any port town, New Orleans teems with importing goods from North American continent, the Caribbean, and Europe – mainly France, exporting cotton and drawing people with its lure of fast money and loose morals. It was a boisterous town.

A visitor to New Orleans, Colonel James Creecy, summed it up in rhyme in 1837. We can only imagine the scene by the end of the century:

'Have you ever been in New Orleans? If not, you'd better go,
It's a nation of a queer place; day and night a show:
Frenchmen, Spaniards, West Indians, Creoles, Mustees,
Yankees, Kentuckians, Tennesseans, lawyers and trustees,
Clergymen, priests, friars, nuns, women of all stains,
Negroes in purple and fine linen, and slaves in rags and chain,
Ships, arks, steamboats, robbers, pirates, alligators,
Assassins, gamblers, drunkards, and cotton speculators;
Sailors, soldiers, pretty girls, and ugly fortune-tellers,
Pimps, imps, shrimps, and all sorts of dirty fellows;
White men with black wives, and vice versa too.
A progeny of all colors an infernal motley crew!'

By the late nineteenth century, the moral character of the French Quarter was in decay. The 1850s saw the Vieux Carré as a thriving neighbourhood comprised of a cross spectrum of ethnic groups; foreign born, American-born, and Louisiana natives of which approximately one-third were classified as Creole as dictated in the laws of Louisiana.

By the 1890s, 'Creole society' was a relic in the city where it had once had such a vital presence. The upper and middle classes had moved to the St. Charles Avenue area of the city. When they left the area, the former elegance of the French Quarter descended into an abandoned slum. Displaced people, poor blacks, and poverty-stricken European immigrants settled into the area. With their arrival, narcotics, alcohol, and other vices – mainly prostitution – gripped the Vieux Carré. The trade in carnal

pleasure led to the establishment of a red-light district so that city authorities could control the spread of disease and crime.

Storyville was sectioned between the streets of Iberville, St. Louis, North Basin, and North Robertson. Its name was derived from Alderman Sidney Story, who created an ordinance in 1897 legalizing prostitution.

The district was created after Story and other officials toured the prominent red-light districts of Europe. The sex trade had always been a part of New Orleans's French Quarter. Following the Civil War in the United States, the city struggled with the influx of newly freed African Americans who moved to New Orleans from plantations, and they were placed into the same social and racial category as French-speaking Afro-Creoles. It was a time of rapid change brought about by Jim Crow laws and racial segregation. The area of town that had catered to music and adult entertainment was split by the new Southern Railway Terminal. The monied population pouring into the city didn't want to see that part of town, but they wanted to regulate drugs and prostitution. That was the beginning of Storyville. The new train station brought tourists and money into the area. It didn't take long for Storyville to gain recognition, and by 1900, it was becoming New Orleans's largest revenue centre. Once the brothels were established, restaurants and saloons began to open in Storyville, bringing in additional tourists.

Between 1895 and 1915, blue books were published in Storyville, much like the publications found in London. These books were guides to prostitution for visitors to the district. The books even include advertisements from liquor, tobacco, and medical companies. They list services offered, house descriptions, prices, and the specialty of each house. The Storyville blue books were inscribed with the motto; Order of the Garter: *Honi Soit Qui Mal Y Pense* (Evil to him who evil thinks).

Establishments in Storyville ranged from cheap 50 cent cribs to more expensive houses, including an elegant row of mansions along Basin Street. More expensive establishments could cost $10 or more. Black and white brothels coexisted in Storyville. The women listed in the books are categorized: 'W' stood for white; 'C' for coloured; 'Oct' for octoroon.

The owners of the brothels, saloons, and cribs would hire musicians to entertain the clients. Since the audience was not particularly interested in the music offered, the musicians had the freedom to experiment with

their styles, combining influences from the Caribbean, Africa, and France with the contemporary sounds of the day. This experimentation led to jazz – America's first art form.

During the meeting of the Organization of American Historians in early 2017, the brilliant presentation was held; *New Orleans: Portal to Commodified Circulation of Prostitution*, which offered invaluable insight into research regarding the subject of prostitution in the 1800s. The panel consisted of the highly-esteemed Dr Leslie Fishbein, American Studies Department, Rutgers University; Pamela D. Arceneaux, Historic New Orleans Collection and author of *Guidebooks to Sin: The Blue Books of Storyville, New Orleans*; Dr Emily Landau, historian and author of *Spectacular Wickedness*; and Pulitzer Prize winner Natasha Trethewey of Emory University.

As noted in the OAH schedule, the panel discussed the following:

'As a port city noted for the French influence on its culture and mores, New Orleans historically has attracted residents and visitors who found its cosmopolitan tolerance for what other cites viewed as vice compelling and refreshing. One result was the tolerated vice district, Storyville, that existed in New Orleans from 1897-1917, but that experiment in segregated vice was not simply a temporary anomaly in the American approach to regulating prostitution. It also represented a new set of cultural and commercial attitudes as New Orleans created an elaborate set of institutionalized mores to accompany segregated vice that reflected the cosmopolitan complexity of the city's hybridized culture. This session will address the evolution of that culture from its inception through the reign and demise of Storyville and its aftermath, examining Storyville in fact and legend and addressing the ways in which prostitution circulated within Storyville as a vice district, including its notorious Blue Books printed annually to advertise the district's sexual wares, its coverage in newspaper accounts, and the photographs of the district and its prostitutes and madams by Ernest J. Bellocq and the ways in which Storyville has been memorialized in poetry, music, art, photography, and film.'

The panel's discussion humanized the women of Storyville, and gave a sense of compassion and understanding of the very human, emotional side of late Victorian Era prostitution in the US. It is the story of American racial coding and class distinction, and a very Southern story. It is also the tale of survival and making the best of a bad situation, which is also the epitome of Southern history. The session was captivating and compelling.

It explains the structure of the District, the business behind the pleasure, and the influence Storyville had on fashion (the first high heels were brought into the United States by way of Storyville, via Paris).

The Edwardian Era and the First World War ended many of the cultural constraints felt worldwide during the Victorian Era and brought a desire to lose old-fashioned thinking for a new twentieth-century view on sexuality and morals. Fashion styles and sexual attitudes changed as women began to play a more active role, and began to work at careers outside of the home. Yet, the Victorians did inadvertently set the stage not only for the independent woman of the twentieth century. The women's Suffrage Movement saw females across the globe gain the right to vote and play a part in the government.

Victorian sexuality can be approached from many directions: prostitution, disease, religion, marriage, and pornography. These aspects overlap and influence each other, creating tremendous diversity in attitudes toward sex at any given point in the era's history and beyond. Each of these factors provide the context in which sexual identities are created. Sex commerce leading to cultural prestige has gone full circle and we see it in contemporary society via the adult entertainment industry. A glance into the nineteenth century gives us a taste of life before women's rights and education, where a career choice outside marriage was limited mainly to servitude or prostitution.

Victorian prostitution reinforced gender norms, but in some instances, it provided opportunities for women to assert power. As madams, courtesans, or kept women, they could sometimes own property and achieve social acclaim. Yet for the majority of prostitutes, it was a difficult, short life, and many times, the choice was not made by them. They suffered abuse and exploitation at the brothels and were unwanted

and on the societal fringe of the cities they inhabited. They existed on the margins.

Because of the restraint placed upon them, most women welcomed the suffrage movement when it evolved and became an issue of human rights at the end of the Victorian period. Modern women are fortunate that they are not subject to the societal and cultural restrictions of the era, and that they may choose the occupation and career that best suits them and their unique talents. Likewise, in the post-Victorian period, love changed in a way that made it inseparable from erotic longings and pleasures. The sexualization of love, and the erotic aspects of sex within marriage became cultural norms in the twentieth century. An intimate culture of sex, one valued for its sensual, pleasurable, and expressive qualities also flourished. Sex for carnal pleasure became accepted in contemporary society by the end of the century. The stage was set for the rise of women as stars of stage and screen, which started with the courtesans and kept women of high society in the previous century. The roll of celebrity status in popular culture also became a cultural standard.

Yet, not that long ago, without the protection of a wealthy or titled man, there was no access for women to achieve professional recognition. In a man's world, the masculine component holds the power. The only weapons in the cache of the female sector were allure and seduction.

References by Chapter

Chapter 1

AQUILLA CLARKE, Ronald. DAY, Patrick A.E. *Lady Godiva Images of a Legend in Art & Society.* Coventry, City of Coventry Leisure Services, 1982.

BAXTER, Stephen. *The Earls of Mercia. Lordship and Power in Late Anglo-Saxon England.* Oxford, Oxford University Press, 2007.

BEDE. *The Ecclesiastical History of the English People,* 3rd ed., trans. Judith McClure and Roger Collins. Oxford, Oxford University Press, 2008.

CAMPBELL, James. JOHN, Eric. WORMALD, Patrick. *The Anglo-Saxons,* 2nd ed. Edited by James Campbell. London, Penguin Books, 1991.

CROSSLEY-HOLLAND, Kevin, trans. 'A Marriage Agreement' in *The Anglo-Saxon World an Anthology,* 4th ed., Oxford, Oxford University Press, 2009.

DONOGHUE, Daniel. *Lady Godiva A Literary History of the Legend,* Kindle edition. London, Blackwell Publishing, 2003.

FLEMING, Robin. *Britain after Rome. The Fall and Rise 400 to 1070,* 2nd ed. London, Penguin Books, 2011

GRAFTON, Richard. *Grafton's Chronicle or History of England.* London, G. Woodville, 1809.

HIGHAM, Nicolas J., RYAN, Martin J. *The Anglo-Saxon World.* New Haven and London, Yale University Press, 2015.

HOLLAND, Tom. *Æthelstan.* Milton Keynes, Penguin Books, 2016.

HUNT, John. *Warriors, Warlords and Saints. The Anglo-Saxon Kingdom of Mercia.* Alcester, West Midlands History Limited, 2016.

MORRIS, Marc. *The Norman Conquest.* London, Windmill Books, 2013.

RAMIREZ, Dr. Janina. *Power, Passion and Politics in Anglo-Saxon England. The Private Lives of the Saints.* London, Penguin Random House, 2015.

SWANTON, Michael, trans. *The Anglo-Saxon Chronicles,* 2nd ed. London, Phoenix Press, 2000.

TENNYSON, Alfred. *The Poetical Works of Alfred Tennyson Vol IV.* (Leipzig: Bernhard Tauchnitz, 1860) 123.

VENNING, Timothy. *The Kings and Queens of Anglo-Saxon England.* Stroud, Amberley Publishing, 2013.

WENDOVER, Roger of. *Flowers of History The History of England From the Descent of the Saxons to A.D. 1235,* trans. J.A. Giles. London, Henry. G. Bohn, 1849.

Online References:

Baxter, Stephen. *PASE Domesday,* accessed Mar, 2017.
https://domesday.pase.ac.uk/Domesday?op=5&personkey=38916&orderField=tenant1086#list

Haddon-Wright, Emma. Twitter posts. 2017.
https://twitter.com/RedLunaPixie/status/856582547542872064
https://twitter.com/RedLunaPixie/status/856579419162517509

Jones, Clare. *Prostitution and the Contagious Diseases Acts, (1864, 1866 and 1869).* Accessed May, 2017.
http://herstoria.com/prostitution-and-the-contagious-diseases-acts-1864-1866-and-1869/

Josephine Butler Memorial Trust, 'A brief introduction to the life of Josephine Butler,' accessed May, 2017
http://www.josephinebutler.org.uk/a-brief-introduction-to-the-life-of-josephine-butler/

Mumby, Julie. *Anglo-Saxon Inheritance,* accessed Apr, 2017.
http://www.earlyenglishlaws.ac.uk/reference/essays/anglo-saxon-inheritance/

St Albans Abbey. *Chroniclers of St Albans Abbey,* Accessed Mar, 2017.
https://www.stalbanscathedral.org/history/the-road-to-magna-carta/chroniclers-of-st-albans-abbey

Worcester, John of. *Chronicle of John of Worcester 456-1040 AD.* 2009,
http://www.bsswebsite.me.uk/History/JohnofWorcester/Chronicle_John2.html?t1=godiva#

Chapter 2

DARLINGTON, RR & MCGURK, P (Ed). BRAY, J & MCGURK P (Trans). *The Chronicle of John of Worcester Volume II.* Oxford University Press. 1995.

REFERENCES BY CHAPTER

FAIRWEATHER, Janet (Trans). *Liber Eliensis: A History of the Isle of Ely from the Seventh Century to the Twelfth.* The Boydell Press. 2005.

FARRER, William (Ed). *Early Yorkshire Charters Volume I Anterior to the Thirteenth Century.* Ballantyne, Hanson & Co. 1914.

FISHER, DJV. *The Anglo-Saxon Age.* Longman. 1973.

FLETCHER, Richard. *Roman Britain & Anglo-Saxon England 55BC-AD1066.* Stackpole Books. 1989.

GARMONSWAY, G.N. (Trans). *Anglo-Saxon Chronicle.* Everyman's Library. 1953.

GILES, JA (Trans) Roger of Wendover. *Flowers of History, Comprising the History of England from the Descent of the Saxons to 1235; Formerly Ascribed to Matthew Paris.* Forgotten Books. 2012.

GILES, J.A. (Trans). Æthelweard. *The Chronicle of Fabius Æthelweard From the Beginning of the World to 975AD, in Old English Chronicles.* George Bell & Sons. 1906.

HART, Cyril. *Athelstan 'Half-King' and his Family, in Anglo-Saxon England Volume 2.* Edited by P Clemoes. Cambridge University Press. 1973.

HENSON, Donald. *A Guide to Late Anglo-Saxon England from Ælfred to Eadgar – 871 to 1074AD.* Anglo-Saxon books. 1998.

HILL, Paul. *The Age of Athelstan.* Tempus. 2004.

KYLIE, Edward (Trans & Ed). *The English Correspondence of St Boniface: Being for the Most Part Letters Exchanged Between the Apostle of the Germans and His English Friends.* Chatto & Windus. 1911.

LAPIDGE, Michael. Blair, John. Keynes, Simon. Scragg, Donald. The Blackwell Encyclopaedia of Anglo-Saxon England. Blackwell. 2000.

LAPIDGE, Michael. *Æthelwold as Scholar and Teacher, in Bishop Æthelwold: His Career and Influence.* Edited by Barbara Yorke. The Boydell Press. 1988.

LOVE, Rosalind C (Trans & Ed). Goscelin of Saint-Bertin. *The Hagiography of the Female Saints of Ely.* Clarendon (OUP). 2004.

LOYN, H.R. *The Governance of Anglo-Saxon England 500-1087.* Edward Arnold.1984.

NELSON, Janet L. *Politics and Ritual in Early Medieval Europe.* The Hambledon Press. 1986.

PFAFF, Richard W. *The Liturgy in Medieval England: A History.* Cambridge University Press. 2009.

PREEST, David (Trans). William of Malmesbury. *Gesta Pontificum Anglorum.* The Boydell Press. 2002.

RABIN, Andrew. *Female Advocacy and Royal Protection in Tenth-Century England: The Legal Career of Queen Ælfthryth, in Speculum Vol 84 No 2.* University of Chicago Press. 2009.

RIDYARD, Susan J. *The Royal Saints of Anglo-Saxon England: A Study of West Saxon and East Anglian Cults.* Cambridge University Press. 1989.

ROACH, Levi. Æthelred the Unready. Yale University Press. 2016.

ROBERTSON, AJ (Trans). *Anglo-Saxon Charters.* Cambridge University Press. 1956.

ROBINSON, J Armitage. *St Oswald and The Church of Worcester, in The British Academy Supplemental Papers.* Oxford University Press. 1919.

ROLLASON, DW. *The Cults of murdered Royal Saints in Anglo-Saxon England, in Anglo-Saxon England Vol II.* Edited by P Clemoes. Cambridge University Press. 1983.

SCRAGG, Donald (Ed). Edgar King of the English, 959-975. The Boydell Press. 2008.

SHARPE, John, & **GILES**, J.A., (Trans). William of Malmesbury. *Chronicle of the Kings of England, ca. 1090-1143.* H.G.Bohn. 1847.

SHORT, Ian (Trans & Ed). Gaimar, Geffrei. *Estoires des Engleis.* Oxford University Press. 2009.

STAFFORD, Stafford. *Queen Emma & Queen Edith.* Blackwell. 1997

STENTON, Frank. *Anglo-Saxon England.* Oxford University Press.1943 (2001).

SYMONS, Dom Thomas (Trans). *Regularis Concordia: The Monastic Agreement of the Monks and Nuns of the English Nation.* Oxford University Press. 1953.

THORPE, Benjamin (Trans). Ælfric. *The Homilies of the Anglo-Saxon Church Volume II.* London for the Ælfric Society. 1844.

TURNER, Andrew J & **MUIR**, Bernard J (Ed & Trans). Eadmer of Canterbury. *Lives and Miracles of Saints Oda, Dunstan & Oswald.* Clarendon (OUP). 2006.

REFERENCES BY CHAPTER

WALKER, Ian W. *Mercia and the Making of England.* Sutton. 2000.

WHITELOCK, Dorothy (Trans). *English Historical Documents Volume I c.500-1042.* Oxford University Press. 1955.

WILLIAMS, Ann. *Alfred P Smyth, DP Kirby. A Biographical dictionary of Dark Age Britain c.500-c.1050.* Seaby.1991.

WILLIAMS, Ann. *Æthelred the Unready the Ill-Counselled King.* Hambledon and London. 2003.

WILLIAMS, Ann. *Princeps Merciorum gentis:* The Family, Career and Connections of Ælfhere, ealdorman of Mercia, 956-83, in Anglo-Saxon England Volume 10 Edited by P Clemoes. 1982.

Online References:

King's College London & University of Cambridge. Prosopography of Anglo-Saxon England. http://www.pase.ac.uk/index.html

King's College London & University of Cambridge. The Electronic Sawyer. http://www.esawyer.org.uk/about/index.html

Miller, Sean. *Anglo-Saxon Charters* (Anglo-Saxons.net). http://www.anglo-saxons.net/hwaet/

Chapter 3

ARNOLD, Catharine: *The Sexual History of London.* New York, St. Martin's Press, 2011

BRUNDAGE, James: *Sex and Canon Law, Garland Reference Library of the Humanities Volume 1696.* Issue 1996: Pages 33-50. Print.

BRYANT, Nigel (translator): *The History of William Marshal,* Woodbridge, The Boydell Press, 2016

BURFORD, E.J: *Bawds and Lodgings, a History of the London Bankside Brothels c. 100-1675, London,* Peter Owen, 1976

CADDEN, Joan: *Western Medicine and Natural Philosophy.* Garland Reference Library of the Humanities Volume 1696. Issue 1996: Pages 51-80. Print.

CAPELLANUS, Andreas: *The Art of Courtly Love.* Translated by John Jay Parry. New York, Columbia University Press, 1960

DÜLL, S., **LUTTRELL**, A., & **KEEN**, M: *Faithful Unto Death: The Tomb Slab of Sir William Neville and Sir John Clanvowe, Constantinople 1391.* The Antiquaries Journal, 71, 174-190, doi:10.1017/S0003581500086868, 1991

GADDESDEN, John: Rosa anglica practica medicine, Venice, Bonetus Locatellus, 1516.

GIES, Frances and Joseph: *Marriage and Family in the Middle Ages*, New York, Harper & Row, 1987

GIES, Frances and Joseph: *Life in a Medieval Castle*, New York, Harper Perennial, 1974

GIES, Frances and Joseph: *Life in a Medieval City*, New York, Harper Perennial, 1969

KARRAS, Ruth Mazo: *Sexuality in Medieval Europe*, New York, Routledge, 2005

MURRAY, Jacqueline: *Twice Marginal and Twice Invisible: Lesbians in the Middle Ages*, Garland Reference Library of the Humanities Volume 1696. Issue 1996: Pages 191-222. Print.

PAYER, Pierre J: *Confession and the Study of Sex in the Middle Ages*, Garland Reference Library of the Humanities Volume 1696. Issue 1996: Pages 3-32. Print.

RIDDLE, John M: *Contraception and Early Abortion in the Middle Ages,* Garland Reference Library of the Humanities Volume 1696. Issue 1996: Pages 3-32. Print.

SALISBURY, Joyce E: *Gendered Sexuality*, Garland Reference Library of the Humanities Volume 1696. Issue 1996: Pages 81-102. Print.

TANNAHILL, Reay: *Sex in History.* New York, Stein and Day, 1992

Chapter 4

AHSLEY, Mike: *British Kings and Queens,* Constable Robinson, 1998.

BREWER, Clifford: *The Death of Kings,* Abson, London, 2005.

CECIL, David: *The Cecils of Hatfield House*, Cardinal, London, 1975.

DODD, A.H.: *Elizabethan England,* BCA, London 1973.

DOVER WILSON, John (ed): *Life in Shakespeare's England,* Penguin, London, 1968.

IRWIN, Margaret: *That Great Lucifer: A Portrait of Walter Ralegh,* Allison & Busby, London, 1998.

LOADES, David: *The Tudors, the History of a Dynasty*, Bloomsbury, London, 2012.

PENN, Thomas: *The Winter King: the Dawn of Tudor England,*
Penguin, London, 2012.

PLOWDEN, Alison: *Elizabethan England*, Reader's Digest, London,
1982.

SALGADO, Gamini: *The Elizabethan Underworld*, BCA, London, 1972.

STARKEY, David: *The Reign of Henry VIII: the Personalities and
Politics*, Vintage, London, 2002.

WEIR, Alison: *Britain's Royal Families*, Pimlico, London, 2002.

WEIR, Alison: *Elizabeth the Queen,* Pimlico, London, 1999

Chapter 5

BATES, Catherine. *Masculinity and the Hunt: Wyatt to Spenser*. OUP:
Oxford, 2016.

BRIDGES, Susan. *Thomas Wyatt: The Heart's Forest*. F&F: London,
2012.

CAVENDISH, George. *Thomas Wolsey, late Cardinal his life and
death*. The Folio Society: Bristol, 1962

IVES, Eric. *The Life and Death of Anne Boleyn*. Blackwell: Oxford,
2011.

MACKAY, Lauren. *Inside the Tudor Court*. Amberley: Stroud, 2014.

NORTON, Elizabeth. *The Anne Boleyn Papers*. Amberley: Oxford,
2013.

ROBINSON, John. *Court Politics, Culture and Literature in Scotland
and England 1500 – 1540*. Ashgate Publishing: 2013.

SHULMAN, Nicola. *Graven with Diamonds*. CPI Group: London,
2011.

SOUTHALL, Raymond. *The Courtly Maker: An Essay on the Poetry
of Wyatt and His Contemporaries*. Blackwell: Oxford, 1964.

TELFORD, Lynda. *Tudor Victims of the Reformation*. Pen and Sword
Books: Barnsley 2016.

WARNICKE, Retha M. *The Rise and Fall of Anne Boleyn*. CUP:
Cambridge, 1989.

WARNICKE, Retha M. *'The Eternal Triangle and Court Politics:
Henry VIII, Anne Boleyn, and Sir Thomas Wyatt.'* Albion: A Quarterly
Journal Concerned with British Studies, vol. 18, no. 4 (1986): 565–
579.Accessed January 7, 2017

WEIR, A. *The Lady in the Tower: The Fall of Anne Boleyn.* Random House: London, 2009.

WYATT, Thomas Sir. *Delphi Complete Works of Sir Thomas Wyatt.* Delphi Classics: 2014, Kindle edition.

Chapter 6

BUCHANAN, George. Rerum Scoticarum Historia. Edinburgh, 1582.

CALENDAR OF STATE PAPERS, Scotland: Volume 1, 1547-63, editor Joseph Bain. Originally published by Her Majesty's Stationery Office, London, 1898.

CHALMERS, C.R. and CHALONER, E.J. 500 Years Later. *Journal of the Royal Society of Medicine*, Royal Society of Medicine Press. December 1, 2009 vol. 102 no. 12, pages 514-517.

Fraser, Antonia. *Mary, Queen of Scots.* London: Weidenfeld & Nicolson, 1969.

HAWKINS, Sir John. *A General History of the Science and Practice of Music*, Volume 2. J. Alfred Novello, 1853.

HURREN, Dr Elizabeth T. King Henry VIII's Medical World, Senior Lecturer History of Medicine at Oxford Brookes University.

IVES, Eric. *The Life and Death of Anne Boleyn.* Blackwell Press, 2005.

MASSIE, Allan, *The Stuarts,* Jonathan Cape, 2010.

PAGE, Christopher. *The Guitar in Tudor England: A Social and Musical History.* Cambridge University Press, 2015.

STARKEY, David. *Elizabeth: The Struggle for the Throne.* Harper Perennial, 2007.

STING. *Songs from the Labyrinth.* Great Performances. February 26, 2007, PBS.

THOMAS, Keith. *Religion and the Decline of Magic: Studies in Popular Beliefs in Sixteenth and Seventeenth-Century England.* Penguin Books, 1991.

Chapter 7

A&E Television Networks (n.d.a) *Mary Tudor.* Biography.com. https://www.biography.com/people/mary-tudor-9401296

A&E Television Networks. (n.d).. Lady Jane Grey. Biography.com. https://www.biography.com/people/lady-jane-grey-9320636

REFERENCES BY CHAPTER

BBC (2014) *Mary I.*
http://www.bbc.co.uk/history/historic_figures/mary_i_queen.shtml
Borman, T. (2016). *Robert Dudley: Elizabeth I's Great Love.*
http://www.historyextra.com/article/elizabeth-i/queen-elizabeth-great-love
Claire (2010). *The Elizabeth Files. Did Robert Dudley Murder Amy Robsart?* http://www.elizabethfiles.com/did-robert-dudley-murder-amy-robsart/3611/#ixzz4ihd7EHbQ
Cmbanalia (2016) http://historum.com/speculative-history/121804-saving-lady-jane-grey.html
Elt on WI Mary Tudor is Really Pregnant? (2011).
https://www.alternatehistory.com/forum/threads/wi-mary-tudor-is-really-pregnant.220472
Evan at AlternateHistory.com (2014)
https://www.alternatehistory.com/forum/threads/queen-for-more-than-9-days.303852
Galli, M. (2005). *Queen Elizabeth I of England.* MMV Prof. Pavlac's Women's History Site.
http://departments.kings.edu/womens_history/elizabeth.html
Hanson, M. (2015). *'Lady Jane Grey – Facts, Biography, Information & Portraits.'* https://englishhistory.net/tudor/relative/lady-jane-grey
Hanson, M. (2015a). *'Katherine Parr – Facts, Information, Biography & Portraits.'* https://englishhistory.net/tudor/monarchs/katharine-parr
Jade at Did Robert Dudley Murder Amy Robsart? (2012).
http://www.elizabethfiles.com/did-robert-dudley-murder-amy-robsart/3611/#ixzz4ihd7EHbQ
JonasResende at AlternateHistory.com (2014)
https://www.alternatehistory.com/forum/threads/queen-for-more-than-9-days.303852
Levin, C. (2015) *Mary I's phantom pregnancy.* History extra.
http://www.historyextra.com/article/sex-and-love/mary-i%E2%80%8099s-phantom-pregnancy
Nytram01 at AlternateHistory.com (2014)
https://www.alternatehistory.com/forum/threads/queen-for-more-than-9-days.303852
Paranoid Marvin. (2016) http://historum.com/speculative-history/121804-saving-lady-jane-grey.html

Patricia Getz at Did Robert Dudley Murder Amy Rosbart? (2012). http://www.elizabethfiles.com/did-robert-dudley-murder-amy-robsart/3611/#ixzz4ihd7EHbQ

Ridgway, C. (2016). *'Gloriana': Elizabeth I's final years by Gareth Russell*. https://www.tudorsociety.com/gloriana-elizabeth-is-final-years-by-gareth-russell

Sharnette, H. (2017). *Robert Dudley, Earl Of Leicester.* Elizabeth I. http://www.elizabethi.org/contents/queensmen/robertdudley.htm

Stevie at Did Robert Dudley Murder Amy Rosbart? (2012). http://www.elizabethfiles.com/did-robert-dudley-murder-amy-robsart/3611/#ixzz4ihd7EHbQ

Teenage Scandal of Queen Elizabeth I (n.d). http://www.elizabethan-era.org.uk/teenage-scandal-of-queen-elizabeth-i.htm

The Tudor Enthusiast (2012). *Queen Mary Dies at 42* http://thetudorenthusiast.weebly.com/my-tudor-blog/queen-mary-dies-at-age-42

Watt, N. (2011). *Royal equality act will end succession of first born male - rather than older sister.* The Guardian. https://www.theguardian.com/uk/2011/oct/28/commonwealth-royalty-succession-change

Chapter 8

ACTON, William. *Prostitution, Considered in Its Moral, Social, and Sanitary Aspects in London and Other Large Cities and Garrison Towns, with Proposals for the Control and Prevention of Its Attendant Evils.* London: John Churchill and Sons, 1870.

ARCENEAUX, Pamela D. *Guidebooks To Sin: The Blue Books of Storyville, New Orleans.* The Historic New Orleans Collection. 2017.

ARNOLD, Matthias. *Henri de Toulouse-Lautrec.* Taschen, 2000.

BEATTY, Laura. *Lillie Langtry - Manners, Masks and Morals.* London: Vintage. p. Chapter XXVII Down the Primrose Path. 1999.

BLYTH, Henry. *Skittles: The Last Victorian Courtesan.* Rupert Hart-Davis, London, 1970.

BOOTH, General William. *In Darkest England and the Way Out.* Funk & Wagnalls.1890.

Charles Smart, ed., *The Medical and Surgical History of the War of the Rebellion*, Part III, vol. II, Medical Volume. District of Columbia, 1888.

REFERENCES BY CHAPTER

CHIDSEY, Donald Barr; *The California Gold Rush.* Crown Publishing Inc, New York. 1968.

FORD, Colin and **HARRISON**, Brian. *A Hundred Years Ago: Britain in the 1880s in Words and Photographs.* Cambridge: Harvard Univ., 1983.

GRAHAM, Ian. *Scarlet Women: The Scandalous Lives of Courtesans, Concubines, and Royal Mistresses.* Macmillan, 2016.

HICKMAN, Katie. *Courtesans*, Harper Collins, 2003.

HYDE, H. Montgomery. *The Cleveland Street Scandal.* London: W. H. Allen. 1976.

HYDE, H. Montgomery. *The Other Love: An Historical and Contemporary Survey of Homosexuality in Britain.* London: Heinemann. 1970.

LANGTRY, Lillie. *The Days I Knew - An Autobiography.* St. John: Redberry Press. 1989.

LEES-MILNE, James. *The Enigmatic Edwardian.* Sidgwick and Jackson. 1986.

LOWRY, Thomas P. *Sexual Misbehavior in the Civil War: A Compendium of 1,036 True Stories.* Xlibris Press, 2006. (He notes the terms whore, whorehouse, and bordello were infrequently used terms during the Civil War era).

LOWRY, Thomas P. *The Story the Soldiers Wouldn't Tell: Sex in the Civil War.* Stackpole Press, 1994.

MAYHEW, Henry, and **TUCKNISS,** William. *London Labour and the London Poor: a Cyclopedia of the Condition and Earnings of Those That Will Work, Those That Cannot Work, and Those That Will Not Work.* London: Griffin, Bohn, and Company, 1861.

MITCHELL, Sally. *Daily Life in Victorian England.* Greenwood Press, 1996.

SHANLEY, Mary Lyndon. *Feminism, Marriage, and the Law in Victorian England.* Princeton University Press, 1993.

SIGWORTH, E.M and **WYKE**, T.J. *Study of Victorian Prostitution and Venereal Disease.* London: Methuen, 1980.

The Contagious Diseases Acts, also known as the CD Acts, were originally passed by the Parliament of the United Kingdom in 1864, with alterations and editions made in 1866 and 1869.

SPARKS, Edith, *Capital Intentions: Female Proprietors in San Francisco, 1850-1920.* University of North Carolina Press. 2011.

VICNIUS, Martha. *Suffer and be Still. Women in the Victorian Age.* Indiana University Press.1973.

WALKOWITZ, Judith R. *Prostitution and Victorian Society: Women, Class, and the State.* Cambridge: Cambridge UP, 1980.

'A Strange Cargo,' Cleveland Morning Leader, July 21, 1863.

Allingham, Philip V. 'Oscar Fingal O'Flaherty Wilde (1854-1900).' The Victorian Web. 2010.

'Harper's Weekly,' March 8, 1862.

Schuele, Donna C. *"None could deny the eloquence of this lady": Women, Law, and Government in California, 1850-1890.* California History, Vol. 81, No. ¾. University of California Press in association with the California Historical Society, 2003.

Serratore, Angela. 'The Curious Case of Nashville's Frail Sisterhood.' Smithsonian Magazine, 2013.

The Historic New Orleans Collection. www.hnoc.org.

U.S. Census Bureau (1860). Tennessee State Government Archives, History. Retrieved from http://Tennessee Electronic Library (TEL).

www.nola.com/175years

www.victorianweb.org/

Zepp, George. 'City's Civil War 'Secret' Revealed.' The Tennessean, 2003.

Index